HOW TO USE YOUR EYES

HOW TO USE

YOUR EYES

JAMES ELKINS

ROUTLEDGE

New York • London

Published in 2000 by Routledge

29 West 35th Street, New York, NY 10001

11 New Fetter Lane, London EC4P 4EE, Great Britain

Further information on page 259

PREFACE

Our eyes are far too good for us. They show us so much that we can't take it all in, so we shut out most of the world, and try to look at things as briskly and efficiently as possible.

What happens if we stop and take the time to look more carefully? Then the world unfolds like a flower, full of colors and shapes that we had never suspected.

Some things can't really be seen without reams of special information. I cannot hope to understand the monitors I see in pictures of NASA's command center, or the strange implements in my doctor's office. I don't pretend to be able to guess the insides of my digital watch and I can't decipher the scary-looking devices in the electric relay station that is a few blocks from where I live. There are books that can help you learn to understand such things, but this is not one of them. This book won't tell you how to repair your refrigerator or read bar codes. It's not a museum guide, either—you won't learn how to understand fine art. And you won't learn how to predict the weather by looking at clouds, or how to wire a house, or how to track animals in the snow.

In short, this is not a reference tool. It's a book about learning to see *anything*, learning to use your eyes more concertedly and with more patience than you might ordinarily do. It's about stopping and taking the time simply to look, and keep looking, until the details of the world slowly reveal themselves. I especially love the strange feeling I get when I am looking at something and suddenly I *understand*— the object has structure; it speaks to me. What was once a shimmer on the horizon becomes a specific kind of mirage, and it tells me about the shape of the air I am walking through. What was once a meaningless pattern on a butterfly's wing becomes a code, and it tells me how that butterfly looks to other butterflies. Even a

postage stamp suddenly begins to speak about its time and place, and the thoughts of the person who designed it.

I have tried to avoid writing about things that are already widely appreciated. (People do write about stamps, but only to list their value.) There is a chapter on oil paintings, but it is about the cracks on the surfaces of the pictures, not the paintings themselves. There is a chapter on bridges, but it doesn't mention the famous ones. Instead it is about culverts: a kind of bridge so ordinary and lowly that it doesn't seem like a bridge at all. A culvert is any waterway that goes under a road, and it can be nothing more than a buried pipe. Yet there is a great deal to be seen in culverts: they can tell you whether the land is eroding, if it ever floods, and how the population in the area is affecting the landscape.

The most common things, like culverts, tend to be the most overlooked. Many people know how to tell an elm from a maple or an oak, but fewer can do that in the wintertime, so I have included a chapter on twigs. Fingerprints are with us all the time, and they are a stock-in-trade of murder mysteries, but how many people have learned how to identify them? (The chapter on fingerprints will tell you how, following the official FBI manual.) Faces are among the most familiar things of all, but they are very different when you can look at them and know the names of the folds and wrinkles, and see what is underneath, and how the face will change with age. A muscular shoulder can be a lovely sight, and it is all the more interesting when you can also see how the muscles work together, compressing and pulling in complicated, evanescent patterns.

Shoulders, faces, twigs, sand, grass—they are the ordinary stuff of life. We see them, and ignore them, every day. It struck me when writing the chapter on grass that if it hadn't been for this book, I might very well have gone on ignoring grass my whole life. I have sat on grass, and mowed it, and have picked it absentmindedly; and I have noticed it in passing when it grows too high on a neighbor's lawn. But before I sat down to write the chapter on grass, I had never really paid attention to it. I guess I thought I could always do that sometime in the future, when I am retired and have time to spare. But a little cold-blooded calculation makes me wonder

about that. A normal lifetime, for a person who lives in a developed nation, is about 30,000 days. Grass is in bloom for about 10,000 of those days, and certainly I could take one of them to sit down and get to know grass. But it is frightening how quickly life passes. I am a little over forty years old, and that means I have used up more than half of those 10,000 days that I have been given for viewing grass. If I'm lucky, I have about 30 summers left. Each summer has about 60 days of good weather, and maybe 20 days when I actually get outside and have time to spare. That adds up to a little over 600 chances to see grass. They can easily slip away.

(The mathematician Clifford Pickover has a clever, but depressing way of re-minding himself how long he has to live. He calculated that he has 10,000 days left to live, based on his age and life expectancy; then he drew a square grid with 10,000 squares—100 squares on each side. The grid hangs over his desk. Every morning when he comes in to the office, he crosses out one square. I don't think I could stand to have Pickover's calendar, but he is exactly right to remind himself how quickly time passes.)

Many chapters in this book are about common things like grass that can be seen just about anywhere. But that is not all there is to the visible world: there are also wonderful objects that are uncommon or rare. To see an example of the ancient Mediterranean script called "Linear B" you might have to go to London or Athens. I have written about it to show how much there is to be seen even in small, "uninteresting" archaeological artifacts. To see an alchemical emblem or a Renaissance rebus, the subjects of two other chapters, you would have to visit a large library. Still, it is important to know that such things are out there: they are richer in meanings than the ordinary images you can see in museums, and often more beautiful.

Linear B, Renaissance rebuses, and alchemical emblems are the rarest things in this book. Everything else can be seen with only a little effort. All that's required to see culverts is to stop the car when you cross a gully, get out, and walk down the slope to the streambed. To see your fingerprints, all you need is a little ink (from a stamp pad, for instance), and a photocopy machine to enlarge the prints so they can be studied. It helps to have a good magnifying glass if you're going to be looking at sand, but it isn't absolutely necessary. Hieroglyphs and Egyptian scarab beetles are in many museums, and you can find Chinese and Japanese calligraphy everywhere from magazines to movies. X rays, perspective pictures, engineering drawings, and maps (the subjects of four other chapters) are all part of modern life. Ice halos—the subject of a section toward the end of the book—are uncommon, but since I first learned about them I have seen several each winter. A great deal depends on knowing when and where to look. An especially spectacular halo, called the 22° solar halo, fills a large part of the sky (see the picture, p. 191); you might think that if one appeared over a city it would cause a sensation. But the last one I saw, in the sky over Baltimore, went entirely unnoticed. There it was, like a huge eye with the sun at its center, bearing down on the whole city—and no one saw it. People didn't *expect* to see anything, so they didn't look up. And the 22° halo is so large that even if someone happened to glance up into the sky—which was, at any rate, a blinding white—they would have seen only a small portion of the enormous perfect circle hovering overhead.

So what does this all add up to? What is the common thread that binds sunsets to fingerprints, or culverts to Chinese script? They are all hypnotic. Each has the power to hold my attention utterly captive simply by the fact that it exists. For me, looking is a kind of pure pleasure—it takes me out of myself and lets me think only of what I am seeing. Also, there is pleasure in discovering these things. It is good to know that the visual world is more than television, movies, and art museums, and it is especially good to know that the world is full of fascinating things that can be seen at leisure, when you are by yourself and there is nothing to distract you. Seeing, after all, is a soundless activity. It isn't talking, or listening, or smelling, or touching. It happens best in solitude, when there is nothing in the world but you and the object of your attention.

My favorite chapters of this book are the ones on the sunset and the night. It's a little-known fact that if there are no clouds in the sky, the colors of the sunset follow a certain specific sequence. When I discovered that, I spent some wonderful evenings sitting outside, with my notes in hand, watching for the oranges, purples, and reds to appear, and discovering the various sunset phenomena: the amazing "purple light" that appears about twenty minutes after sunset, and the "Earth's shadow" that rises up in the east. Afterward, when the sunset is over, night begins and there are other lights to be seen: stars, of course, but also lovely faint lights that come from the air itself (called the "airglow") and lights from the dust that circles the planets (called the "zodiacal light"). These are very precious things to know, because the world looks different when you know them.

I hope this book will inspire every reader to stop and consider things that are absolutely ordinary, things so clearly meaningless that they never seemed worth a second thought. Once you start seeing them, the world—which can look so dull, so empty of interest—will gather before your eyes and become thick with meaning.

James Elkins

Chicago, spring 2000

THINGS MADE BY MAN

I

how to look at

a postage stamp

This is a diagram of the first postage stamp, the "Penny Black," showing the young Queen Victoria. The key was designed to help tell the difference between the several physical versions of the stamp; it points out places where the engravers altered the original design, strengthening it and bringing out the queen's features. After millions of years of use, the lines had worn down, and they had to be deepened. Later versions of the Penny Black are just a little coarser-looking than earlier ones, and the queen eventually got the kind of intent stare she has in Figure 1.1. After that the designers changed the color, and the queen ended up with fat cheeks and a somewhat silly expression (Fig. 1.2, top left).

The stamp just says "POSTAGE" and "ONE PENNY." (With the period, to make it more emphatic.) In 1840, England was the only country making stamps, so there was no need to add the words "Great Britain." Even today English stamps are the only ones without the name of the country, although France tried to rival them at one point by reducing their name to a tiny "RF," for "République Française." When it comes to designing stamps, space is at a premium. The omission of "Great

figure 1.1

A. B. Creeke, Jr., diagram of the original die of the world's first postage stamp, the Penny Black. Designed by Sir Rowland Hill, profile engraved by Frederick Heath, background by Messrs. Perkins, Bacon, and Company.

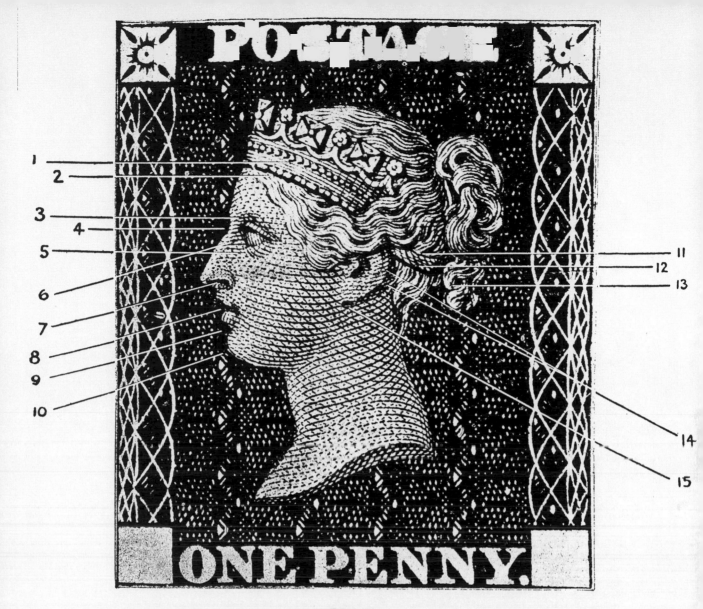

DIE II.

1.—The deep shading at the side of each stone, in the upper of the two rows of jewels in the band of the diadem, gives them a diamond-shaped appearance.

2.—The shading below the band of the diadem is very heavy.

3.—There are eight heavy lines at right angles to the curve of the upper eyelid.

4.—The nose, at its juncture with the forehead, is concave, which gives the bridge a convex appearance, entirely altering the shape of the organ.

5.—The lower eyelid is heavily shaded with lines.

6.—The shading on the eyeball is very pronounced.

7.—The nostril is larger and distinctly arched, with heavier shading.

8.—The mouth is almost closed, showing a much longer upper lip.

9.—The top of the chin shows a distinct indentation, causing the lower lip to appear much fuller.

10.—A line has been added to the bottom of the chin, almost at the edge, following its curve up to the above-mentioned indentation.

11.—The top of the band behind the ear is quite distinct.

12.—The lower edge of the band is formed by one thick line, the white space having disappeared.

13.—The penultimate twist of the pendent curl curves distinctly round towards the centre of same.

14.—The shading on the external rim of the ear is lighter and less distinct.

15.—The lobule of the ear ends abruptly on reaching its lowest point.

16.—The shading of the cheek is much heavier, and of a coarser character.

by Mr. Creeke), originally appeared in the Christmas, 1897, Number of "*The Stamp [Collectors' Fortnightly.*"

Britain" freed up a fraction of a square inch, and gave the artists more room for the queen's face.

Postage stamps are little universes, compressing the larger worlds of art and politics into a square half-inch. The art gets cramped but it also gains a surprising depth, and the politics gets boiled down to platitudes. Stamps make up for their tiny size by having detailed designs, some of them done with microscopically fine engraving machines. The airy trellises that run up each side of the Penny Black and the filigreed lathe work background were made with a machine specially designed for the purpose. Afterward, the central area was erased, and the artist Frederick Heath engraved the queen's profile. Many of the lines are too small to be quite seen with the naked eye. But they are designed so that we *almost* see them, and that lends the stamp an entrancing softness. It is as if the stamp had its own atmosphere, like a little bell jar with a plant inside. Heath would have had a magnifying apparatus, so that his view of the stamp would have been like the large key plate. Today, people with Heath's skills are almost nonexistent, because the work can be done on computer at any convenient magnification. The Penny Black is exactly what it appears to be: a tiny artwork, made on a tiny scale. Today's stamps are ordinary pictures electronically reduced.

The words "POSTAGE" and "ONE PENNY.," together with the two filigreed borders, make a complete frame around the queen's profile. The frame is jointed at the top with two Maltese crosses and at the bottom with two blank squares. In actual specimens of the Penny Black and later issues, there is a different letter in each box; note the "G" and "J" on the stamp in Figure 1.2. They are "check marks" intended to defeat forgers, and each stamp in a sheet had a different combination. I can imagine contemporary counterfeiters having a laugh over this—these days counterfeiters are hardly deterred by metallic strips, anticopying patterns, and micrographic writing. To counterfeit these stamps, all they would have needed to do was to fill in the squares with the letters of the alphabet.

The whole ensemble ends up looking like a painting in a frame. That was the first and most important model for stamps, and it never quite worked. The Penny Black (and the red version in Figure 1.2) doesn't really look like a painting or a

figure 1.2

Nineteenth-century British stamps. 1 penny rose, 1864; 4 penny gray brown, 1880–81; 6 penny gray, 1873–80; 2 penny lilac, 1883–84; 2½ penny lilac, 1883–84.

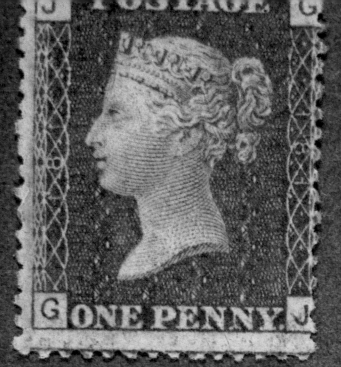

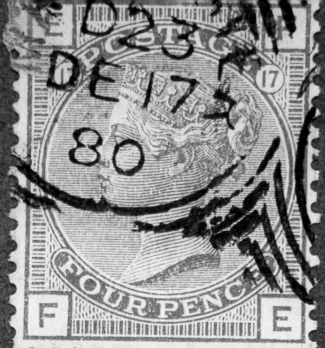

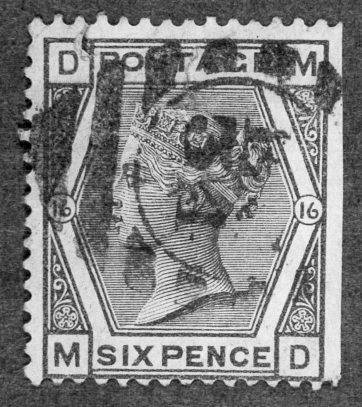

framed medallion, and even if it did, its size would make it look odd. In the next two decades other designers tried to create designs that were intrinsic to stamps. The fourth stamp made after the Penny Black is the 4 penny rose, designed by Joubert de la Ferté; Figure 1.2, top right, is an adaptation of his design. Ferté kept the profile of Victoria but reduced the frame to a set of geometric lines of the kind that might ornament a Greek temple. It is much weaker—much less like a simple picture and frame—than the Penny Black. The "check marks" have grown too big for the frame: they look more like sturdy pillars on the ground plan of some neoclassical house. Victoria's face is set in a disk, and the disk overlaps the frame on both sides. The idea was to make the stamp look more like a coin, but the idea backfires, and it ends up looking like a large heavy medal placed on top of a picture frame. Ferté's design could never actually be constructed in three dimensions; it is a paradoxical composition of two different things: an antique medallion and a framed oil painting.

Soon afterward there was a series of stamps in which each value was given a separate design so they could be quickly distinguished. The three pence stamp has three intersecting arcs, the six pence, six (as in Figure 1.2, middle), the nine pence, nine. But this kind of symbolism quickly becomes a problem. The shilling stamp was an ellipse—not an obvious choice—and the two shillings was a mandala, a kind of cat's-eye ellipse. Other series were designed with even more elaborate shape symbols, but they were never released—and for good reason, since they were more confusing than useful.

Then the designers tried another strategy, and based their stamps on architecture instead of paintings, coins, or numerical symbols. Cecil Gibbons, a philatelist who has studied this subject, calls the new architectural stamps "atrocious." The designs were divided into blocks, as if the stamps had been built out of rough-hewn marble. Some look as though they were made a little too quickly, so that the blocks don't fit properly. A couple are reproduced at the bottom of Figure 1.2. The stamp at the lower left is made of little blocks, and the blocks don't quite fit—there is a little shadow in the gap between them. The one on the lower right is reminiscent of a round window with marble trim.

figure 1.3

Cochin $^1/_2$ puttan yellow, 1892. Scott no. 1.

After the masonry series, the designers turned to heraldry and coats of arms. They made stamps with little shields and rows of compartments with the devices of the royal family. Victoria's head began to look like the helmet that is put on the top of a traditional coat of arms, and the stamps filled up with obscure symbols.

From this point it is easy to follow the history of stamp design. Each new formula is a new metaphor: first oil paintings, then coins, then number symbols, then masonry, then heraldry. . . . King George V (who reigned from 1910 to 1936) was a philatelist, and the stamps of his period introduce the horizontal "commemorative" format, which gives more room. In 1929 Britain issued the first stamp without a frame, or rather the first stamp that let the white paper border be the frame. Nowadays anything is possible, and there are triangular stamps, relief-surface stamps, and even 3-D stamps; but these basic design problems have never been solved. The underlying issue is that we still treat stamps as if they had to be modelled on something (paintings, masonry), instead of thinking of them as little objects in their own right.

It is nearly impossible to find stamps that do not rehearse the issues first broached by the Penny Black. In the nineteenth century, country after country produced stamps that looked just like England's, or else they borrowed their designs from English innovations. Italy, Germany, France, and the United States all began with variants of themes that had already been explored by English designers. Even today stamp designs are centralized, and many of the world's smaller nations have their stamps made for them by a few companies in New York City. The early stamps of Mongolia were designed in Hungary as part of a long-standing agreement between the two countries. The Hungarian artists were in turn influenced by British design. The stamps of some nineteenth-century Indian states, such as Cochin, Alwar and Bundi, Jhalawar, and Travancore, were often designed in a central British office, and they have the same classical frames as the early British stamps (Fig. 1.3). Victoria gets replaced by all sorts of exotic things. This Cochin stamp has a shell of Indra and a ceremonial umbrella. Nepalese stamps have Nepal's symbols—a *sripech* and crossed *kuchris.* The Mongolian stamps have the *soyombi,* a kind of coat of arms. To find stamps that are genuinely beyond the reach of European influence it is necessary to look at places so poor and so isolated that they were physically incapable of European-quality printing and design. Some early issues of the Indian state Bhor, for example, are little more than colored washes that were accepted as stamps (Fig. 1.4).

Stamps get ignored because their politics are reductive and their pictures are unrewarding. They tend to be simple and to borrow their ideas from other arts. On occasion a stamp might say something new, or say it in a new way, but most of the

figure 1.4

Bhor $\frac{1}{2}$a carmine, 1879. Scott no. 1.

time stamps rehearse the lowest common denominator of a nation's patriotism or its sense of art. Since the mid-twentieth century, the general trend throughout the world has been toward harmless or comical motifs: flowers, animals, movie stars, platitudes. Stamps are getting more trivial, sweet, and childish with each passing year, as if to atone for their first century of aggressive, sentimental nationalism.

Every once in a while, stamps can be interesting both politically and artistically. The stamps issued by the newly independent Irish Free State (1922–49) are an example. Ireland had just won its independence, and it took itself very seriously. Heavy, medieval symbols—the shamrock, the Irish harp, the Red Hand of Ulster—were done in somber greens and browns. The captions were seldom in English but in Irish or bilingual Irish and Latin. When Ireland lifted its trade restrictions in the 1950s the stamps began to get playful in the modern manner.

In our rush to be inoffensive we have largely lost the idea that stamps can have interesting meanings, and in our desire for modern efficiency we have forgotten that stamps can be tiny worlds filled with details that can barely be seen. Early American stamps are exceptionally finely done (Fig. 1.5, bottom row). The nearly microscopic lines produce a wonderful, shimmering effect; the tiny "motorwork" scrolls are so fine that they are barely visible even at this magnification. The stamp at the upper right has lines so small they are altogether invisible. Done this way, even a landscape a quarter-inch across can look enormous, full of light and distance and air. Compare it to the stamps in the middle, which were recently printed to commemorate the old stamps. The new stamps are coarse, crude, and uninteresting. Clearly, no one was meant to look at them. The sky is filled with dashes that look like rows of migrating geese, and the picture is ringed with a set of fake pearls.

I wouldn't say that all stamp designs should be as subtle as these old stamps—but at least the old designers knew that there is no reason to make everything easy to see. It's a lovely feeling to be drawn closer and closer to a tiny scene and to wonder at its depth and detail. Nineteenth-century stamps could work that kind of magic. Now all we have is colored flaps of paper, with almost nothing to catch the eye.

figure 1.5

Nineteenth-century American stamps, alongside a modern reprint. United States 12 cents black, 1861–62; United States 24 cents red lilac 1861–62; 3 cents ultramarine, 1869; and a modern reprint of an unused issue from 1869.

Design originally prepared, but not used, for U.S. postage series of 1869

2

how to look at

a culvert

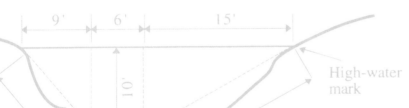

9' 6' 15'

10'

13'

18'

High-water
mark

A culvert is a place where a stream passes underneath a road. It might be as simple as a buried pipe to guide the water, or it can be a tube as large as a two-story house.

As people slowly pave over the whole Earth, culverts get more and more common. Forested land and grassland absorb rainwater, and so does cultivated land. City buildings, houses, parking lots, streets, and sidewalks do not retain rainwater, and so streams carry more water in urban and suburban areas than they do out in the country. In cities, nearly 100 percent of the rainfall has to be carried off by gutters, storm drains, and rivers; so there are more culverts—and bigger culverts—in populated areas. Areas prone to flooding also need large culverts to cut down the chances that the road would have to be rebuilt when a big storm hits. In general, every time a road crosses a stream, it needs a culvert. The artificial network of roads and the natural network of rivers and streams cross one another in hundreds of thousands of places, and the majority of them are culverts, not bridges.

You can't really see culverts from the highway and you may not notice you are driving over them at all. They do not look like bridges, and typically they are marked only by little concrete rails about a foot high or metal safety rails to keep cars from going over the side. On a superhighway you will see the gully on each side

of the road and the embankments leading down to the stream. To really see the culverts you have to stop the car and walk down the slope toward the stream.

If you live in the middle of a city, you won't see any culverts at all, because the streams are sent completely underground. Several cities have rivers that are completely invisible; Baltimore is one. An X-ray view of Baltimore would reveal a large river running directly underneath the city streets. Chicago has a "Deep Tunnel"—a gigantic tube 300 feet underground—to catch excess rainwater.

Most people probably remember culverts from their childhood: if you waded in a stream you would eventually come upon a place where the stream went under a road; and then, if you were adventurous, you followed the streambed into the dark culvert and eventually out the other side. Some culverts are like big garages open at each end. They don't have much mystery. But others are long and sinuous. I remember walking through an especially long one: I kept going for several minutes in deep darkness, listening to the echoing sounds of the water and the cars overhead, until I emerged in another landscape on the other side.

It can be a sobering experience to explore a stream in an urban area. A few years ago, I walked along a stream in downtown Baltimore. The stream ran at the bottom of a small woody gully, so it was out of sight of the houses up above. A worn, muddy pathway followed the streambed. It was littered with garbage. There were signs of campfires and drinking parties. In one place pages torn from a pornographic magazine littered the pathway. The stream passed through four culverts: two small ones, which were dark and cold, and two larger ones decorated on the inside with graffiti and empty beer bottles. The whole experience was very different from the streets just above, which were more orderly and peaceful.

If you have never explored culverts, you might want to stop next time you pass one on the highway, and walk down and have a look. Suburbs and superhighways are good places to see culverts, and some of the largest ones are out in the country. There are giant culverts in the Southwest, where dry streambeds might suddenly swell with a flash flood; and there are also huge culverts in the Southeast, where the chances of intense thunderstorms are higher than in other parts of the country. Figure 2.1 is an old culvert in Tarrant County, Texas; when the picture was taken the stream was nearly dry, but the height of the culvert shows what can happen in a sudden summer storm. When a stream floods, even if it floods only every few years, the culvert has to be able to carry the water, so the culvert entrances are normally much higher than the water level of the stream. The inside walls of the culvert will be stained at different levels by floodwaters, so you can make a rough guess about the level of the runoff during spring rains and during exceptional floods.

The trick in building a culvert is to tamper as little as possible with the stream's natural direction and speed. If the stream doesn't flow straight into the culvert, it becomes necessary to build a large curved "wing wall" to guide the water in. Any change in water speed changes the streambed—if the water goes faster, the bed will erode; and if it slows, the bed will silt up. If the culvert tilts downhill too fast, the water will pour out with too much force and start undercutting the stream on the downhill side; if the culvert is too flat, it will start filling with silt. If the area has a relatively dry season when the water slows down naturally, then the culvert may need a bevelled floor just to keep the flow up to speed so that the culvert can clean itself.

Some streams actively erode their own beds. If the land around a stream is mixed earth and vegetation but the streambed is rock, then it is actively eroding; on the other hand, a stream with a silty, muddy bottom is probably laying down sediment as much as carrying it. The culvert has to match those conditions. In a swift stream, it has to have a large "head"—that is, a large

figure 2.1

A culvert in Tarrant County, Texas. 1939.

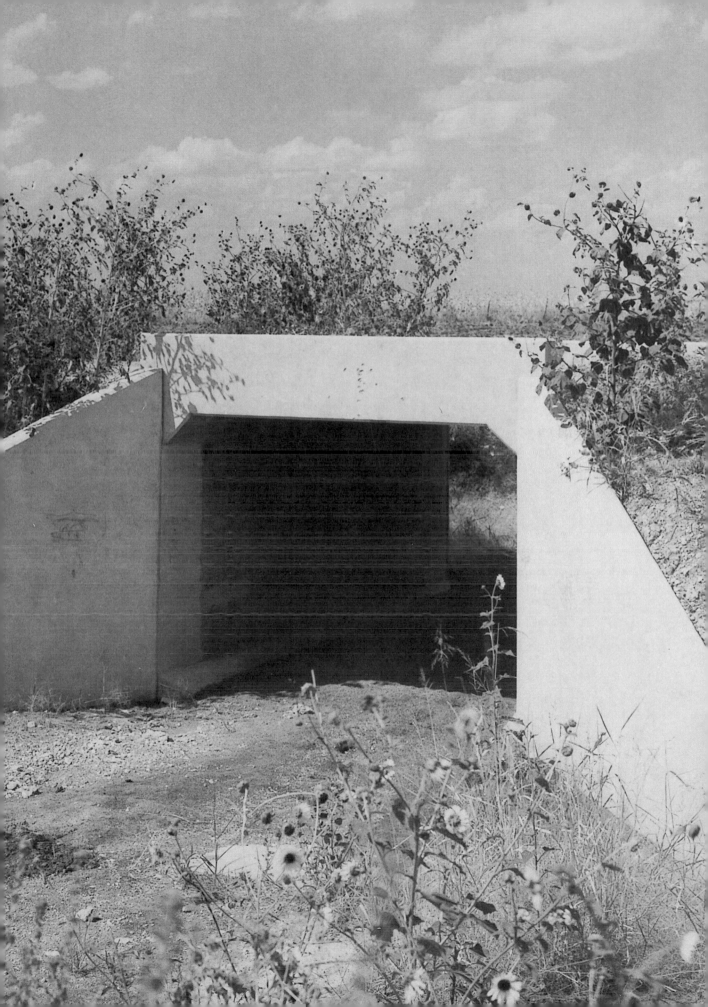

difference between the maximum height of water in the inlet and the outlet. In a slow-moving stream, the culvert has to have just enough extra head so that silt doesn't clog the culvert itself, but not so much that the fast-moving water causes problems on the downhill side.

Both the entrance and the exit have to be carefully designed. It's important to keep culverts from jamming with debris, so in areas where there are large trees or underbrush that might be swept downstream, culverts will need large openings and rounded corners to help the trees slip through. Most culverts need a wall on top, wing walls on the sides, and a solid anchor in the streambed, because when the water level is high, it can start dissolving the earth around the culvert, undermining it and eventually undercutting the road surface. The exact curve, or lack of curve, in the entrance walls can affect the flow rate by up to 50 percent. Just beveling the entrance increases the flow capacity by 7 percent to 9 percent, and curved wing walls increase it up by to 12 percent.

On the downhill side, the engineers work to avoid a sudden outpouring of water. If a pipe were simply put underneath a highway and allowed to spill out on the downhill side, the water might cut a new gully. The gully will cut *uphill,* back toward the culvert, and eventually undermine the highway itself. Entrance and exit are very different—as you can see by walking through the culvert or by crossing the road to the other side.

Culverts can have rectangular openings, circular openings, elliptical openings, or crosses between those three. If the stream has a deep, narrow cross section, a similarly shaped culvert saves money over a broad one. On older and less well funded roadways, the culvert might be broad and low because the road isn't high enough. Conversely, when the road is very high above the stream, the culvert may be circular because that shape is most economical when there is heavy pressure overhead. A half-moon shape with the straight segment at the bottom is optimal when the load is so great that it has to be evenly distributed.

All these things are studied with great precision. If you're mathematically inclined, you can calculate several things about the stream and the culvert using some simple formulas. I put these in here for readers who enjoy calculations; but you can deduce how well the culvert has fared just by looking at how well it fits into the stream at both ends.

Every stream and river has a *cross-sectional area,* which can be roughly estimated by eye. The easiest way is to divide it into triangles and rectangles, as in Figure 2.2. (The numbers are rounded, because I am assuming these are estimates made by eye.) Engineers call the cross section of the stream the *equivalent waterway area.* In this example it is the sum of the areas of the two triangles and the rectangle; here it is 45 + 60 + 75 = 180 square feet. The *wetted perimeter* is also important; it is the

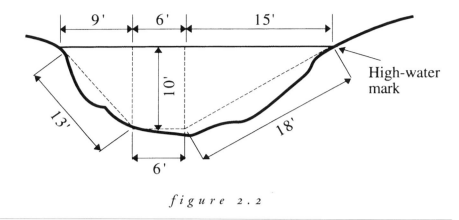

f i g u r e 2 . 2

Calculating the cross section of a streambed.

length of the streambed in cross section, in this case 13 + 6 + 18 = 37 feet. The *hydraulic radius* is the equivalent waterway area divided by the wetted perimeter, in this case a little over 40 feet. The *slope* of the stream is the change in elevation, in feet, divided by the length that is being considered. I find the easiest way to guess the slope without a tape measure is to hold up a pencil so that it appears to touch the streambed in one place, and then use the same pencil to measure the vertical drop (Fig. 2.3). If the pencil is 6 inches long, the drop here is 2½ inches, so the slope is 0.4. Ideally the slope of the culvert is the same as the slope of the adjoining parts of the stream.

Using these numbers you can calculate the water discharge, measured in cubic feet per second, using this formula:

$$\text{Water discharge } Q = CA\sqrt{rs}$$

where *A* is the equivalent waterway area, *r* is the hydraulic radius, *s* is the slope, and *C* is a constant called the *coefficient of roughness*. If the channel is clean earth, *C* is between 60 and 80; if it is stony earth, *C* is between 45 and 60; if it is rough and rocky, *C* is between 35 and 45; and if it is badly obstructed, *C* is between 30 and 35.

The wetted perimeter, the equivalent waterway area, and the hydraulic radius can be compared in the stream and in the conduit. Since the water discharge has to be the same in the culvert and the stream, a smaller waterway area means the water is moving faster, and you can see how the engineers have balanced things out to minimize the environmental impact.

If you look on the inside walls of the culvert and along the stream banks, you can usually discern the flood level of the stream. If it is late in the dry season, you will also see marks that indicate its normal level. Calculating *Q* for different levels will show how the water flow varies through the year. Culverts are always designed with

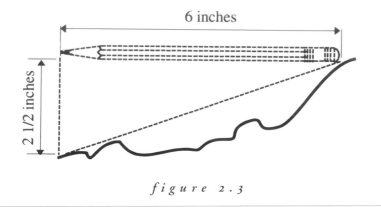

figure 2.3

Using a pencil to estimate slope.

a particular flood level in mind. The shape of the culvert determines how much water discharge it can manage. Box culverts with square cornered entrances are the least efficient; rounded wing walls help, and so do different cross sections. The water flow also depends on the "head"—the difference between the water elevation at the entrance and exit—so that when water backs up on the intake side, it will finally reach a point where the efficiency of the culvert is maximized—but by that time it may also have eroded the embankment.

A culvert is a lovely kind of thing because it is so utterly ignored. We don't notice them, but they are rich with information; they are mute records of the changes that civilization has brought to the landscape. The culvert in Figure 2.4, near where I grew up, is a disaster—it was put in with too much head (it was too steep), and the water came out violently and started eroding the bank. Now it is shored up with some huge slabs of rock, and both banks are reinforced with rocks. It has stabilized but it remains as evidence of hasty construction—a very common sight in America.

Culverts are hidden injuries; the roads may look fine, but the culverts are evidence of what has been done to the landscape. Looking at them, you can see how the streams once went and how the landscape was shaped before rivers had to be hidden underground. And culverts are also opportunities to sample the feel of the place without interference from tarmac or manicured lawns. The culvert in Tarrant County, Texas, has the sun-baked look of the arid Southwest, and the one near Ithaca, New York, has the damp chill of upstate New York in the winter.

figure 2.4

A culvert in Tompkins County, New York. Date unknown.

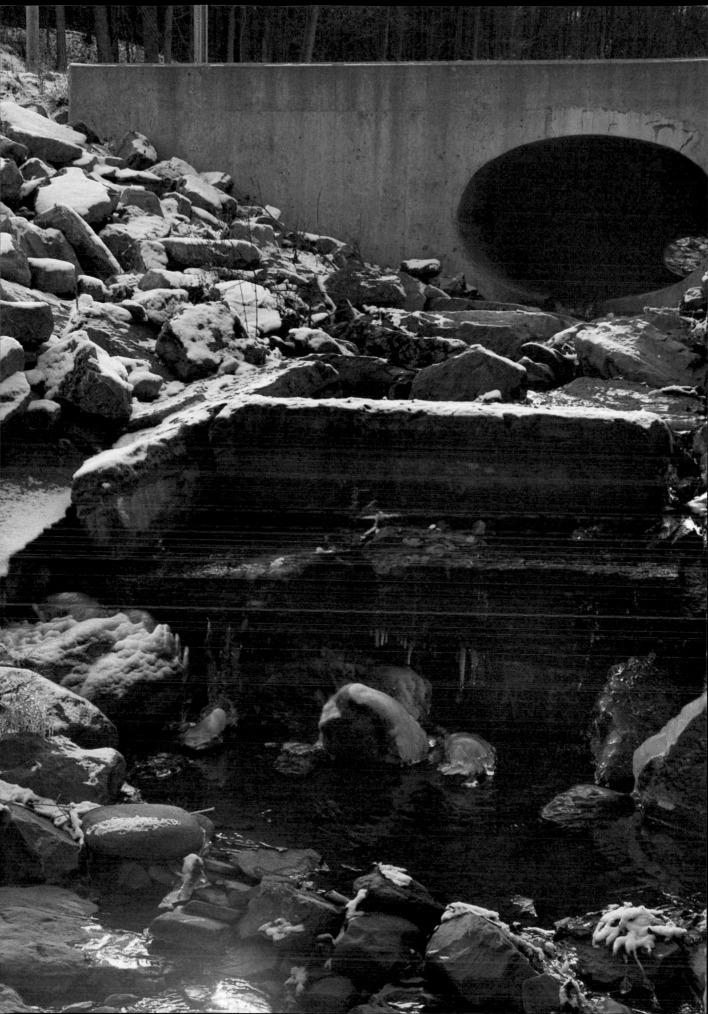

how to look at
an oil painting

Here is something to try next time you go into an art museum. Go to the Old Master galleries but don't look at the paintings in the ordinary way. Stoop down so you catch the glare of the lights, and look up at the pictures. You will not be able to see what the paintings show, but you'll get a good look at the *craquelure:* the fine network of cracks that scores the surface of most Old Master paintings.

Craquelure has a great deal to say about when paintings were made, what they were made of, and how they have been treated. If a painting is old enough, the chances are that it has been dropped a few times, or at least jostled, and the signs of its mistreatment can be read in the craquelure. Whenever a painting is moved, there's a chance it will be poked by a shipping crate, by a corner of another painting, or just by someone's elbow. A little ding like that on the back of a canvas will result in a little spiral or a miniature bull's-eye target of cracks on the front. If something was scraped along the back of the painting, the cracks on the front will concentrate along the line of the scrape, like a lightning stroke.

Few museum visitors realize how many paintings have been seriously damaged and then invisibly restored. Flecks of paint fall off paintings, and often paintings are damaged by fire, water, vandalism, or just the wear and tear of the centuries. Conservators are exceptionally good at replacing even large patches of lost paint, and museums do not usually announce the fact that their paintings have been restored. By looking at craquelure you can tell what the conservators have replaced, because the new spots and patches will not have cracks in them. Conservators can mimic

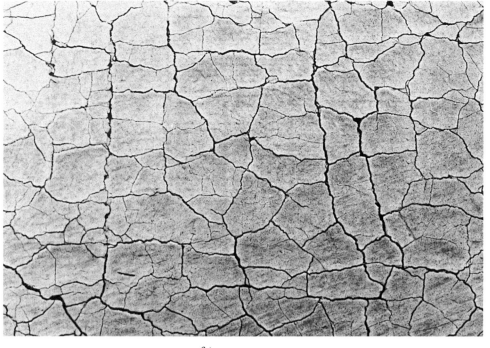

figure 3.1

Craquelure pattern in an oil painting, showing jagged and straight
cracks with square islands.

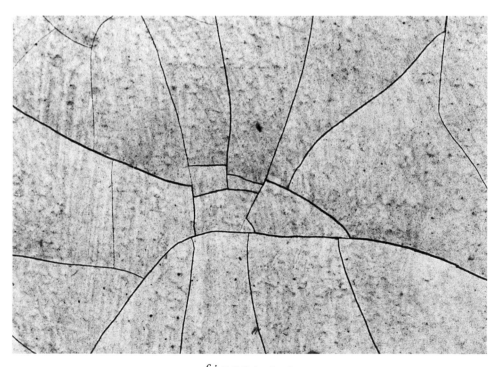

figure 3.2

Craquelure pattern in an oil painting, showing smooth and curved cracks with
curvilinear islands.

the undulating surfaces of paintings, so that the paint looks thick or thin, but they do not often try to replicate the cracks. Counterfeiters have faked cracks by putting paintings in ovens, and they have even rubbed ink in the cracks to make them look old, but they cannot reproduce authentic centuries-old craquelure patterns.

Recently a conservator named Spike Bucklow made a thorough, scientific study of the patterns of cracquelure and came up with a system for classifying paintings according to their cracks. He uses seven diagnostic questions:

1. Do the cracks have a predominant direction? (In Figure 3.1 they do, especially at the left; but in Figure 3.2, they do not.)

2. Are the cracks smooth or jagged? (Figure 3.1 shows jagged cracks, Figure 3.2 smooth ones.)

3. Are the islands of paint between the cracks square, or some other shape? (In Figure 3.1 they are square, especially at the left.)

4. Are the paint islands small, as in Figure 3.1, or large, as in Figure 3.2?

5. Are all the cracks the same thickness, or is there also a second network of thicker or thinner cracks? (Neither Figure 3.1 nor Figure 3.2 have a secondary network of cracks.)

6. What about the junctions between the cracks? Do they all form a connected network, or are they separated from one another? (Both Figure 3.1 and Figure 3.2 have connected networks.)

7. Is the network ordered or random? (Figure 3.1 is ordered; Figure 3.2 appears random.)

When there is a predominant orientation, as in Figure 3.1, the cracks usually follow the weave of the canvas (typically, they follow the weft and not the warp). If the painting is done on wood, the cracks either follow the grain or go at right angles to it. Most cracks in paintings that are not caused by accidents are due to the flexing of the canvas or the slow warping of the wood.

Craquelure can also give information about the structure of the paint. In past centuries, painters began their work by putting down a covering layer to seal the canvas or the wood and prepare it for the paint. In house painting that layer is called "primer"; artists call it "ground," "size," or "gesso." The cracks that are caused by the panel or canvas support are known as "brittle cracks." Another kind of crack, called "drying crack," is caused by the paint layer contracting as it dries and shifting on the surface of the ground. A drying crack typically varies from thin to thick,

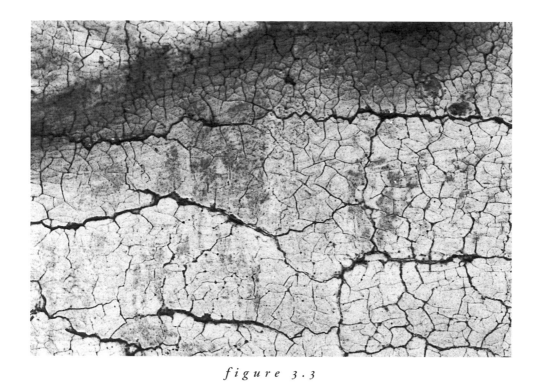

figure 3.3

Typical craquelure pattern from a fourteenth- to fifteenth-century Italian painting on panel.

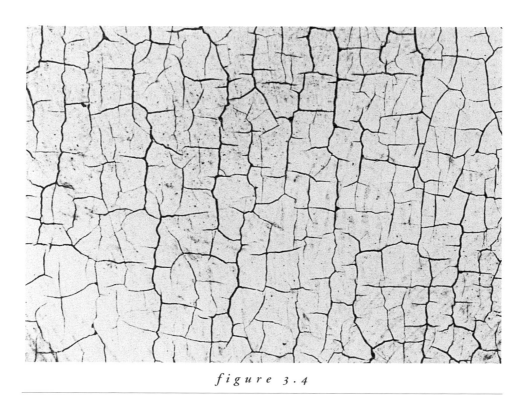

figure 3.4

Typical craquelure pattern from a fifteenth- to sixteenth-century Flemish painting on panel.

while a brittle crack remains the same width. Drying cracks look like cracks in mud: the plates of mud contract and pull away from one another, opening spaces in between. Brittle cracks look like cracks in a pane of glass, as if the whole painting had shattered in a single instant. If you look for drying cracks, you'll find they vary from place to place in a single painting, because they depend on the thickness and oiliness of the paint. Painters have always experimented with exotic media, and many painters never learned how to put down stable layers of paint, so you can find places where different layers are cracked in different ways. When you look for patterns in craquelure, it is best to avoid areas in paintings that are very thick or thin or have rough textures. The best is a flat stretch of evenly painted sky, because it has the most to say about what is underneath the top paint layer.

Craquelure is not a hard-and-fast method of classifying paintings, but it comes close. Bucklow has shown that just a few criteria can serve to identify paintings fairly accurately. Figure 3.3 is a fourteenth-century Italian painting done on wood. Paintings from the 1300s and 1400s that were made in Italy and painted on wood often show the following characteristics, as this one does:

- The cracks have a predominant direction.
- They are perpendicular to the wood grain.
- They form small- to medium-sized islands.
- The cracks are usually jagged.
- There is sometimes a second network of smaller cracks.

In panels like this, the small cracks form first and then some of them get larger as the panel underneath continues to change shape. Notice that the large cracks are mostly horizontal, while the small cracks go in all directions. That is a sign that they reflect the warping of the wood panel support—the smaller cracks record local tensions, but overall the panel is being stretched top to bottom, and the large cracks show that more clearly. The large cracks are far apart because fourteenth- and fifteenth-century Italian painters used very thick coats of gesso. The thick gesso helps distribute the forces of the warping panel, so that when large cracks finally appear on the surface, they are widely spaced. The fact that the small cracks are jagged shows that the gesso has large crystals or grains in it that reorient the tension in random directions. A very finely ground gesso, with tiny grains, would be more likely to produce cracks oriented in a single direction.

Figure 3.4 is a sixteenth-century Flemish painting, also on a panel. Like many fifteenth- and sixteenth-century Flemish panel paintings, it has the following features:

- The cracks have a predominant direction.
- They form parallel to the wood grain.
- The islands between cracks are small.
- The cracks are smooth.
- The cracks are straight.
- The paint islands are square.
- The cracks have a uniform thickness.
- They are usually highly ordered.

Here the cracks are actually following the growth rings of the oak panel underneath the painting. In older pictures each board tends to warp separately, so the whole painting looks like a series of parallel ocean waves. Looking at the craquelure, you can sense the panel underneath even when the boards are nearly flat. In this example, the small cracks are smooth and run at right angles to one another because the size has no large grains or crystals as it does in Figure 3.3.

Figure 3.5 is a seventeenth-century Dutch painting—a period that includes Vermeer and Rembrandt. This painting is on canvas, and the weave is directly visible in the orientation of the cracks. They are fine and close together, indicating that the ground is thin, so that tensions in the canvas are transmitted directly to the surface instead of being spread over a larger area of the picture (as in Figure 3.3). The telltale characteristics of seventeenth-century Dutch paintings are:

- The cracks have a predominant direction.
- They are strongly oriented, usually perpendicular to the longest side of the picture.
- They form medium-sized islands.
- They are jagged.
- They form squares.

When canvases are carelessly nailed to their stretchers, the canvas can pull at the nails and sag down in between, like an animal hide stretched on a wooden frame. Often enough you can see the actual weave of the canvas through the painting, and

follow the U-shapes around the edges. When the ground is thicker, the weave is not visible, but the distribution of cracks can give the same information.

The last example, Figure 3.6, is an eighteenth-century French painting, also on canvas. Bucklow lists its traits as follows:

- The cracks have no predominant direction.
- They form large islands.
- They are smooth.
- They are curved.
- They do not form square islands.

French paintings of this period have thicker grounds, which effectively "decouple the paint layer from the support"—that is, the cracks can form at a distance from the tensions that generated them. (Figure 3.2 is also a French painting.) When the ground layer is strong, new cracks do not form as often; instead, existing cracks tend to grow longer. The final pattern of cracks shows the "global" tensions of the whole canvas, rather than the inch-by-inch forces of the weave (as in Figure 3.5).

Bucklow's work is complicated, but using these simplified criteria you can spend an afternoon in a museum trying *not* to see the paintings. It is interesting how much you can learn and how much you end up seeing when you look just at surfaces. The four traditions I have summarized are usually well represented in museums, and they are fairly consistent. If you inspect more exotic kinds of paintings, you will find many other patterns that do not fit these criteria. Every once in a while, the crack pattern is more beautiful than the painting itself. I feel that way about an abstract painting by Piet Mondrian that I saw a few years ago: the painting itself is just a few black and red lines, but the craquelure pattern has a lovely, perfect spiral.

It may seem perverse to go to an art museum just to look at the cracks in paintings. But paintings are very complicated objects, and there is a great deal to see. Even people in my field of art history tend to be overwhelmed, and so we overlook the most obvious things: the frame, the dust, the varnish, and the cracks that cover virtually every painting.

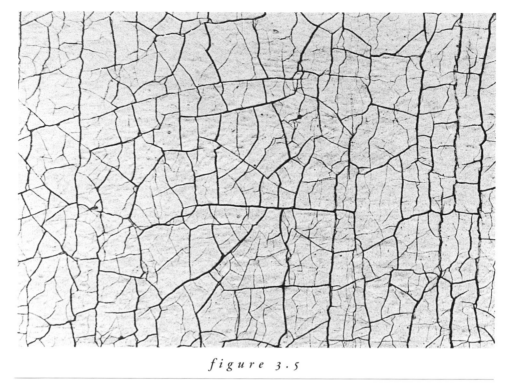

figure 3.5

Typical craquelure pattern from a seventeenth-century Dutch painting on canvas.

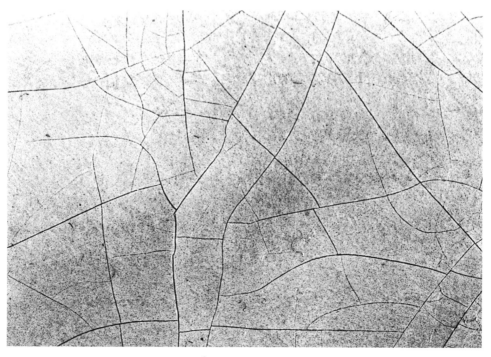

figure 3.6

Typical craquelure pattern from an eighteenth-century French painting on canvas.

4

how to look at
pavement

Many things can go wrong with roads—not just the common pothole, but a whole exotic stable of defects. Cement pavements crack in all sorts of patterns, some of them very like the craquelure in paintings. The other major kind of road surface, which the engineers call "hot mix asphalt," is prone to even more involved flaws.

The road surface in Figure 4.1 is heavily distressed (engineers don't talk about "damaged" surfaces, but "distressed" ones). When a surface starts to crack as badly as this one, trucks will dislodge the pieces, creating potholes. This road has already had two potholes, which have been filled with more hot mix asphalt. But it is only a matter of time before more pieces are lost, forming more potholes.

The whole pattern in the foreground of the picture is called *fatigue cracking* or *alligator cracking*. It could have been caused by overuse—this is Monroe Street, in the Loop in Chicago—or bad drainage, which allowed water to permeate the surface layer. Or else it could have been caused by a road surface that is too thin to sustain the weight of the trucks that pass over it. (This is Chicago, after all, and a

figure 4.1

Cracked pavement. Monroe Street, Chicago. 1998.

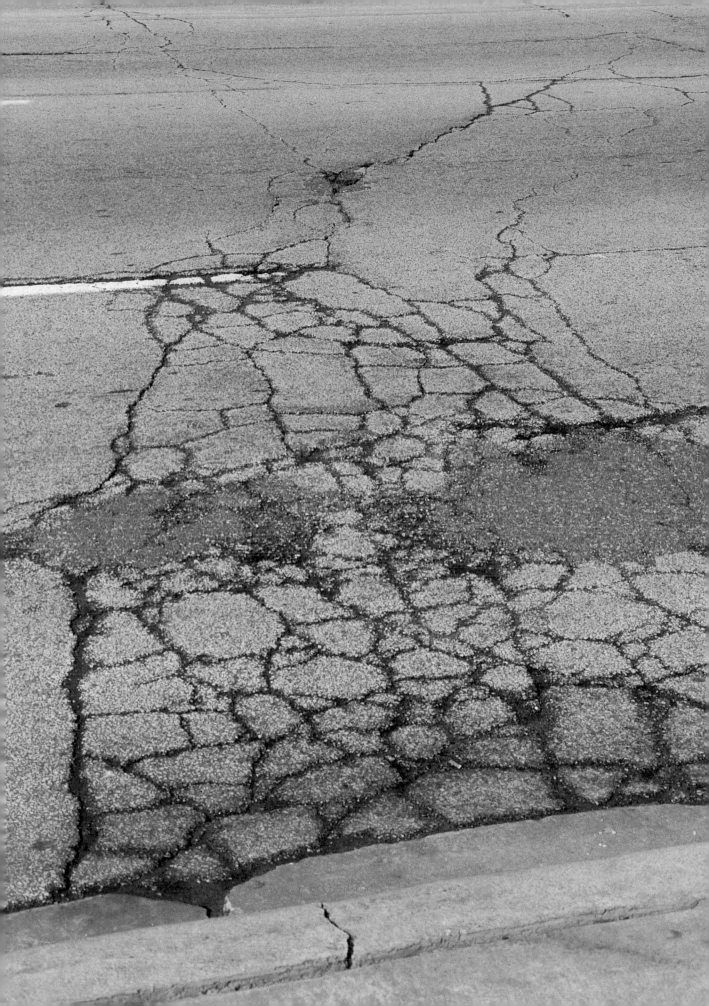

figure 4.2

Rutting.

corner or two may have been cut.) Or it could have been caused because the under-lying layers of the road are too weak. In this case it looks as if the underlying material is giving way, because the alligator cracking lies on a bigger crack that goes right up onto the curb (at the bottom of the photo), which is also cracked. Probably the whole infrastructure of the road will have to be rebuilt.

Potholes and alligator cracking aren't the only things that happen when asphalt pavement gets distressed. This road is also suffering from *low-temperature cracks.* The cracks open in the wintertime when the temperature drops and the asphalt

contracts and breaks into segments. Some cracks run across the road like railroad ties; one is visible here at the top left of the photo. *Longitudinal low-temperature cracks* go along the road in between lanes. This is a five-lane road, and it has low-temperature cracks between each lane and even in the middle of a couple of lanes. *Block cracking* is another kind of low-temperature crack; it breaks the road surface up into rectangles (very much like some oil paintings). This road is immune from block cracking simply because it gets so much traffic. When the road is less used, the asphalt isn't packed down (or, as the engineers say, "densified") and it can experience "thixotropic hardening." Thixotropically densified hot mix asphalt is prone to block cracking, but the pavement here is too dense for that.

Naturally, some of the ills of pavement are technical. But many are colorful—there's *rutting,* for example, when grooves form in the wheel path of cars and trucks (Fig. 4.2). Rutting is familiar to people who live in the country and travel on dirt roads. If the dirt turns to mud, the ruts can quickly get as deep as a pickup truck's clearance, and then only heavy machinery can use the road. In Europe and America there are remnants of ancient roads that have literally dug themselves down into the ground, so the roads run in five or ten foot ditches. (In America, parts of the Oregon trail were like that.) On ordinary asphalt roads, engineers will start considering repairs as soon as the ruts begin pooling water. Even a one-eighth-inch rut might hold enough water to make a car hydroplane out of control. The Chicago road in

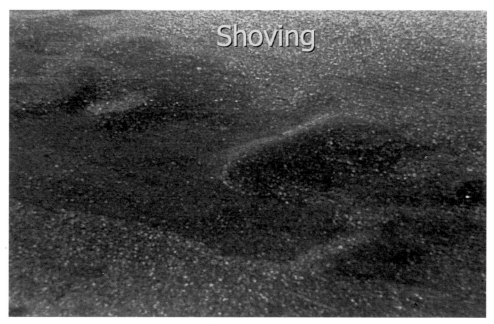

f i g u r e 4 . 3

Shoving.

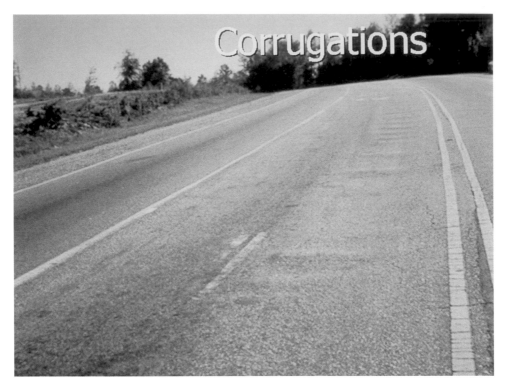

figure 4.4

Corrugations.

Figure 4.1 also has rutting (it is clearest on the far side of the street), but this rutting probably will not be repaired. It is under control because the road is on a grade, so water can't collect.

Besides rutting, there's *shoving,* which can be caused when the road's top layer slips over the underlying layer (Fig. 4.3). Shoving is common at intersections, where cars push the pavement each time they stop and start. Bus stops are especially prone to shoving, because buses are heavy and move slowly enough to grip the pavement and move it. I have seen pavement in Paris (just opposite the old Opéra) that has been shoved a full five feet down the road, shearing the painted stripes into zigzags.

Corrugation is a kind of shoving, where the shoves form ripples in the road (Fig. 4.4). The road in Chicago is faintly shoved and corrugated, as you can see by looking at the gentle undulations in the farther lanes.

In all there are three ways asphalt can get distressed: by cracking, by distortion (rutting, shoving, corrugation), and by just plain disintegrating. Some roads disintegrate by *wear loss*—the gradual removal of the road by passing tires. The Chicago

road shows wear loss, which has made the surface smooth. Engineers do not mind that kind of distress, provided the wear loss is not uniform. If it happens a bit more here and a bit less there, the tires can still get traction. Other roads are *stripped*—when the underlying layers lose their bond with the top asphalt layer. Trucks can strip pavements, and so can storms. I have seen a road that was entirely stripped by a winter storm—the wind pried chunks off the road and threw them onto the verge. A third kind of disintegration is *ravelling*. Roads ravel (or rather, they become unravelled) when small bits are torn off, exposing deeper and larger pieces. Ravelling, like cracking, ends in potholes.

Cracking, distortion, disintegration, ravelling, shoving, rutting—I love the terminology of distressed pavement. The utterly ordinary mangled surface of the road in Chicago, which I walk past blindly every day on my way to work, is full of metaphors for human disaster. It's aging, it's cracked and distorted, it's been pockmarked and shoved and rutted until it's nearly ready to be replaced.

5

how to look at

an X ray

Despite the appearance of all sorts of new ways of imaging the body—CAT scans, MRI, positron emission tomography, ultrasound—old-fashioned X rays are still among the most beautiful images. The reason is simple: they are not digitized, so they have a much higher resolution than the pixellated computer-generated images used in the more "advanced" techniques. X rays can have a lovely, thin, veiled appearance and a delicious softness that conjures the delicate insides of the body more faithfully than the hard-edged rectangles of the computer screen.

Figure 5.1 is an especially beautiful kind of X ray called a xeroradiograph. In the 1970s they were very popular, especially for mammography, but they have been discontinued because the X-ray dosage is unacceptably high. The image shows an upper arm down to the elbow, with the blood vessels. The translucent edges of the arm are fat and skin, and underneath them are the denser muscles. At the top right is the principal shoulder muscle, the deltoid (it is also discussed in Chapter 18). The bone curves up to the place where the deltoid attaches, to give it strength. Below that, the muscles divide faintly but unmistakably into two layers: the deeper one is

figure 5.1

Positive xeroradiogram of an arm.

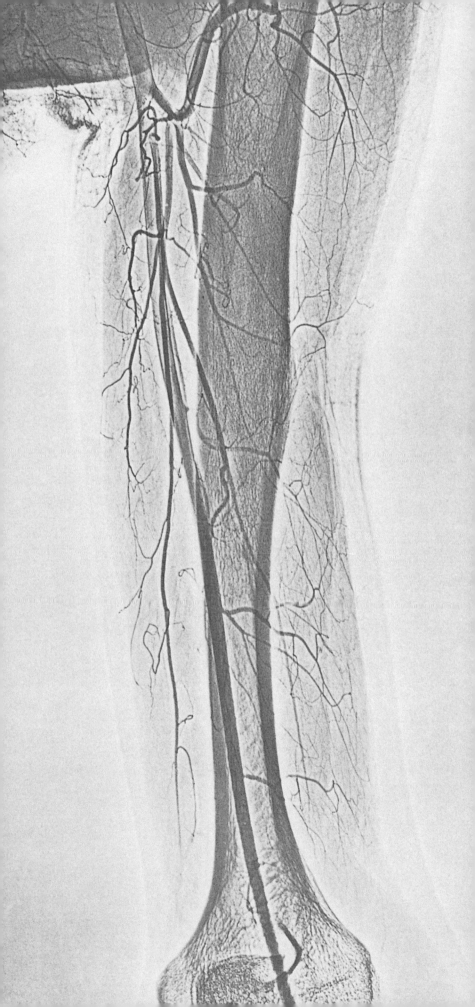

the triceps, on the back of the arm, and the one toward the surface is the biceps, in the front. Even the armpit is shown in crystal clarity.

Modern computer methods reconstruct the body in three dimensions; they slice it and reassemble it electronically, providing vivid images of the depths and thicknesses of the body's insides. X rays are the exact opposite: they flatten the body into a two-dimensional shadow. It takes a lifetime of work to learn to read X rays—years of medical training, and years of practice thinking three-dimensionally about a flat film. To understand an X ray you have to mentally rebuild the body into three dimensions; only then is it possible to begin to assess the patient's condition. This ability to see three dimensions where there are only two is one of the themes of this book. It recurs in different guises when it comes to looking at engineering drawings (Chapter 10) and diagrams of crystals (Chapter 30). Yet there is no single skill of visualization that covers every case, no way to learn how to see the extra dimension for all possible subjects—and the reason is that a radiologist does not see the third dimension itself, but rather the objects that are in it. The spleen, the stomach, the liver, the transverse colon are the objects that a radiologist is trained to see, just as an engineer can look at a flat picture and see gears, cams, levers, and bolts, or a mineralogist can look at a picture and see facets, orientations, planes, and angles. Even a mathematician who specializes in the fourth dimension is trained mostly to see four-dimensional cubes and toruses, not four-dimensional people. Visualization, in other words, is not a subject, as some psychologists take it to be. It is a skill that depends narrowly and precisely on what is there to be seen.

X rays are normally viewed as negatives, exactly as if you were to look at negatives of family photographs. In this chapter I have reproduced the X rays in the normal way, but I have presented the key diagrams (Figs. 5.3, 5.4, 5.6, and 5.7) as positive prints. Radiologists don't use positive prints, and some say they would not be able to read them as well. It is true that there is nothing like sitting in a dark room, with X-ray films hung up on the viewer—the light comes *only* from the plate itself, and there is no glare and no distraction. In those viewing conditions the grays and blacks are very subtle, and the whites are brilliant. But there is no intrinsic rea-

figure 5.2

Chest film. 1987.

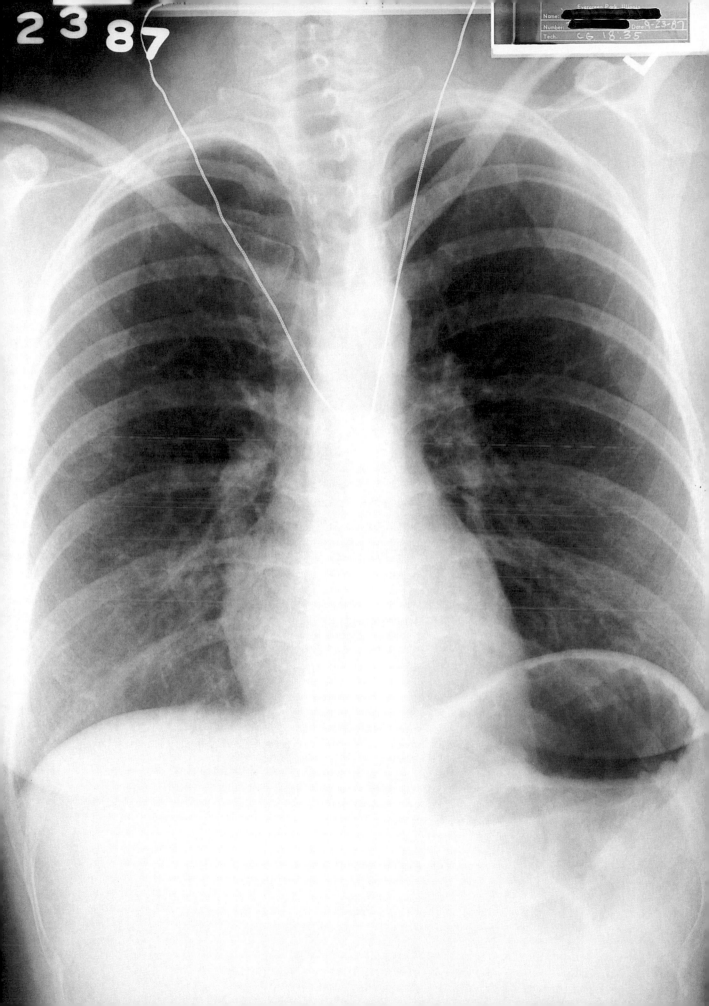

son why positive prints wouldn't work just as well. I leave it to readers to decide which of these two alternatives works best.

To read a normal "chest film," as it is called, a radiologist first counts the ribs and visualizes them as they curve around the chest (Fig. 5.2). The ribs are clearest around the back of the body, where they attach to the vertebrae. In front, they are not bones but cartilages, which are more transparent in the X ray. They attach to the sternum, which is bony but is hard to see because it lines up with the spinal column. It is labeled A in Figure 5.3. So to begin, a radiologist will use the collarbones (clavicles) as a guide. (They are labeled B.) The clavicles attach to the top of the sternum, just above the place where the first rib attaches (C). Hence the first rib can be followed up and back to where it attaches to the spine. From then on, the ribs can be counted from the top down, beginning at the back at the spine and following them around to the front to the place where they disappear into cartilage. The first few times I did this, it took several minutes; but it becomes easier, and experienced radiologists count ribs automatically.

Just where the rib bones give way to cartilage, there are calcifications that extend a little way into the cartilages. On women, the calcifications tend to have a single point, and on men, they have two points or two bulges. This patient is a woman—as you can see from the breasts—and she has the characteristic pointy calcification. It is visible, just barely, at the ends of the ninth and tenth ribs. (One spot is marked with an arrow.) This particular sexual difference is one of the ways that male and female skeletons can be distinguished.

The shoulder blades (scapulae, D), arm bones (humeri, E), and clavicles all converge on the shoulders. This patient has raised one arm up higher than the other, which also raises the scapula on that side. The outlines of the scapulae are unusually clear on this film—you can see that one goes down to the space between the seventh and eighth ribs, and the other is higher than the seventh rib.

Note too that the ribs look as though they have silvery borders, especially at the sides; that is because bone is most dense around the outside and thinner on the inside. It's like holding a straw up to the light: it will be darker on either side than in the middle.

X rays are like photographic negatives, so the darker areas are where the X rays penetrated to the plate. X rays go through air very easily, making the lungs look like a hollow space between the ribs. X rays don't pass quite as easily through fat, as you can see by looking at the breasts. Toward the bottom of the plate, along the patient's right side (our left side, since she is facing us), it is possible to distinguish a dense, thin layer of muscle over the ribs, covered by a thicker, more superficial layer of fat,

and you can follow the fat up into the armpit on that side. More X rays are stopped by organs such as the liver, spleen, kidneys, intestines, and stomach, so the lower part of the abdomen is milky and dense. Bone and muscle are best at stopping X rays; notice how the heart—the pear-shaped mass in the middle, sagging toward the patient's left side—looks almost as dense as the ribs.

The heart looks like a water-filled balloon. Radiologists count up to nine contours, each corresponding to a separate part. In this case, the only ones that are visible are the left atrium, the left ventricle, and the right atrium (Fig. 5.4, F, G, H). The whitish curve above the heart is the descending aorta, the main artery that brings blood to the lower trunk and legs (I). It is possible to see other vessels as well: the pulmonary artery (J) and the smaller azygos vein (K) that runs behind the heart down the right side of the spine. Normally, the heart would be a little farther over to the patient's left side, but this woman has turned slightly to her right. The turn is apparent in the spine itself: if you look up at the neck, you can see that the spinous processes of the vertebrae (circled on Figure 5.4) are off center. Spinous processes are what you see and feel on the back of someone's neck, and so, because these are shifted to the patient's left, she must have turned to her right.

Radiologists watch for enlarged hearts (a sign of heart disease) and hearts that are actually pushed to one side or the other (which may be a sign of lung disease or tumors). As a general rule, the width of the heart on the X ray should be less than half the maximum width of the rib cage measured from side to side inside the ribs. That is the "cardiothoracic ratio," and it is used as a rule of thumb to assess the possibility of disease. This woman's cardiothoracic ratio is less than one half.

The large, dark cavity that occupies most of the space on this film is the lungs, which are dark because they are filled with air. They meet along the azygoesophageal recess—medicine is full of these mouthfuls of words—which is the thin white line in the very middle, below the cross. The windpipe (trachea) is also filled with air, so it is well delineated; I have outlined it at the top of Figure 5.4. Normal lungs look mostly black and empty, but a tenuous network of blood vessels branches outward from large vessels just above the heart. Occasionally a vessel will be oriented head-on to the film and will appear as a little dot. In this film there are several (marked with arrows on Figure 5.4). Patients with tuberculosis and other diseases show spots, more or less faint and weblike, in parts of the lung. Radiologists are very sharp-eyed for slight increases in lung density; any thin veil or dappled patch might be the sign of an incipient disease. This lung is healthy and full of air.

The abdomen is divided in two portions by two opaque bulges. They mark the position of the curves of the diaphragm, a tentlike muscle that isolates the lungs

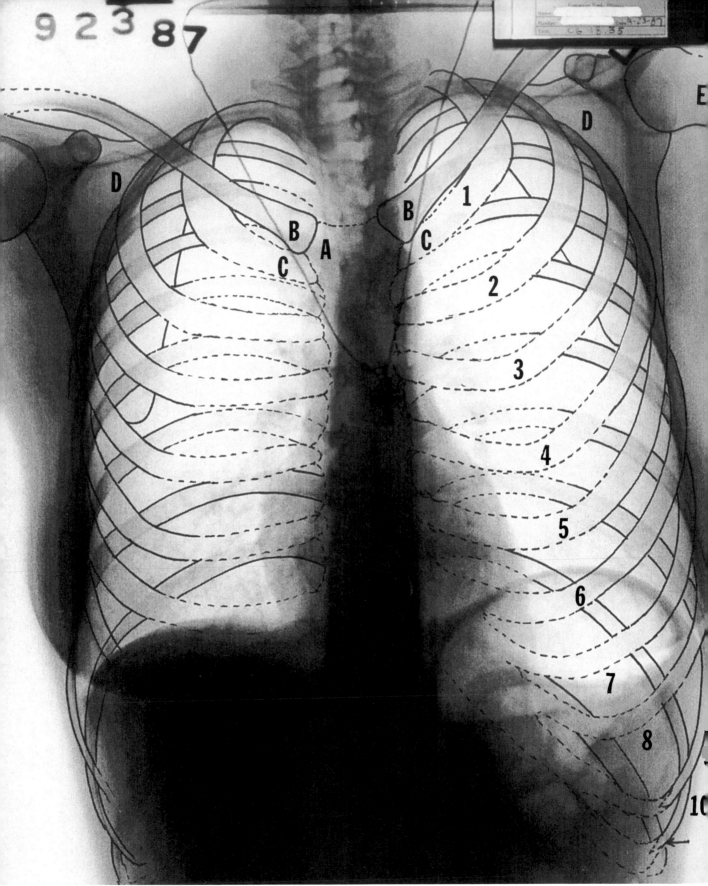

figure 5.3

Diagram of the bones in Figure 5.2.

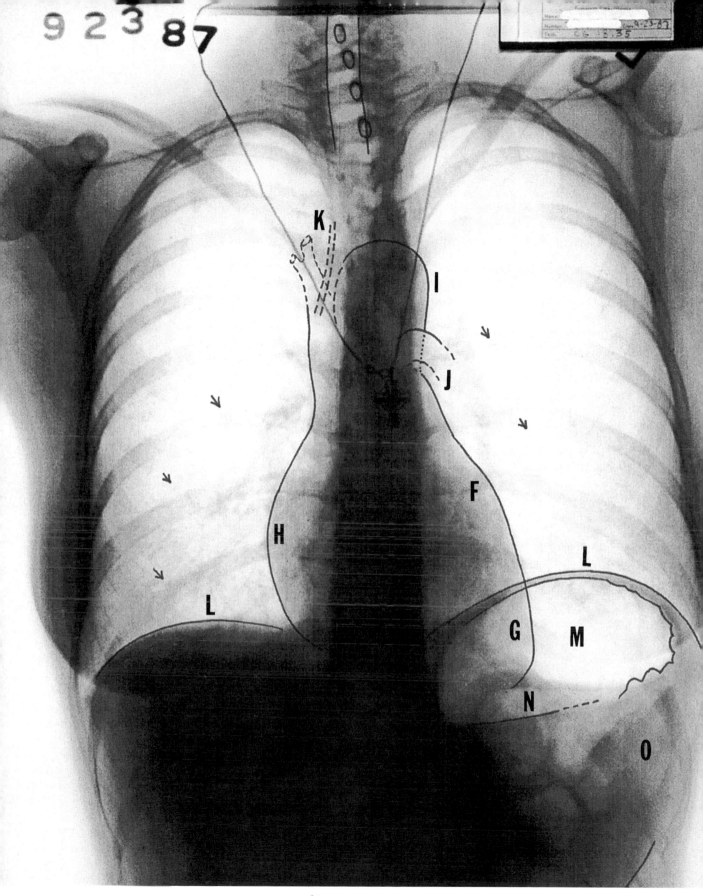

figure 5.4

Diagram of the soft tissues in Figure 5.2.

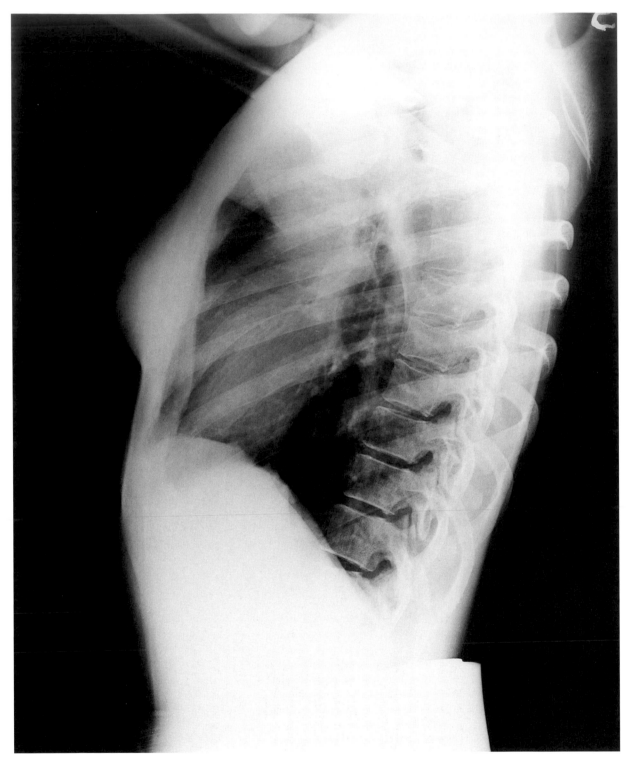

figure 5.5

Lateral chest film. 1972.

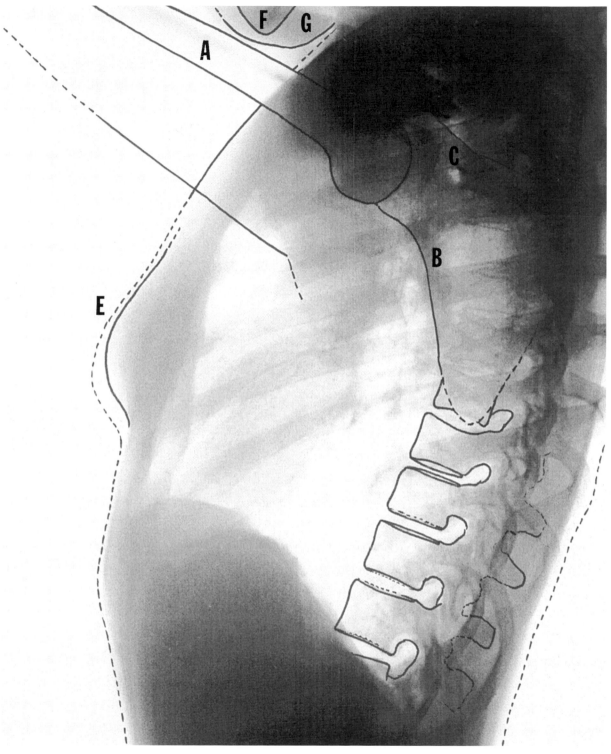

figure 5.6

Diagram of the bones in Figure 5.5.

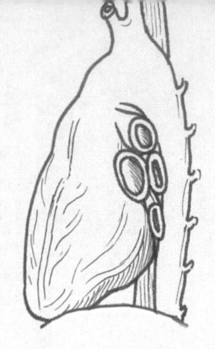

from the viscera below (L). Just below the diaphragm on the right side of the abdomen (the left side of the X ray) is the liver, the largest organ. In a normal chest film it shows up as a pure opaque mass. The stomach is on the other side (the right side of the X ray). Typically, there is a bubble inside it, composed of swallowed air (M). The inside of the stomach is corrugated with folds called rugae, which are visible all around the air bubble. Lower down, you can see the level of dissolved food and gastric juices, which shows how full the stomach is (N). Any translucent areas below the stomach are gases in the colon (O). Often the colon has a kind of speckled appearance, which is the mixture of intestinal gas and semifluid feces: radiologists watch for "speckled fecal shadows" and gas bubbles as clues to the position of the parts of the colon. This patient has gas and some speckling.

On this patient, it's also possible to see the lower tip of the spleen, an organ that lies behind and below the stomach. About the only other thing that is visible in the gut is the spine. The kidneys can sometimes be seen— they look more like fat, round pillows than stereotypical kidney shapes and

figure 5.7

Diagram of the soft tissues in Figure 5.5.

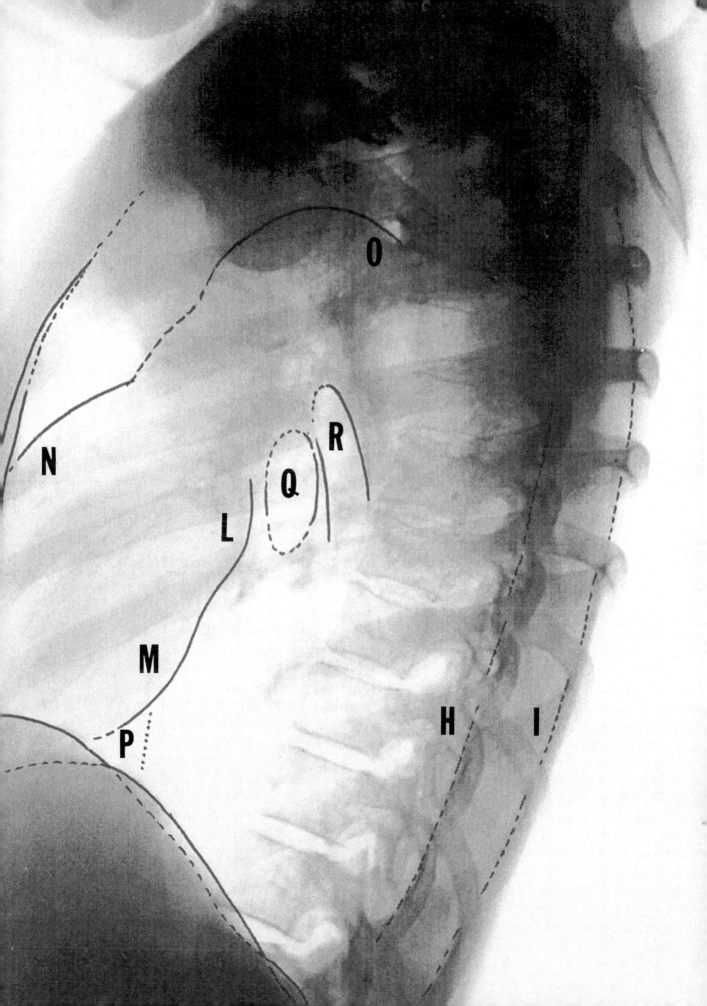

they tilt up and in slightly. Occasionally, too, it is possible to see two pyramids of thick muscles tapering up from the pelvis toward the top of the kidneys; they are the strong psoas muscles that help keep us upright. But for the most part, chest films are exposed to give information about the lungs and heart.

Lateral X rays are the second most common kind of chest film (Fig. 5.5). People normally imagine that the spine is at the back, but a lateral view shows just how deeply the spine is embedded in the torso. No one tries to count ribs in a lateral view, because they are too confusing. This patient is turned a little from a perfect side view, because one set of ribs curves farther to the right of the spinal column than the other. The ribs farthest to the back may be the patient's right side.

The shoulders are also in different positions. One humerus is clearly visible (Fig. 5.6, A), and there are faint indications of the scapula that attaches to it (especially the front margin, B, and part of the "spine" on top, C). The other shoulder is raised far up over the rib cage, and part of the scapula is visible at the upper right (D). It is typical of lateral films that it is nearly impossible to tell which shoulder is which: has she raised her right arm over her head, or her left?

This is a young woman with small breasts. One can be seen only very faintly on the original film (E), and the other is more pronounced because it overlaps. She has her chin down on her chest: her mandible is F, and the soft tissues of her chin are pressed around to her neck (G). The radioopaque shield she is wearing is to protect her ovaries.

Aside from the spine, the easiest thing to see on a lateral chest film is the outline of the lungs. Their front border is fairly clear, but since the patient has turned slightly, the backs of the right and left lungs are in different places. The lungs go all the way back to the ribs, well behind the spinal column. One lung—it may be the left—goes back to the line marked H on Figure 5.7, just in front of one set of ribs, and the other goes back to the line I. At the bottom, the lungs are bordered by the diaphragm. On the body's right side, the diaphragm goes all the way to the front, as at J. On the left side, the diaphragm is lower in front to make room for the stomach (K). The outlines of the two diaphragms cross and recross one another, ending in back at two different levels. (Their ends are very subtle, and are lost in these reproductions. The right diaphragm appears to end a little lower and farther to the right, which suggests the ribs at I are her right ride, and those at H are her left.)

The heart is large—larger than you might expect—and shows three bulges for the left atrium (L), left ventricle (M), and right ventricle (N). You can just faintly see the trace of the aortic arch, the huge artery that leads from the heart down the trunk (O), and on the original film there is also a hint of the vena cava (P). Every-

thing else is very confused and hard to see. The two bronchi, feeding air to the lungs, are fairly clear because they are dark with air (Q, R). The little outline at the top left fills in some of the gaps in this picture. It shows the esophagus, leading to the stomach (shaded); but to really see the esophagus, the patient has to swallow a solution of barium. The barium coats the esophagus as it is swallowed, making a lovely snaking shape.

These X rays and the xeroradiogram are all of healthy people. Normal X rays are not often published, however; books on radiography are filled with bizarre and unpleasant X rays of diseases and deformed bodies. Some X rays are funny—films of people who have swallowed things by accident—but most are horrifying. It was touching and sad to see a series of films made of a young woman who is dying of tuberculosis: each plate shows the lungs a little brighter and more clotted with scar tissue than the plate before, until finally she cannot breathe. The series ended with a photograph of the lung itself, taken at the postmortem. There are also pictures of people with serious fractures, people born without collarbones, people who have had arms and legs amputated. All this is silently recorded, and in the same exquisitely beautiful tones of gray and white. The images have a kind of unfeeling beauty, no matter what they record: it makes me wonder what happened to the pain.

6

how to look at
linear B

Some things I describe in this book tend to be hidden away in the corners of big museums. When I go to museums, I mainly spend my time ferreting around, peering into dusty display cases, walking off to the ends of long corridors. Museums are right to put the major artworks front and center, but they are wrong to hide the other thing—the many objects from the many cultures that never made oil paintings or marble sculptures.

One such kind of fascinating, overlooked object is the little clay bars made in ancient Crete around 1250 B.C. They are inscribed in a kind of writing called Linear B (there are also Linear A, C, and D). Linear B is one of the success stories of modern linguistics. It used to be that no one could read what was written on the clay bars; then in 1952, after several generations of unsuccessful attempts, a linguist named Michael Ventris deciphered the script. It turns out that Linear B is a record of the Mycenean language, which is now extinct. ("Linear B" is the name of the writing, as "Roman script" is a name for our writing.)

figure 6.1

Syllable signs in Linear B.

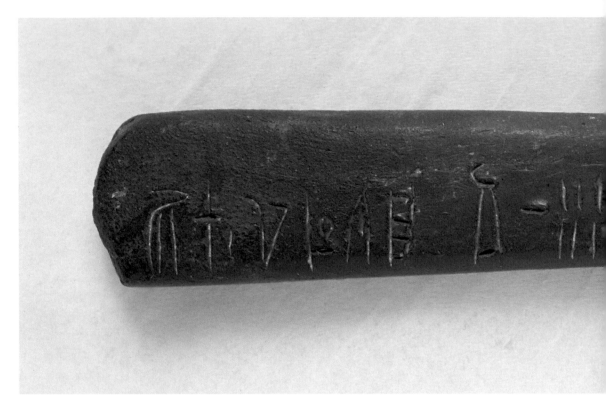

figure 6.2

Pylos tablet Ab 573. Athens, National Museum.

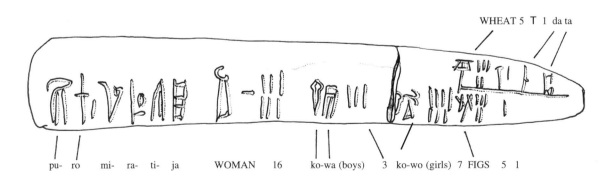

WHEAT 5 T 1 da ta

pu- ro mi- ra- ti- ja WOMAN 16 ko-wa (boys) 3 ko-wo (girls) 7 FIGS 5 1

figure 6.3

Transliteration of Pylos tablet Ab 573.

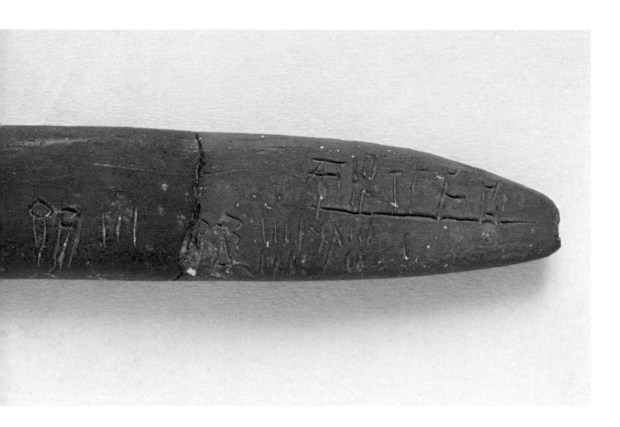

Like many ancient writing systems, Linear B has no alphabet. It does have a list of signs that every literate person would have had to learn, just as children in the West learn the alphabet. In Linear B, some signs are pictures, so they would have been easy to memorize. There are signs for "wheat," "figs," "woman," "boy," and many others; such signs are called "pictographic" or "ideographic." In addition Linear B has a "syllabary"—a set of signs that each stand for a syllable, instead of a single consonant or vowel as in the alphabet. There is a single sign for *ka,* another for *ke,* for *ki, ko,* and *ku.* For that reason there have to be more signs than in an alphabet: about 60, as opposed to the 20-odd signs that make up typical alphabets. The basic syllabary is given in Figure 6.1.

If you see something written in a strange, ancient script, you can tell whether it is an alphabet, a syllabary, or an ideographic script by counting the signs. If there are only about 25, then the script has an alphabet, like English. If there are around 100, it may be a syllabary, like Linear B. If you lose count entirely, it must be an ideographic script, like Chinese.

The tablet in Figure 6.2 was found at the palace of Pylos in Crete. It starts, at the left, with a set of syllable signs. (You might want to see how much of it you can read, or guess, using the list of syllables, before you go on.) The first syllable sign, which is two upright lines capped with a curve, is pronounced *pu.* The second is a simple cross, pronounced *ro.* Together the six syllable signs would have been pronounced

pu-ro mi-ra-ti-ja. They spell two words: *puro* is the ancient name for Pylos, the place where this tablet was written; and *miratija* means Miletus, an ancient seaport in present-day Turkey.

The brief text spelled in syllable signs is followed by an ideogram for "woman," which looks like a woman with a high-waisted dress. It is conventionally transcribed as "WOMAN," in capital letters, as a reminder that it is an ideogram; that is, it doesn't tell how the word *woman* was pronounced in ancient Mycenean. After her comes a little horizontal mark and six vertical marks. That is how the number 16 is written in Linear B. Immediately following are two smaller syllable signs, spelling *ko-wa*, meaning "boys." They are followed by the number three, and—after the crack in the table—two syllable signs, *ko-wo*, meaning "girls," and the number seven. Notice that *wa* and *wo*, the markers of gender, are also little pictures—*wa* is irresistibly a boy, with legs and penis; and *wo* is the classic pubic triangle, found in many ancient Middle Eastern scripts, and possibly two breasts above it.

At that point the tablet splits into two rows. The top one has the ideograph for "wheat," and then the number 5. The next sign is simply called "T"; no one knows what it means. It is followed by the number 1. Underneath is the sign *ni,* which also means "figs," and the numbers 5 and 1. And finally, at the far upper right, two more syllable signs, *da* and *ta.* No one knows what they mean, either.

This tablet is one of a long series that are very similar. Each one starts with "Pylos," and then there is either the name of a place, like Miletus, or the name of an occupation, such as "bath attendants," "corn grinders," "spinners," and "carders." Clearly, these tablets were a census of palace slaves. Judging from the tablets that have survived, the palace at Pylos had around a thousand slaves. Some slaves are named by their occupations, and others, like these, by their native land. It has been suggested that these are new slaves, freshly brought from Miletus, and not yet assigned to a definite occupation. Almost all the slaves are women and children, which also suggests that the men were killed or shipped off somewhere else for harder work. (The palace at Pylos specialized in the manufacture of fabrics.) The purpose of the listings of wheat, figs, and "T" is not entirely clear, but they may indicate monthly rations. The enigmatic *data* at the very end might be something like an official seal or sign, like "APPROVED."

Because the tablet doesn't have full sentences, there is some latitude in the ways it can be read. I might read it literally, like this:

Pylos / Miletian slaves / women 16 / boys 3 / girls 7 / wheat 5 / T 1 / figs 6 /
Approved

Or I might rearrange it so it suits the English language, and read:

> Records of the Palace of Pylos. Miletian slaves: 16 women, 3 boys, and 7 girls.
> Their rations: 5 units of wheat, 1 unit of T, 5 units of figs. Approved.

For some scholars, "slaves" seems too strong a word, but clearly they were virtually slaves; paid in food and assigned to different kinds of work. Because the tablet says so little, it is hard to say what might be implied. Instead of "women 16" the writer might have meant "The king owns 16 women slaves," or "The raid to Miletus yielded 16 women."

These slips and slides make it tricky to give an idiomatic translation. To me the most interesting part is the way the tablet mixes pictures and words. Consider how minimal the ideograms are. "Boys" is just a few little scratches, followed by three more scratches. The "boys" are almost the same as the numbers showing how many boys there are. The little tally marks are very close to being a picture of a row of little boys. And the marks are so matter-of-fact—so demeaning, as we would say. How can people who are designated by such minimal marks *not* be slaves? The marks are like skinny bodies—they occupy space, they stand in rows, and they suggest the orderliness proper to possessions. There are limits to this kind of interpretation, of course. I would not want to say that the number "10," just right of the ideogram for "woman," represents a woman lying down. But the tablet is very like a picture, and that influences the way I read it. Despite the fact that this is a list, and that it is writing, I see the women and children lined up in front of me.

A large number of ancient artifacts written in such forgotten languages as Mycenean, Sumerian, Babylonian, Akkadian, Hurrian, and Luwian can be enjoyed in this way. Looking at them you can ponder what it meant to own slaves, or to be a slave. You can get just a little insight into the way things worked in Crete in such an unimaginably distant time.

There are artifacts in Linear B in the National Museum in Athens, and in Crete. Your local museum probably will not have anything written in Linear B, so you will have to find these objects in books. But there is no reason why museums can't acquire such things. Ask them! For the price of a single painting, a museum could get a wonderful collection of these "minor" artifacts from "minor" cultures.

how to look at chinese and japanese script

There is a long tradition in the West of looking at Chinese characters as if they were pictures. To be sure, many characters do have pictures in them. "Rain" is a lovely example: 雨. It is made of four droplets ⠃⠂ which fall | from a cloud 冂 that hangs from heaven 一.

Other Chinese characters aren't exactly pictures, but they make pictorial sense. The character for "king":

王

is very like the character for "jade":

玉

The character for "mouth":

口

resembles the character for "field":

田

Those four words all resonate in the character for "nation":

国

It's as if "nation" were a king (who is himself like precious jade), standing inside his domain (the field), or ruling by the power of his words (the mouth). The Chinese word for "China" is "middle kingdom," formed by adding the character for "middle" to the one for "nation":

Like many simpler Chinese characters, "middle" is self-explanatory: a line marking the middle of the mouth—or by extension, a territory or even a field.

Because there are a several Western-language books that exposit Chinese in this fashion, it is important to keep in mind that native speakers of Chinese don't learn their own characters this way. The Western way of thinking tends to split Chinese characters into two groups: those that look like pictures, and those that don't. In China there is a traditional way of dealing with this question that is very different—and very surprising to Western ways of thinking.

The Chinese six categories or "writings" (*liu shu*) that describe the variably pictorial nature of characters are:

1. *Xiang xing,* "representing the form." For example, the character "mountain":

This is pretty much the Western idea of "pictographs"—signs that work by resembling what they symbolize. But the sense of naturalism is different from the Western sense. We might not say that those mountains are very realistic, or that "sun":

resembles the sun, or even that "tree":

resembles a tree. (It might look better upside down, so the branches spread upward.) Yet these are all traditional Chinese examples of characters that "represent the form." Apparently Confucius thought the character for "dog," *quan,* looked very much like a dog:

A modern scholar says "this induces us to believe that the dogs, in the times of the philosopher, were strange animals." Another character for "dog":

looks nearer the mark.

2. *Zhi shi,* "indicating the matter." The character for "field" or "square":

was originally a swastika shape, but it is taken to represent a rice field with narrow paths running through it. In a similar fashion "above":

and "below":

point up and down, and the numbers one, two, and three:

are collections of horizontal strokes. This is not the same as the first category; these characters are understood more or less as westerners might think of diagrams. In the Chinese way of thinking, "field" does not resemble a field, at least not the way that "mountain":

resembles a mountain.

3. *Hui yi,* "conjoining the sense." For example, "horse" drawn three times means "gallop." "Tree":

doubled makes "forest":

And, notoriously, "woman" drawn twice signifies "quarrel."

4. *Zhuan zhu,* "redirected characters." For instance, "prince" switched left to right signifies "clerk."

5. *Jia jie,* "borrowed characters." For example "scorpion," *wan,* is borrowed from "10,000," *wan.*

6. *Xing sheng,* "harmonized sound," is made from a semantic determinative and a phonetic sign; for example the sound *ko* from the word for "fruit," added to the character *shui,* "water," denotes *ko, "river."*

This is the Chinese system. A westerner would not be likely to name the relations between pictures and writing in this way. The first four categories are pictorial in a general sense. The linguist Florian Coulmas calls the first category "pictographic," the second "simple ideographic," and the third "compound ideographic." William Boltz says the second category is "ostensibly graphic representations of the thing in question," but the first is "graphically suggestive in some impressionistic sense of the meaning of the word"—a characterization only slightly less opaque than the one the Chinese texts offer.

I think it is difficult for a Western eye, used to Western naturalism, to say that the character for "field" is more or less naturalistic than the characters for "tree" or "sun." Even the third category includes weakly representational examples such as "honest," which is comprised of "man" and "word." The fourth introduces an entirely unfamiliar notion, and the final two categories are different once again since they have to do with sounds. Boltz says the fourth and fifth categories are "classes of usage, not of character structure," and neither is "a description of graphic structure." Yet the fourth does pertain to graphic structure, and neither is purely a matter of usage aside from "graphic" functions. The first category is clearly pictorial; isn't it a different *kind* of category from the other categories?

So one way to look at Chinese is to notice pictorial elements and ponder the differences between Chinese and Western ways of thinking about pictures. Another is to look at calligraphy. In Chinese, as in Japanese, there really is no way of writing that is *not* calligraphy. In the West, calligraphy is just a pastime, a way to make writing pretty. In Chinese and Japanese, writing is calligraphic, and the only time writing *is* mechanical is when it mimics Western typography or computer-generated script. Here are the numbers one through ten in a flowing script, an intermediate one, and a mechanical, Western-style script:

一二三四五六七八九十

一二三四五六七八九十

一二三四五六七八九十

There are many styles of calligraphy in the Chinese and Japanese traditions, ranging from strict rectilinear modes, like the one just above, to extremely fluid and nearly illegible styles. Japanese "grass script" is one of the most amazing. Its characters are so distorted that even Japanese readers need special courses to read them. Figure 7.1 is from a grass script manual for Japanese students. I have added some Roman letters at the top to help identify the characters. The large character on the top, below the letter D, is one of the Japanese characters called *hiragana;* it is pronounced "shi." Under letters A, C, and G, in small vertical brackets, are three possible characters that sound the same in Japanese. Any of them might be used in classical Japanese literature to stand for the sound "shi." (They are Chinese characters called *kanji,* which the Japanese borrowed from Chinese writing.)

The calligraphic character under the letter B is a version of the *kanji* character under the letter A. Can you see the similarity? (I can't.) The calligraphic characters in the two columns under the letters E and F are versions of the single bracketed *kanji* character under letter C. Here the similarity makes some sense, at least with the first few examples under the letter E. Each calligraphic character is from a different classical Japanese text, and the ones just under E are the earliest. They have the strongest resemblance to the character under C, but as time went on—the later examples are further down, and in the column marked F—the zigzag disappeared almost entirely.

How much practice would it take to look at a characters in column F and recognize it stands for the character in brackets under letter C? It's easy to see how entire lifetimes could be devoted to mastering the grass script. If you study the next *kanji* character, the one bracketed under G, you'll see it has a top portion that looks like a double-barred cross, and a lower portion consisting of four marks arranged horizontally. The grass script characters preserve that two-part structure (under columns H and I). But even the earliest examples blur the bottom half of the original character into a rough zigzag, and the later examples (under column I) smooth the bottom half into a single straight line. The four little marks in the lower portion of the character under G are a Chinese character that means "heart," so in a sense it's "heart" that is being smeared and finally flattened.)

figure 7.1

Grass script versions of the Japanese hiragana *character* shi.

高一＝高野切第一種　高二＝高野切第二種　高三＝高野切第三種　継＝継色紙
秋＝秋萩帖　関＝関戸本古今集　倭＝御物本和漢朗詠集　松＝松籟切
十＝十五番歌合　入＝入道右大臣集（頼宗集）　元＝元永本古今集　広＝広田社歌合

The difficulties do not end there, because Japanese calligraphers loved to string characters together, massing several into a single group. Figure 7.2 is a page from later in the same book, showing how to turn groups of *kanji* characters (in vertical brackets) into grass script. The first set of two *kanji* characters in the brackets at the upper right yield the three calligraphic shapes in the first column. If you look closely, you can just barely discern the remnants of the two horizontal lines that comprise the upper *kanji* character. But what an astonishing art form! Look at the very last *kanji* combination, at the lower left: five different characters (in the brackets) are slurred into a single looping line. No writing system is as extravagant, as willfully distorted, as nearly illegible as Japanese grass script. But it is also something anyone can appreciate, to a degree. Only a few Japanese can read it; most of them look at it more or less as I just have: admiring its balance, its flow, and its breathtaking condensation of long, tedious characters into apparently effortless running curves.

figure 7.2

Grass script versions of combined hiragana characters.

合字
の類

【こそ】

【こと】　霊

【らん】

【なん】

【かしく】

【にて】

【かな】　兼

【なりとも】

【けり】

霊　【候】

霊

霊

【こゆ】　実

【やう】　実　霊

【なりけり】

【なりけり】

【もかな】

【まいらせ候】

8

how to look at
egyptian hieroglyphs

Hieroglyphic Egyptian looks simple—after all, it is made entirely of pictures. But it is a complicated and difficult way of writing. Some of the "pictures" are symbols that work like our alphabet does, with a slight difference: in the alphabet, each sign stands for a consonant or a vowel; in the Egyptian "pseudoalphabet," each sign stands for a consonant and also an indeterminate vowel. The pseudoalphabet is short, and easy to memorize (Fig. 8.1). There are three birds (the Egyptian vulture, the owl, and the quail chick), two snakes (the horned viper and the ordinary snake), and three body parts (the forearm, the mouth just above it, and the foot). Most of the other signs are household objects (a wooden or wicker stool, a basket, a jar, and so on).

Unfortunately the pseudoalphabet is only one class of signs in written Egyptian. Other signs stand for combinations of two and even three consonants. (They are known as biliteral and triliteral syllabic signs.) Still other signs represent ideas like "bravery" or "eating," or things like "Pharaoh" or "lion." (Technically, those are

figure 8.1

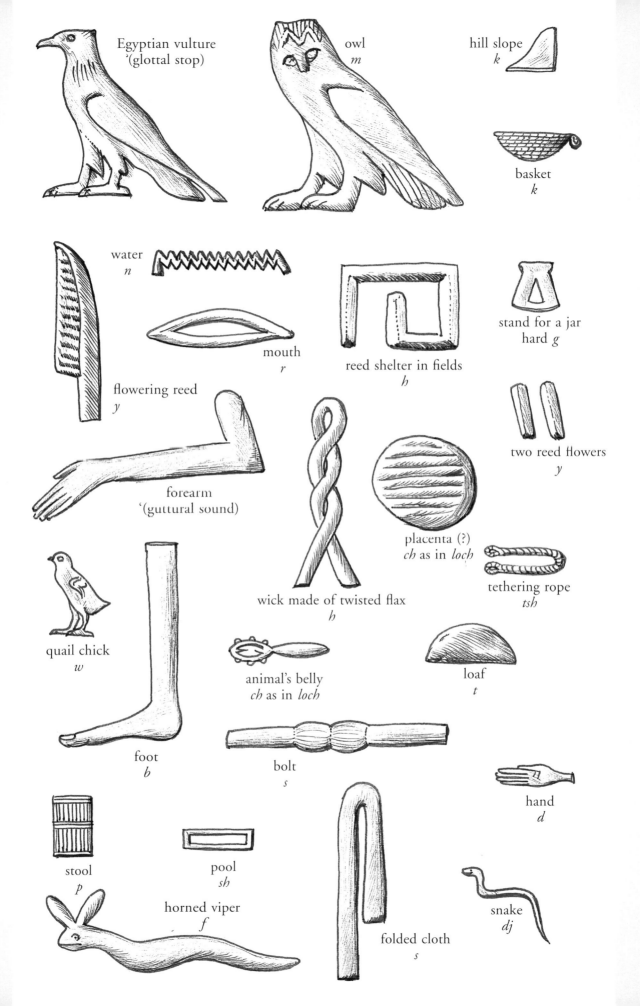

Egyptian vulture
'(glottal stop)

owl
m

hill slope
k

basket
k

water
n

mouth
r

reed shelter in fields
h

stand for a jar
hard g

flowering reed
y

forearm
'(guttural sound)

two reed flowers
y

placenta (?)
ch as in loch

tethering rope
tsh

wick made of twisted flax
h

quail chick
w

animal's belly
ch as in loch

loaf
t

foot
b

bolt
s

hand
d

stool
p

pool
sh

horned viper
f

folded cloth
s

snake
dj

ideographs and pictographs.) So even before you begin to learn the Egyptian language, you have to learn several different kinds of symbols.

Some signs are *acrophones:* that is, they are used only for their first consonant, as if I were to draw a lion in order to represent the sound of the letter "l." Others are determinatives, special signs that help resolve potential confusions—as if I were to draw a lion in order to be sure you knew what I meant by writing "l," "i," "o," and "n." Some determinatives identify the gender of the person or the thing that's being written about; others identify parts of speech (as if to say, "this is a verb"); and others tell the reader when a sign is to be read for its sound and when it really is a picture of what it represents.

Here is an example, the hieroglyphic Egyptian for the verb "to pray."

f i g u r e 8 . 2

The Egyptian verb "to pray."

The bird is conventionally called a "guinea fowl." (It isn't in the pseudoalphabet in Figure 8.1.) If I were an ancient Egyptian scribe, and I were writing a text about birds, I could use the guinea fowl sign to mean "guinea fowl." But the same picture can also function as a syllabic sign, in which case it does not mean "bird" at all: it is simply a symbol that is pronounced *neḥ,* with the rough *ḥ* as in the Scottish word "loch." (In Egyptian, as in ancient Hebrew, vowels are not written. Because the original language is lost, no one knows exactly what the vowels were. For convenience, Egyptologists put the vowel *e* in between most consonants; even though the "guinea fowl" sign is technically just *nḥ,* it is pronounced *neḥ.)*

Egyptian readers would have to be alerted that the guinea fowl sign does not mean "guinea fowl," but rather *nḥ,* and to do that the scribe could add two signs from the pseudoalphabet denoting the sounds *n* and *ḥ.* Those two signs are determinatives or "phonetic complements" of the guinea fowl sign. They repeat the *n*

and the h, but they also make it clear that the guinea fowl is to be understood as a sound and not a bird. Modern Egyptologists write the three signs this way:

$${}^{n}n\underline{h}{}^{h}$$

as a reminder that the "extra" n and h are there to underscore the sense of the primary sign.

To complete the verb "to pray," the scribe would add another determinative, this time a man pointing to his mouth. It indicates that the other signs are a word for a part of speech—in particular, a kind of verb. It contributes the ending (i) and violà!— the four signs spell "to pray."

This may seem very repetitive and time-consuming, but people who are fluent in reading hieroglyphic Egyptian say it lends the script a wonderful clarity. Almost all signs in Egyptian come from pictures, but that fact is not always relevant. The n sound from the pseudoalphabet is also a picture of water, and the h sound is a picture of a twisted piece of flax that was used as a wick in oil lamps. But a reader need not think of birds, water, or lamps when reading this text.

Here is another example: the Egyptian way of writing the word "man," which was pronounced s:

f i g u r e 8 . 3

The Egyptian word "man."

The so-called stroke-determinative is a short vertical line (|); here it indicates that the ideogram "man" is being used to denote the actual object it depicts, rather than the traditionally associated idea. In other words, it literalizes the picture of the man, warning readers against taking it as a symbol of something else or as a sound. In early Egyptian writing, the scribes might also add a sign from the pseudoalphabet just for good measure. The "bolt s" is a such a sign. It is a picture of a door bolt,

but it denotes the sound *s.* In this example, "man" is spelled two ways: the stroke-determinative says, in effect, "this is a picture of a man"; and the "bolt *s*" reminds readers of the sound of the word "man" in the Egyptian language. It's repetitive, but it's clear.

It is not difficult to learn the Egyptian pseudoalphabet and a few dozen other common signs, and with that knowledge you can puzzle out many elements of hiero-glyphic inscriptions. (You won't know what it *means,* because the next step would be to translate the language, but you'll see how the sentences are structured.)

All the repetition, and all the detail, made for slow writing. It's not surprising, then, that written Egyptian also has shortcuts and abbreviations. In later Egyptian, there is even a curved backward-slanting stroke (\) that means "the hieroglyph that would go in this place is too tedious to draw." As the centuries went by, the scribes learned to write faster and faster, and eventually the hieroglyphics melted into a kind of script. At the other end of the scale, there are inscriptions that are so elaborate they seem like little landscapes scattered with implements, birds, snakes, and people. In such cases the signs begin to look irresistibly like pictures. Figure 8.4 is a sample. The sign for "foreign country" (number 1) is usually written as three simple bumps on a register line. This one is delicately drawn with shrubs at the lower levels and steep slopes above. The hills sit on a grayish-blue base, which may represent the Nile. The sign for "horizon" (number 5) is normally a round circle between two bumps. Here it is a huge red sun, just at sunset, looming on the western horizon. As in "foreign country," the desert is pink with reddish rocks. It is irresistible to think of an Egyptian looking across the Nile and watching the sun set out over the western desert. Number 6 is the pseudoalphabetic sign *y,* a picture of a flowering reed—as in Figure 8.1. Egyptian painting and Egyptian writing are full of natural details: a sycamore tree (number 2), a pond with lotus flowers and buds (3), a lotus stalk and leaf (4), papyrus plants (11), a pile of corn (8), a deep pool (9), a red branch (12), and even a starry sky (13), a lotus flower (14), and a thin crescent moon with a single bright star (16).

These pictorial qualities do not add to the literal sense of the sentences they spell, but they always bear on the mood, the connotation, and the sense of the particular time and place when the inscription was made. You can look at hieroglyphs and ponder these stylistic questions. Does the sign for "horizon" (number 5) record a local pattern of vegetation, or a local style? Is "foreign country" (number 1) some-one's particular idea of a foreign land? I have intentionally put together the glyphs in Figure 8.1 from several sources and drawn them at several different scales to bring out the peculiarities of each sign. The owl sign looks curious, as owls often do; the viper sign (lower left) is bizarre, with the horns exaggerated into floppy rabbit ears. No matter how businesslike they get, hieroglyphs are always pictures as well as writing.

figure 8.4

Egyptian hieroglyphs. Thebes, 18th Dynasty.

Egyptian writing seems very pictorial, but Egyptologists pay little attention to its visual qualities. Alan Gardiner's *Egyptian Grammar,* the standard introductory textbook, devotes exactly one sentence to pictorial organization. In the first subsection of Lesson 1, he admonishes the beginning student to "note the effort that is made to arrange the hieroglyphs symmetrically and without leaving unsightly gaps." But for other writers, "the hieroglyphic system . . . virtually *is* painting." I prefer the second view and I am often entranced by the pictures "hidden" in hieroglyphic writing—it makes a trip to the Egyptian section of the museum that much more interesting.

9

how to look at

egyptian
scarabs

Another kind of lovely object that gets hidden away in the corners of museums is Egyptian scarabs (Fig. 9.1). They are small, bug-sized objects shaped like Egyptian dung beetles, which is probably why museums keep them out of sight. But they are often beautifully carved—smooth and detailed on top, and flat on the bottom for inscriptions. Some were used as seals, to make wax impressions on official correspondence; others had magical formulas engraved on them, and a large number were just decorative. If you were an Egyptian living back when these were made—from 2700 B.C. to the first century B.C.—you might well have owned one or more scarabs as good-luck charms and as an identification. (The inscribed lower surface could be pressed into wax, somewhat in the way credit cards are still sometimes pulled through little rollers to take the impression of the raised numbers.)

Because some scarabs had a magical purpose, scholars have wondered about the meaning of the decorative patterns carved on their lower surfaces. Could they have meant something? There is an ingenious theory, spurned by most Egyptologists,

figure 9.1

Egyptian scarabs.

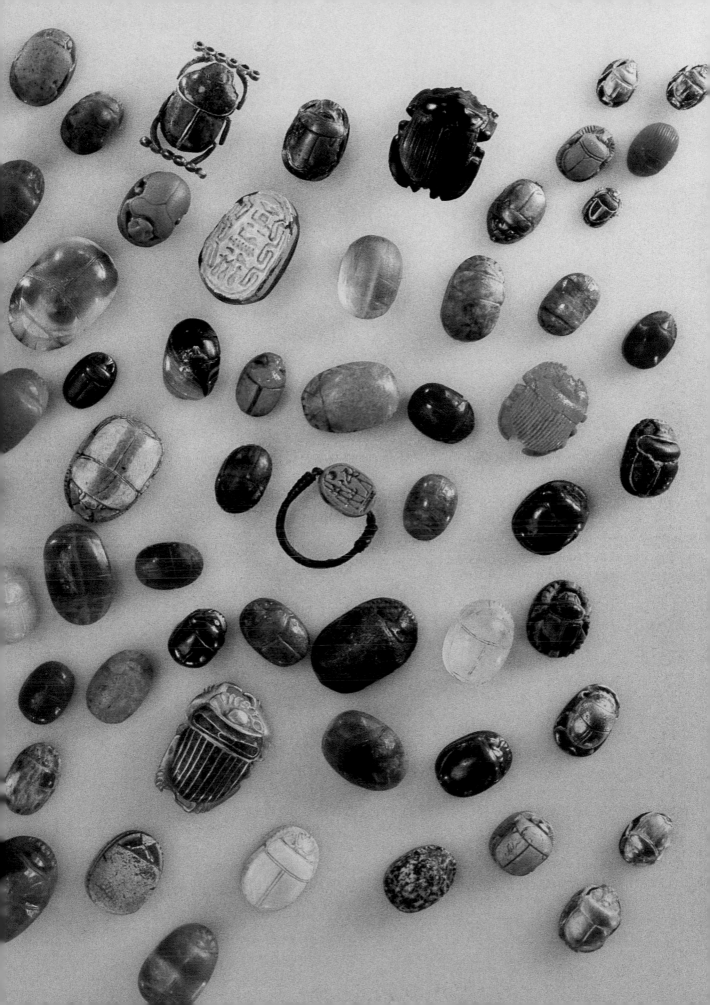

that these "decorations" are really secret sentences about the god Amun, whose name means "the hidden one." The idea is that a hidden message to a hidden god would be more effective than a simple prayer written in ordinary hieroglyphs. Some scarabs were commonly engraved with a prayer called the "trigram of Amun," which reads "Ỉ mn–R ꜥnb. ỉ" or "Amun-Re is my lord." Could scarabs like the one in Figures 9.2 and 9.3 be even more powerful versions of that prayer, in which the hieroglyphs are mysteriously changed into "meaningless" swirling lines?

On the bottom of the scarab in Figure 9.3 are two pincushion squares made of spiral lines linked together. In all, there are five S-shaped spirals and six U-shaped spirals. (I have numbered the U-shaped spirals.) At the left and right are papyrus plants (P), each one bent and tied into a U-shape with two faint lines representing cords (C). To find the hidden meaning in this scarab, the curving lines need to be read three times: once as spirals, again as borders, and then a third time as cords. In the Egyptian language, the first sound of the word for "border" is *a*, the first sound of the word for "spiral" is *m,* and the first sound of the word for "cord" is *n*. Put them together, and you have "Amn." (More exactly: "border" is Ỉnh, yielding an Ỉ: "spiral" is mnn, yelding "m"; and "cord" is nhw, yielding "n". Together they spell Ỉmn.) The lack of the "u" and the slightly different vowels don't matter, since Egyptians wrote only consonants, not vowels. And it's not entirely unlikely that "Amun" would be spelled this way; it's permissible in Egyptian to spell words using the initial sounds of other words.)

Spiral, border, and cord make the god's name. The rest of the prayer "Amun-Re is my lord" comes from the papyrus plants, which have the phonetic value ỉ, and from the way that the small cords, together with the bent papyri, seem to make little baskets; in Egyptian, "basket" is "nb," completing the sentence "Amun-Re is my lord."

If there is a sentence hidden in the papyrus reeds, it is repeated at least twice. There are two baskets and two papyrus plants, enough for two sentences. That would make the prayer that much more effective; and on top of it, the name Amun is repeated at least five times, and perhaps—counting all the spirals—eleven times. If the cryptomorphic theory is right, the design would work like a rosary, cyling and

figure 9.2

An Egyptian scarab, side and top view.

recycling the name of Amun as the viewer's eye follows the deceptively complicated pattern of the spirals, always returning to the papyri and baskets.

It is an attractive theory, but it is very likely that the people who promote it go too far. A consensus of Egyptologists has long since turned against them. William Ward speaks for most scholars in the field when he says that "practically any scarab . . . can be made to render the name of Amon." Still, many scarabs mix clearly hieroglyphic symbols with apparently decorative elements; and after all, the God Amun was "the hidden one." Next time you are in a museum that has Egyptian art, have a look at some scarabs and judge for yourself.

figure 9.3

An Egyptian scarab, bottom view.

how to look at
an engineering drawing

You don't need special training to read an engineering drawing. There are only three obstacles, and two of them are easy to surmount. First, engineering drawings look complex because everything is transparent, so you see through to the farthest parts of the machine. Second, everything is flattened, and so you need to mentally reconstruct the third dimension. And third—the difficult point—you have to be able to turn on the machines in your imagination and picture how they move. (Strangely enough, these are exactly the skills necessary to read an X ray, as I have described in Chapter 5. You could substitute "body" for "machine" in the sentences above and have a perfect description of reading an X ray. In this sense, at least, the body really is like a machine: or rather, we often treat the body as if it were a machine.)

Figures 10.1, 10.2, and 10.3 are drawings for a machine that winds thread onto the bobbin of a sewing machine. It's typical of the machine age that very few people have the faintest idea how such a simple thing is accomplished. I don't understand washing machines, refrigerators, cars, dishwashers, sewing machines, or any of the other mechanical devices that I use. But I know I *could* understand them, because I can read engineering drawings. (Electric and electronic circuits are another matter. I still can't understand anything but the simplest electrical schematics.)

The bobbin on a sewing machine is a metal cone, and the thread has to be wound around it in a specific way: it has to have a uniform thickness at its base, and then taper toward the apex of the bobbin. That is shown in Figure 10.1, which

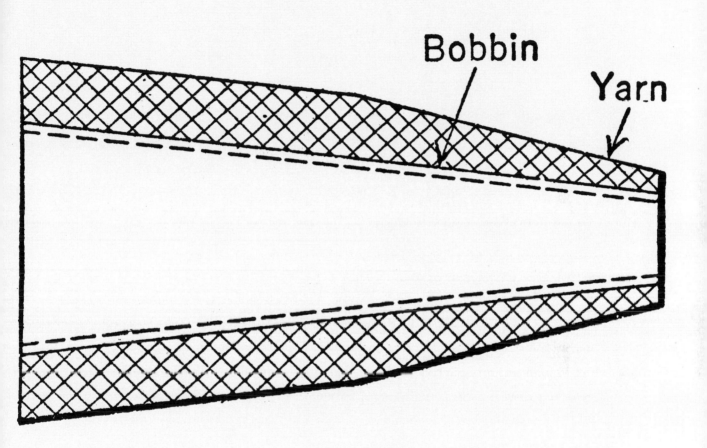

figure 10.1

Bobbin wound with string.

figure 10.2

Machine for winding the bobbin.

is a section through a bobbin. A bobbin could be spun very simply, the way that thread is wound into a cylindrical spool in the factory: the bobbin spins, and the thread is guided from the top to the bottom and back again. That winds the thread exactly as a fishing reel does, but it would not work for the bobbin because the thread would be equally thick across the length of the bobbin. It takes a more complicated machine to achieve the taper on the upper half of the bobbin.

The next drawing shows the mechanism. It consists of a guide for the thread (letter A), which slides back and forth on a stationary support (C). The guide is moved by an L-shaped "bellcrank lever" (M–M). Notice that the bellcrank lever has three pivots, one at each end and a third in the middle, at the elbow. The parts that move it are the "cross-head" (G) and a bar (O). Their motions are what determine how the lever slides back and forth on the stationary support (C).

The cross-head moves back and forth on two tracks (E, F). It is driven by a cam (K) on a shaft (L). (If you don't know what a cam is, don't try looking it up. It is easier to study the diagram until it becomes clear.) These last two elements, (K) and (L),

have to be imagined in three dimensions, behind the tracks (E) and (F)—picture a metal cylinder lying on the table; imagine that a hole is drilled down its longitudinal axis, so that it becomes a tube. Picture a metal shaft or axle that runs the length of the cylinder; that is the shaft (L). If the cylinder is cut at an angle (leaving the shaft intact), and then the parts are pulled apart slightly, there will be a channel formed that runs around the shaft. If the cylinder is then cut away from both ends, leaving only a little material on either side of the channel, the result will be the flanged channel that appears at (K). Imagine the cylinder and the shaft glued together into one piece, so that the shaft (L) and the channel (K) turn together. The pivot (H) in the cross-head (G) sits in that channel, and so as the shaft (L) turns, the pivot and cross-head move right and left.

The way to learn engineering drawing is just to stare and stare until the thing finally pops out into three dimensions. (These drawings are a little like Magic Eye pictures—you have to just relax and keep looking.) Here the shaft and channel (L and K) are behind everything else. The pivot (H) sits in the channel in front of both the shaft and the channel: the pivot is closer to us than they are. The cross-head (G) is even closer, and the **L**-shaped bellcrank lever (M) is the closest of all. When engineering students are taught to read these diagrams, they are tested by being asked to sketch the machines in three dimensions, as they would look from some other viewpoint. A good engineer could draw this machine from above, from below, from the right and left, and in various perspectives. It all depends on how well you can hold it in your mind.

By themselves, these parts (that is, L, K, G, E, M, A, and C, all the ones I have mentioned so far) would be enough to cover the bobbin with a uniform thickness of yarn. The crank (L) would turn, and the pivot (H) would move along the cam (K), pushing the bellcrank lever (M) back and forth, as in a fishing reel. To achieve the taper on the right half of the bobbin, the bellcrank lever (M) is also attached to a bar (O). The attachment (m) is a "roll," a little knob that moves in a channel cut in the bar (O). The bar, in turn, is attached to a fixed pivot at (n), and its other end is attached to a pin (P). There's a second cam (Q), a disk with a cardioid (heart-shaped) channel cut into it. The pin (P) can move only in the cardioid channel. The cam itself (Q) turns on an axle (r), which points away from us. The axle and the cam are turned by a worm gear (S). Worm gears are well named: they look like worms, and they are good for turning things very slowly. As the teeth of (S) engage the gear (r), the whole cam (Q) turns, but slower than the rest of the machine.

So the question is: When the machine is turned on, what is the effect of the bar (O)? How does the cam (Q) move the bar? To see what happens, you have to pic-

figure 10.3

Diagram of the machine's motions.

ture the assembly in motion. This drawing is like a flash photograph, arresting the machine in mid-movement. As the cam turns—it doesn't matter if it turns clockwise or anticlockwise—at first the bar (O) will not move. The pin (P) will continue to move in the channel, and as long as the channel stays even with the rim of the cam, the bar (O) won't move. The top of the bellcrank lever (M) will be free to move through a wide arc.

When the cam (Q) turns far enough, the pin (P) will start moving in toward the axis of the cam, pulling one end of the bar (O) with it. That means that the bar (O) will be closer and closer to horizontal. Imagine what happens when the bar is perfectly horizontal—the bellcrank lever (M) forms a perfect backwards **L**; it slides left and right, with the roll (m) just moving left and right along the bar (O). The bobbin end of the bellcrank level (A) will move through a much smaller distance.

As the cam (Q) continues to turn, the pin (P) will move even farther down, and the end (A) of the bellcrank lever will be able to move even less. At that point, the bobbin is completely wound.

You'll know that you understand this drawing when you can picture how the bellcrank lever (M) moves under the influence of the two different parts of the machine. This kind of visualization can be very trying, and drawings like this are sometimes augmented by more abstract diagrams that show the skeletal outline of the motions. Figure 10.3 is such a diagram. It shows the same elements, but in skeletal form. The line (nP) is the bar (O), and it is shown in the three positions I have just described: up, horizontal, and slanted down. The L-shaped bellcrank lever is shown as a right angle. The cross-head (G) always moves the bellcrank lever left and right from the letter (H) over to the vertical line. When the machine is in the position shown in the main drawing, the pin (P) will be fixed in its uppermost position. At that time, the bellcrank lever will look like the right angle (AHP). As it slides to the left, the pivot (P) has to stay on the solid line, so the top part of it (A) moves through a distance equal to S_1. Later—in the second stage—the bar (O) is horizontal, and the bellcrank lever moves from the position shown by the interrupted line (that is, the line that is dotted and dashed), over to the left through the smaller distance S. And finally, when the bar (O) falls beneath the horizontal (note the dotted lines), the bellcrank lever moves from the position given by the dotted lines over to the left through a distance S_2. The thread guide (A) moves over less and less of the bobbin, producing the taper. The exact taper depends on the shape of the cardioid channel.

Some people find this kind of description utterly tedious, and for others it is a kind of fascinating treat, a puzzle that needs to be solved. People get very good at visualizing machines, and the book I've taken this from, called *Ingenious Mechanisms for Designers and Inventors,* has hundreds of such designs. It is meant to be read through by a reader who can take in the essential points without too much trouble. Outside of engineering, few people know the intricacy of these diagrams and drawings or how much ingenious thought can be compressed into a single picture. If you have struggled through even half this description, you have a taste for what keeps engineers and mechanics so busy.

II

how to look at

a rebus

A rebus is a puzzle made of pictures that looks like a sentence. Rebuses appear in Sunday newspapers and TV game shows, and in children's books. In past centuries, though, a rebus was a very serious thing. They used to be made in imitation of Egyptian hieroglyphs—and because no one could read hieroglyphs, they were thought to be very profound and mysterious. Some people thought that the deepest ideas could be expressed only by pictures, because pictures had a direct line to the truth. (Letters, by contrast, were artificial creations.) No one quite realized that the Egyptian *language* lay beneath the Egyptian hieroglyphs; they thought of hieroglyphs as pictures that could be read in any language.

Rebuses and other mysterious symbolic pictures were all the rage in the Renaissance. Artists, scholars, and philosophers invented strange-looking pictures that had obscure meanings, thinking in a kind of unfocused way that the Egyptians must have done the same. By far the most elaborate rebuses are in a book called the *Hypnerotomachia poliphili,* which can be translated, somewhat inelegantly, as *Poliphilus's Dream of the War of Love.* Everything about the book is beautiful and

figure II.I

A page from Francesco Colonna, Hypnerotomachia poliphili. *1499.*

retico basamento in circuito inscalpto digniſſimaméte tali hieraglyphi.
Primo uno capitale oſſo cornato di boue, cum dui inſtrumenti agricul-
torii, alle corne innodati, & una Ara fundata ſopra dui pedi hircini, cum
una ardente fiammula, Nella facia dellaquale era uno ochio, & uno uul-
ture. Dapoſcia uno Malluuio, & uno uaſo Gutturnio, ſequédo uno Glo
mo di filo, ifixo i uno Pyrono, & uno Antiquario uaſo cũ lorificio obtu
rato.. Vna Solea cum uno ochio, cum due fronde intranſuerſate, luna di
oliua & laltra di palma politaméte lorate. Vna ancora, & uno anſere. Vna
Antiquaria lucerna, cum una mano tenente. Vno Temone antico, cum
uno ramo di fruƈtigera Olea circunfaſciato. poſcia dui Harpaguli. Vno
Delphino, & ultimo una Arca recluſa. Erano queſti hieraglyphi opti-
ma Scalptura in queſti graphiamenti.

Lequale uetuſtiſſime & ſacre ſcripture penſiculante, cuſi io le interpretai.

EX LABORE DEO NATVRAE SACRIFICA LIBERA
LITER, PAVLATIM REDVCES ANIMVM DEO SVBIE-
CTVM. FIRMAM CVSTODIAM VITAE TVAE MISERI
CORDITER GVBERNANDO TENEBIT, INCOLVMEM
QVE SERVABIT.

NO.	POLIPHILUS'S DESCRIPTION	POLIPHILUS'S LATIN TRANSLATION	MY ENGLISH TRANSLATION	THE MEANING	SYMBOLISM
1	Bucranium (ox skull) with farming implements	EX LABORE	After laboring,	labor	An ox or cow skull is a reminder of death, and a classical architectural ornament
2	An eye and a vulture on a flaming altar resting on goat's feet	DEO NATURAE SACRIFICA	sacrifice to the God of Nature	God, nature, sacrifice	God was sometimes symbolized by an eye, because He is omnipotent
3	A basin	LIBERALITER,	liberally	liberal	Libation was a liquid offering, poured out
4	A vase, pouring	PAULATIM	in that way you will gradually	gradual	No arcane symbolism here—the thin-necked vase pours more slowly than the basin
5	A ball of yarn on a spindle	REDUCES	lead back	lead back	This is reminiscent of Ariadne's thread, which helped Theseus return from the labyrinth
6	An antique vase, tied with a ribbon	ANIMUM	your spirit	spirit	The old conflation of spirit and spirits kept in a bottle
7	A sole with an eye, with sprigs of palm and olive	DEO SUBIECTUM.	to subjugation under God.	subjugation under God	God, again, is symbolized by the eye. The palm and olive may be the peace and fruitfulness of His kingdom

NO.	POLIPHILUS'S DESCRIPTION	POLIPHILUS'S LATIN TRANSLATION	MY ENGLISH TRANSLATION	THE MEANING	SYMBOLISM
8	An anchor, tied to	FIRMAM	The secure	secure	It symbolizes the steadiness of divine protection, moral and intellectual virtue, confidence in God, and Hope
9	A goose	CUSTODIAM	shelter	shelter	It would remind readers of the geese that saved the Roman Republic by their vigilance
10	An antique oil lamp held by a hand	VITAE TUAE	of your life	life	Lamps symbolize life or the soul
11	An old rudder with a sprig of olive	MISERI-CORDITER GUBER-NANDO	will be compassionately guided,	compassionate guide	rudders are guides
12	Two grappling hooks held by a ribbon	TENEBIT,	held,	held	and grappling hooks hold things
13	A dolphin, tied to	INCOLU-MEMQUE	and intact	intact	Arion, the Greek poet, was saved from drowning by a dolphin who loved his songs
14	A closed coffer.	SERVABIT.	preserved.	preserve	The coffer symbolizes conservation

mysterious. It is written in a combination of Latin and Italian, so it is very hard to read and nearly impossible to translate. It is gorgeously bound and printed, with mesmerizing woodcut illustrations of the strange story. At the very beginning of the book, Poliphilus falls asleep. He wakes up inside his dream, and soon afterward he falls asleep, and wakes up again inside his dream within a dream. The whole book takes place in his sleep, except the last page, when he thinks he has found his true love—but when he tries to embrace her, he wakes up and finds himself alone with a lovely, fragrant smell in the air. His dream is full of strange symbolic people and places: a broken colossal statue of a man with passages inside all marked with anatomical names, a hollow sculpture of an elephant pierced through with a huge stone obelisk, a stepped pyramid with a rotating statue that whistles in the wind. Poliphilus, the hero, wanders through the landscape looking at things and wondering what they might mean. He sees inscriptions in Latin, Greek, Hebrew, and Arabic, and some inscriptions that are just pictures. The most unusual inscription of all is a long rebus, or pseudohieroglyph, that he finds when he climbs up a stairway into the hollow elephant.

The inscription is utterly mysterious (Fig. 11.1). Poliphilus helps us out by describing the signs (at the top of the page) and then translating them (at the bottom). He writes his interpretation in block capitals as if it were another ancient inscription. The pseudohieroglyph is very complicated, and I have summarized its meaning in the table on the previous pages. On the left is Poliphilus's description of each picture, and then his translation into Latin and my translation into English. He turns the rebus into a long sentence, which you can read by looking down the fourth column.

Like the dream within a dream, this is a puzzle within a puzzle, because you have to figure out how Poliphilus managed to translate the inscription. The fourth column gives the answer—each hieroglyph means something, and the concepts have to be fleshed out into a fully grammatical sentence. (I have also added a final column, listing some of the associations the symbols would have had to people who first read the *Hypnerotomachia poliphili*.)

It may seem that this is a detailed interpretation, but with mysteries like this there is always more to be seen. The skull is the common end of all labor, and so it adds a certain bite to the concept of work, but could it also stand for the Latin word *ex*, the "afterward" of labor? Why are there two farm implements, instead of just one? Is their repetition a reminder of the tedium of work? Or are they merely poised in a decorative balance? And what about the ribbons? The idea of work is tied to the

idea of death, and the rebus uses ribbons to tie the pictures together. But could the ribbon also be a sign that we should combine several pictures into one idea?

And what if you choose not to follow Poliphilus's description? Can you make some other sentence out of the rebus?

Description, translation, meaning, symbolism—four layers of secrecy. The *Hypnerotomachia poliphili* is a wonderful book with enigmas to last a lifetime. Its world is very fragile, and beautifully balanced—a perfect house of cards in a dream. The book has many descendents, all the way down to strange and romantic CD-ROM games such as "Myst" and "Riven." But no one has ever made rebuses as intricate as these, and no one has ever felt more certain that pictures hide real meaning.

how to look at
mandalas

A mandala is a Tibetan religious image that is used for meditation. In the 1920s the psychoanalyst Carl Jung discovered mandalas and began using them as part of his therapy. He had his patients draw pictures, and he would analyze them to find out their unconscious thoughts. In Jung's sense of the word, a mandala is any circular image with symbols, from round windows in medieval cathedrals to Navajo sand paintings. Jung's interpretation has nearly taken over from the original meaning. Real Tibetan mandalas are interesting, complex objects, and a great deal has been written about them. I have listed some books at the end of this volume; but the subject here is mandalas without the Sanskrit diacritical marks—that is, mandalas as they are understood in the West.

For several years shortly before 1950, Jung treated a woman he called "Miss X." When she first came to see him, she brought him a self-portrait (Fig. 12.1). She had recently gone back to her mother's home country, Denmark, in hopes of restoring some sense of connection to her. (Jung says that like many academic women, she had a positive father figure and a distant mother—she was "fille à papa.") While she was there, she had been deeply affected by the landscape. It made her feel "caught and helpless," and in her painting "she saw herself with the lower half of her body in the earth, stuck fast in a block of rock."

Her breakthrough came in the next session, when she showed Jung a painting of the same shoreline but with a shaft of lightning striking a luminous sphere (Fig. 12.2).

figure 12.1

Miss X, picture 1.

figure 12.2

Miss X, picture 2.

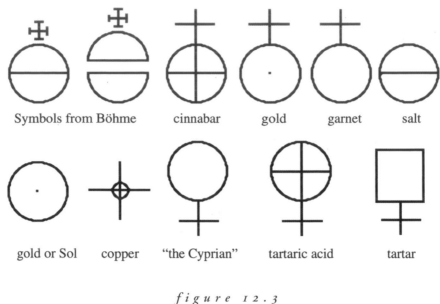

Symbols from Böhme cinnabar gold garnet salt

gold or Sol copper "the Cyprian" tartaric acid tartar

figure 12.3

Symbols adduced by Jung to explain Figure 12.2.

Before, she had been mired in the life she wanted to forget. With the second painting she was transformed—she was no longer a realistic figure, but a sphere.

For Jung, mandalas have to be round because they symbolize the inner life of a person, which is a microcosm—a small universe in itself. Miss X took the first step toward drawing mandalas when she condensed herself into a sphere. Looking back at the first picture, it seems clear that she had an inkling of that idea, because some of the rocks around the figure are globular and almost spherical. It is as if they were other people stuck on the same dreary shore, or as if they were versions of herself. Even her body is rounded like one of the rocks, and she seems to be rooted to the ground. Jung sees the round rocks in the second picture as two of Miss X's closest friends, immured in the same dark substrate as she was. He says the lights that gleam on the pyramidal forms are the unconscious contents of Miss X's psyche pushing upward toward consciousness.

The instant she sees herself as a sphere, she also sees that she can escape. The sphere is hit by a stroke of lightning and broken away from the other rocks. For Jung, this is the crucial moment because it reveals that Miss X has torn herself away from the influence of her mother, at least enough to begin thinking of herself as an independent individual. The "fire-flash," he says, splits the psyche from its dark unconscious substrate.

Jung draws a parallel between Miss X's experience and the writings of Jacob Böhme, a German Renaissance mystic. Böhme wrote at length about a shattering experience he had in which he felt himself split into two parts. At first he imagined himself as a "dark substance," the equivalent of the clammy rocks in Miss X's paint-

ing. "When the fire-flash reaches the dark substance," he writes, "it is a great terror." He emerged entirely changed, and he drew the orb (Fig. 12.3, upper left) to denote his new state. The lower cup-shaped half is "the Eternal Nature in the Anger" that is "the Kingdom of Darkness dwelling within itself," while the upper half with the cross is the "Kingdom of Glory." Böhme used alchemical symbols to help him visualize what had happened to him, and he also calls the upper part "salniter," an alchemical ingredient that Jung interprets as "the paradisal earth and the spotless state of the body before the Fall." Böhme's diagram is a self-portrait of the new shape of his soul, and for Jung it is a perfect mandala.

Jung then goes on to add symbol after symbol, playing a kind of theme-and-variations with the picture of the orb. He likens it to the old chemical symbols for cinnabar, gold, garnet, salt, the Sun (Sol), copper, "the Cyprian"—that is, Venus—and even rather ordinary chemicals like tartaric acid and tartar. Many of these are things that "shine like glowing coals," like Miss X's shining sphere. Jung did extensive research into alchemy, and for him each of these symbols has special meaning. Gold, for instance, is sometimes symbolized by a circle with a central dot, and that in turn is the ultimate sign for the perfected psyche. The dot is the still center of the psyche and it occurs—so Jung says—in many cultures throughout the world. He thinks of it as a great mystery and says it is "simply unknowable." Salt was also important for the alchemists, and Jung notes the way it fuses the hemispheres of Heaven and Earth, bringing them together in a single sign.

After a few pages these symbols (and there are many more that I am not naming) combine into a heady mixture. In Jung's view, they all show that Böhme and Miss X both experienced a fundamental, transformative experience: the violent rupture that tears the *rotundum,* the incipient sense of the self, from its dark, unconscious matrix. The psyche is then free to understand itself. All the later mandalas that Miss X made are pictures of the *rotundum,* and especially pictures of its internal organization. Once she freed herself from the "confused mass" of her unconscious feelings, she was able to begin the work that Jung calls "individuation"—the long process of harmonizing and quieting the self, bringing all its parts into balanced relation with one another.

People who don't like Jung complain that his symbols are so diffuse that eventually everything means everything else, and that is certainly a danger in Jungian analysis. His followers love the weird density of symbols he brings to bear. Speaking of the second painting, he says: "she had rediscovered the historical synonym of the philosophical egg, namely the *rotundum,* the round, original form of the anthropos (or στοιχειον στογγυλου, 'round element', as Zosimos calls it)." The many symbols

open out meaning in many directions; it seems uncontrolled to some, and very rich to others. There is also the question of influence, since Miss X had apparently read some of Jung's works before she went into therapy with him, so she knew what she might be expected to produce. After her breakthrough pictures, she went on to paint dozens more mandalas and she continued in therapy with Jung for a number of years.

One of the later mandalas gives a hint of the possibilities (Fig. 12.4). This is her seventh picture, and now she is concentrating wholly on herself. She had painted a few pictures in which the mandala was circled by a black snake, but now the snake has been absorbed, and its darkness suffuses everything around the mandala and it has even seeped into the center of the mandala—that is, the center of her psyche. The fourfold division shows she has reached a more advanced state (Böhme's "mandala" had only two parts). A little golden pinwheel at the middle rotates clockwise, indicating that Miss X is trying to become conscious of some parts of her mind that had been hidden. (An anticlockwise rotation would mean she was turning toward her unconscious.)

The golden "wings" all around are bonded to a golden cross, and Jung sees that as a hopeful sign: "it produces an inner bond," he says, "a defense against destructive influences emanating from the black substance that has penetrated to the centre." Since the cross signifies suffering, the whole mandala has a mood of "more or less painful *suspension*"; Miss X feels herself balanced "over the dark abyss of inner loneliness." Several of the symbols I collected in Figure 12.3 reappear in this mandala. Jung mentions tartaric acid and notes that *spiritus tartarus* means "spirit of the underworld." The sign for copper, he adds, is also the sign for red hematite, called "bloodstone." In other words, Miss X is revealing a cross that "comes from below," an inversion of the normal Christian cross. This one stands for suffering, but it is an inner, dark suffering and not an outward suffering.

In my experience, relatively few people read Jung's books, especially the more abstruse ones. But his ideas have been very widely disseminated (by Joseph Campbell as a prominent example), and many people—artists, designers, architects—are entranced by round, symmetrical forms. Everything from logos to rose windows to "dream catchers" draws on the same repertoire of forms that Jung first articulated. And who is to say that they don't serve well as reflections of their designer's thoughts?

figure 12.4

Miss X, picture 7.

how to look at perspective pictures

Virtually every picture you see is in perspective: every photo in a magazine, every billboard, every family snapshot, every scene in every movie, every image on television. The only pictures that are not in perspective are photos made with fish-eye lenses, photos that have been digitally manipulated, and—allowing for artistic license—some paintings. Medieval paintings are not in perspective, and neither are older Japanese and Chinese paintings. But these days it is not easy to find a picture that is not in perspective. Even collages are often just collections of perspective pictures.

Most people in the world grow up seeing perspective pictures, and they seem natural and right to millions of viewers. Given that, it is surprising that very few people know how they work. Try this experiment: make a little freehand sketch of a cube on the margins of this page. (Don't look too much at Figure 13.1. The idea is to see what kind of cube you naturally draw.) Take the edges of your cube, and extend them into space. I tried it and got this result:

figure 13.1

Perspective picture of a cube. 1755.

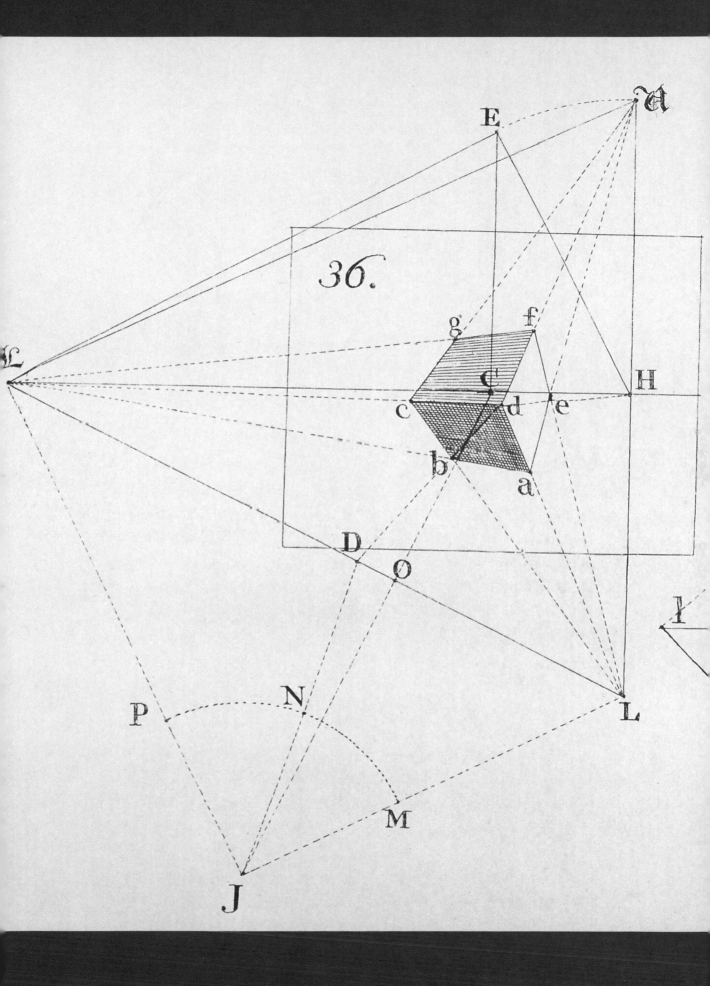

36.

This cube is not in perspective. The laws are very strict, and they say that if lines are parallel to one another in real life—as they are on the real cube I am imagining—then they have to converge to a single point. One of my lines misses the point by a wide margin.

The practice of perspective is full of rules; it is permissible, for example, to have the front edges of the cube be parallel to one another. But all the rules come down to a single one, which is illustrated in Figure 13.1.

Imagine that the surface of the page is a flat floor, and you are standing on it. Say you are about as tall as the line EC, so that if you stretched out flat on the floor, your head would be at E and your feet at C. Imagine, too, that the rectangle is a window, an opening in the floor, and you are looking through it at the cube, which is floating underneath. It does not matter what size the cube is: it could be about six feet across or the size of a planet. Nor does it matter how far away it is.

Picture yourself standing in the center of the window, looking straight down at the cube, with your feet planted on the letter C. If you were to trace the outline of the cube onto the window, you would get exactly the outline that is drawn here. That is one of the miracles of perspective: if you go to a window and trace what you see with a crayon, you will automatically get a picture in perspective that obeys all the rules. If you extend the edges of the cube in all directions, drawing on the floor, they will converge as they do here, on the three points L (at the left), L (normal letter L, at the bottom), and A (at the top right). You're meant to imagine all those lines drawn on the floor and yourself standing there looking at them.

Now the trick is to imagine building a little tentlike structure on the floor. Say that the triangle LEH is a sheet of plexiglass, and that it is hinged to the floor along the line LH. If you stoop down and lift it up, you will be standing right up against it with your eye just at the point E. The triangle LLJ is another such sheet, and it is hinged to the floor along the line LL. If you lift it up, its top edge J will touch the top corner E. The two plexiglass triangles will form a little tent. (There will not be much room for you at that point, unless you step around to the side. But your eye must stay at the point of the pyramid so that you can look down at the cube from the same position.)

This is the kind of setup it takes to explain the single law of perspective. Notice the lines that recede from the edges of the cube, going to the left: they all converge on point L. You might not expect it, but the edge of the plexiglass triangle EL is parallel, in real life, to the three edges of the cube gf, cd, and ba. In other words—and this is the law—if you draw an imaginary line from your eye to the surface that you're drawing on, then the place where that line touches the surface will also be the place where all lines that are parallel to your line converge. If you find that confusing, then you're not alone—it took a century and a half from the time perspective was invented until one

person discovered that law, and then it took another century and a half before it was widely known. Even today, most artists and architects who learn perspective don't learn that law. (They tend to let computers do the work for them.)

You can also think of the law this way: if you are drawing this cube and you are not sure where the edges converge, you need only to draw an imaginary line from your eye toward the drawing, parallel to the edges, to find the point where they converge. With the plexiglass triangles swung up into position, then the line from your eye to the point L will locate the point where fe, da, and cb all converge.

In actual perspective drawing it is not efficient to build pop-up triangles, and so draftsmen rotate the triangles until they are flat on the surface, as they are here. The process is called "rabatment," and in the nineteenth century it was basic knowledge for artists. You'll know you have understood this if you see why the angle LJL and the angle LEH are right angles: because they need to have the same orientations as the cube. And you will have mastered it if you see how the person who drew this located the third vanishing point, the one at **A**, by making the length **A**H equal the length EH.

You can understand ordinary perspective drawings even without grasping the basic law, by watching where lines converge. Points like **L** and **A** are called vanishing points. Notice that lines df and cg are in the same plane, and so are lines dc and fg—they are all in the top face of the cube. It turns out that any lines that are drawn on the top face of the cube will converge somewhere along the line **LA**. If I were to draw a checkerboard on the top of the cube, all the lines would go to **L** or **A**; but more interestingly, if I draw any two parallel lines on the top face, they will converge to a point on **LA**. For that reason the line is called a vanishing line. Every plane has its vanishing line, and all sets of parallel lines in a plane will vanish somewhere on the vanishing line.

This is all very abstract, the way most books on perspective tend to be. Here is a more realistic example (Fig. 13.2). Practically any building can be used to demonstrate perspective; all you need to do is to stand still and visualize how the lines go. First look at the right-hand side of the house and imagine all the horizontal lines—the line of the floor of the porch, the top of the porch, the sills and lintels and sashes of all the windows, and the cornice on top. If they were all extended into space, they would meet in a single vanishing point, which I have labeled A in Figure 13.3. (Most often, vanishing points will be far away from the objects, and so I have made a smaller-scale drawing to go with the large one.)

Then do the same for all the horizontal lines on the front of the house—the front line of the porch floor, the front of the porch roof, the windows and cornice, and, over on the left, the basement windows, the trim line, and all the horizontal lines of the wood siding. All those lines converge farther away, at point B. (When you're doing this

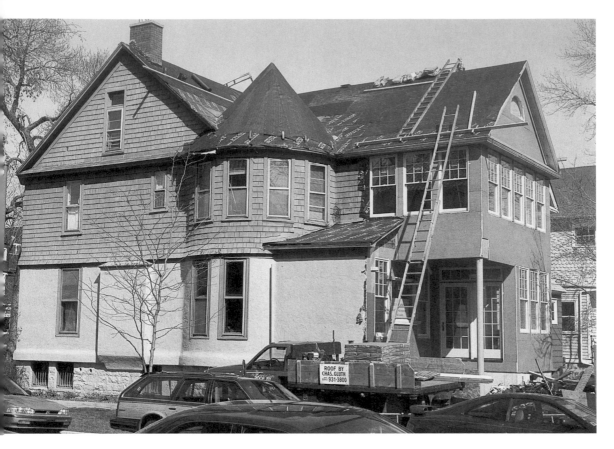

figure 1 3 . 2

A house. Chicago, winter 1998.

outdoors, as opposed to drawing the lines on a photograph, it helps to hold up a pencil to gauge where the lines are going.) A straight, horizontal line between points A and B is the horizon line. If you are looking more or less straight across at the building, the vertical lines will still look vertical, as they do here. If you look up at a skyscraper, you will have to add a third vanishing point up in the sky.

Notice, too, that *all* horizontal lines that are parallel to the ones on the front of the house will converge on point B, including the lines on the chimney and even on the house in the right background. As long as the houses are parallel to one another, their vanishing points will coincide. And the same goes for all houses on any street parallel to this one, even if they are miles away out of sight.

That is the simple part. Perspective becomes more interesting when you think about other planes. The visible part of roof on the right part of the house also forms a plane. Some lines in that plane are horizontal and parallel to the lines on the front walls of the house, and so they will also vanish at point B. But what about lines that slope straight

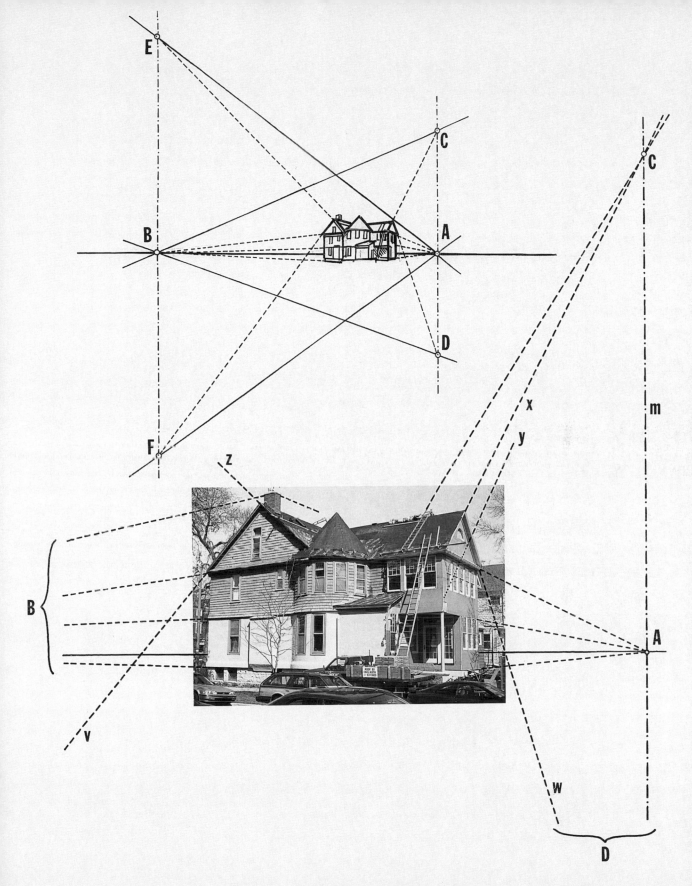

figure 13.3

Diagrams of the vanishing points and lines.

up, like the one labeled x? Here's how to reason it: the sloping line x is in the plane of the roof *and* in the plane formed by the right side of the house. Imagine more lines parallel to x but drawn on the right side of the house; I have drawn one at y. All such lines will vanish somewhere up in the air, directly above the vanishing point A. Line m, therefore, is the vanishing line for all possible parallel lines in the right side of the house. The point C is *also* the vanishing point for all possible lines in the roof that are parallel to x. The line m is the vanishing line for any sets of parallel lines on the right side of the house; and similarly, any parallel lines that are drawn on the roof will vanish somewhere on line BC. The two sides of the upper ladder will probably also vanish at point C. (There is a lower ladder, too, and I will return to it in a moment.)

The other side of the roof was not visible from where I was standing, but its lines would tend *down* toward vanishing points below the horizon. Line w is an example. Because the roof is symmetrical, lines parallel to w will vanish at a point D that is exactly as far beneath A as C is above A.

Over on the other side of the house, roof lines like z will vanish upward to point E; and lines on the farther side, like v, will vanish downward to the point F.

There are also some planes in this house that are like plane of the right-hand roof (the one with the ladder) but not quite as steep. One such is the roof of the small addition to the left of the porch. Its horizontal lines will vanish at point B, but its most vertical lines, like the right-hand cornice, will vanish on the line DAC, somewhere above the horizon and below the point C. And then there's the lower ladder: it also forms a plane, the steepest one of all. Its horizontal lines—the ladder's rungs—will vanish at point B, but its sides will vanish very high, somewhere up above point C.

Once you have studied a house and found the principal vanishing points, then you might try to visualize the vanishing *lines* that go with them. If you turn Figure 13.3 on its side—so the right side is up—the line m makes a perfect horizon, and the dashed lines leading to A and C are like railroad tracks. The windows on the right side of the house even provide some railroad ties. The same is true in more obscure cases. The roof on the right (the one with the higher ladder resting against it) has the vanishing line BC. If you picture the surface of the roof and its vanishing line, and mentally erase everything else in the scene, you will find that you're picturing a new horizon (BC) and that the roof is like a rectangle resting flat on an infinite plain. Then the higher ladder is like another set of railroad tracks, and its rails have to vanish somewhere on that horizon.

Every plane and its vanishing line are like this; it's as if they were originally flat planes (or plains) and were tilted up into position. You can even visualize vanishing lines for planes that are out of sight, like the line BD for the far side of the right-hand roof. I have drawn in several others on the small diagram. After a while, you'll be able

to look at the large photo and picture vanishing lines all around the house. And most important, the planes aren't separate: they all fit together like one of those folding paper toys that flex back and forth, revealing numbers or fortunes.

Perspective is dry—no doubt about it—but once you understand these principles, you will start to see things in a very different way. The visible sides and roofs of every house will become parts of infinite, invisible planes; and all the planes will intersect in vanishing lines. Every ordinary house will reveal itself as part of a larger structure, and you will be able to picture and sense the planes and points that define the structure. It's an interesting feeling; perspective is very exact and rational but it divides the world into geometric shapes so complex and unmoving that it can be claustrophobic and exhausting. Of all the kinds of seeing in this book, this is the one that gives me the least pleasure. I have thought about perspective for over a decade and I no longer want to see the lines. There is pleasure in the learning and in the first discoveries of how the planes interact. The first time I stood in front of a house and imagined all the lines in place, I was astonished. But perspective is also unremitting and it makes the world clearer and more obvious than I like it to be.

14

how to look at
an alchemical emblem

The most intricate pictures I know are Renaissance allegories and emblems; and among emblems, the most involved are those made by alchemists. They are a good example of just how dense with meaning an image can get. Even though the contemporary world is full of images, they tend to be easy to read. *Speed* is a common goal among graphic designers; the graphs and charts in publications such as *US News and World Report* and *Time* magazine are well known for their unsurpassable clarity. In business meetings, people use simple pictures, pie charts, and animations to grab the attention of jaded clients; advertisements and music videos are even simpler—they're meant to be gulped down a dozen at a time. Whole books, like Edward Tufte's *Envisioning Information,* show how to make images that require a minimum of effort on the viewer's part. It's increasingly rare to find complex images that need to be studied or pondered instead of just seen all at once and discarded. That is a pity—it's an impoverishment of our visual culture—because the truly complex images show what images are capable of doing.

figure 14.1

Raphaël Baltens, Mirror of Art and Nature. *1615.*

NATVR

KVNST

Cabala vnd die Alchymei,
Geben dir die hoechste artney.
Darzu auch den weißen Stein,
In dem das fundament allein
Ligt, wie fur augen zu sehn ist,
In disen figuren zu der frist.

Ach Gott hilf das wir danckbar sei,
Fur diese Gab so hoch vnd rein.
Wem du nun auf thuts hertz vnd sin,
Der da volkomen ist hierin.
Zu bereitten hie dises werck,
Dem sey gegeben alle Sterck.

PRI MAT MATE RIA

VLTI MAT IMATERIA

G

A

O

HEISS

TRVCKEN

V T R I
ZOT
L

KALT

FEVCHT

T

FEVER . PHILOSOPHIAE . ERDT.
SVLPHVR
VIRTVTES . ASTRONOMIAE.
ANTIMONIVM
WISMATT.
ALCHIMA . WASSER
LVFFT . VITRIOL

T

Raphael Custodis sculpsit.

Stephan Michelspacher Ex.

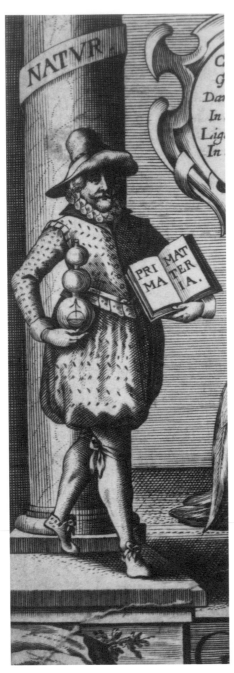

figure 14.2

Detail.

In alchemy the most important things are secret, so "hermetic" learning is very highly valued; but at the same time the secrets are somehow fragile, as if they would melt away if they were exposed to the open air. The trick, for an alchemist, is to hint at the secrets without giving too much away. But the strategy hardly ever works—either the esoteric meaning stays too securely hidden, so nothing makes sense, or it leaks out of the exoteric (plain) meaning, revealing too much and losing its hidden power.

These possibilities are given compelling play in a picture by the seventeenth-century Tirolean alchemist who calls himself Steffan Müschelspacher. The picture is one of four, and it is titled "1. Mirror of Art and Nature" (Fig. 14.1). The author says only that it represents three alchemical processes, and it might—at the bottom, one alchemist watches a still and another peers into an oven. Between them is a container ringed around with an odd fire that is half symbolic and half real. But most of the plate is devoted to other things, and it is typical of an esoterically minded author to leave so much unexplained. As readers, we are supposed to meditate on the picture until we come to our own understanding.

At the top a man who represents Nature holds a book inscribed "PRIMAT MATERIA" (Fig. 14.2), which is the "first substance" from which alchemists began their work. Opposite him is a man representing Art (the banner above him says "KUNST," meaning art), holding a book opened to the words "ULTIMAT MATERIA" (Fig. 14.3), the "final substance," or the goal of the alchemist's labors. The figure of Nature has a tripartite vessel inscribed with a sign that stands for the first substance, and the figure of Art has a vessel called a "pelican," with the same sign upside down, this time standing

for the final substance. (The "pelican" was a vessel with hollow handles. Whatever was inside boiled up and then ran down the handles and back to the bottom. It was named after a medieval story about pelicans, which held that they fed their young by piercing their own breasts and letting their chicks drink their blood. In alchemy, that kind of circulation was thought to make things more pure and powerful.)

Between them are an eagle and a lion, symbols of the alchemical substances mercury and sulfur, and in the middle is a bizarre object that looks like a piece of surrealist furniture. It is a hermetic coat of arms, a kind of dishevelled heraldic device that stands for Müschelspacher's family and for alchemy itself. In a normal coat of arms the shield is topped by a helmet, and the helmet or "helm" is topped by a crown or a ring (called a "torc"), ribbons (called "mantling"), and a crest. There are often animals on either side, supporting the shield. Here the animals have stepped back, and the shield has toppled.

Some parts of this coat of arms are fairly ordinary. The torc is often a crown, and the helmet is exactly right. But the crest is an outlandish combination of a striped Phrygian cap (so named after an ancient Greek hat) and outspread wings painted with black and white circles.

The shield itself is quartered, which is common enough, but its quadrants have unusual decorations. Alchemists were fascinated with things that came in pairs, threes, and fours, and the shield might express that by its four quarters, its sets of three circles, and its two "yin-yang" quadrants. We should probably imagine the circles in color, in which case they would denote the three alchemical colors, black, white,

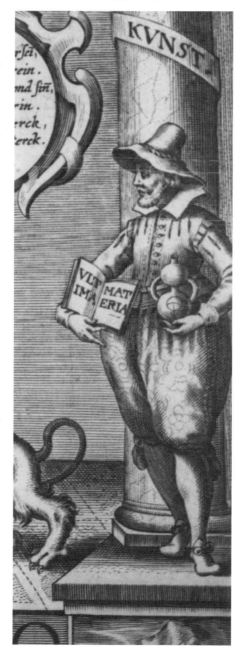

figure 14.3

Detail.

and red. All these things are clues to the alchemical process, which Müschelspacher's readers would have been trying to divine. On an ordinary coat of arms the shield gives information about the person's family, but here the subject is alchemy, and so the shield implies that the final substance, the Philosopher's Stone, is "born" from pairs of opposites and from groups of three and four. It might even be the case that the "yin-yang" quadrants are intended to look like fluids mixing.

It is not easy to know what Müschelspacher's readers would have made of the entire assemblage. It looks a little like the altar of some secret society, with the shield as altar table, the mantling as dossal, and the helm, torc, and crest as sacred objects. It might also have looked like a kind of puzzle, in which the alchemical secrets have been camouflaged as a coat of arms. To a serious alchemist, the crest at the top might well have been reminiscent of the outspread wings of a phoenix, one of the alchemists' favorite symbols. (They were interested in phoenixes because these birds were reborn from their own ashes, just as the alchemists' substances were often resurrected from the charred remnants of previous experiments. It was also thought that the true Philosopher's Stone could not be made without killing and resurrecting it to make the true Stone.)

The top panel is also a kind of rebus, because it can be read, left to right, as a story that reveals the alchemical process: beginning on the left with the first substance, and ending on the right with the final substance. The trick is to come to an understanding of what happens in between. (The two poems don't help much, since they tell the reader that the answer is "plain, right in front of your eyes.")

These mystical emblems can get dizzying. Everything is a clue and nothing is meaningless: even the floor in this top panel is symbolic, because its alternating circles and squares would have reminded some readers of the famous problem of squaring the circle. Ever since the Greeks, people had been trying, starting with a circle, to figure out how to draw a square with equal area. It was the same fascinating, impossible quest as the Philosopher's Stone. Pictures like this are also dizzying because you can never be sure what *kind* of picture you are looking at. Is this top panel a picture of someone's house? Is it a story in pictures? The central motif is clearly related to a coat of arms, but in a sense the whole panel is one big coat of arms, because the two men are like extra supporters. It almost looks as though they might step up and stand alongside the eagle and lion.

The middle panel (Fig. 14.4) is every bit as complicated, but this time Müschelspacher is playing with what are called microcosmic-macrocosmic schemata instead of coats of arms. The two "hieroglyphs," as he would have called them, are also a single diagram, since they are bound by a common frame. The large

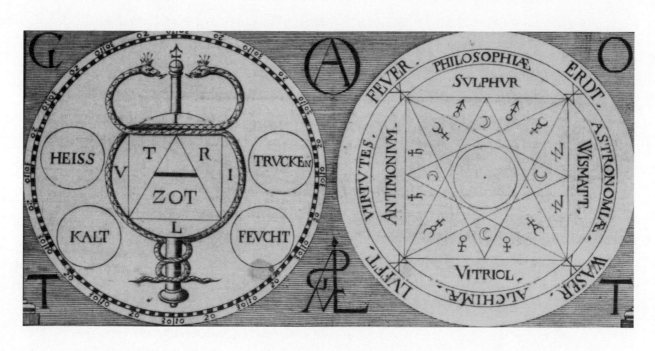

figure 14.4

Detail.

"hieroglyph" on the left spells "VITRIOL," an acronym for a Latin sentence that means "Visit the interior of the earth, and by rectifying, you will find the occult stone" ("Visita interiora terra, rectificando, invenies occultum lapidem"). On the far left and right, alchemists dutifully set to work finding their raw materials. When the letters VITRIOL are scattered, it is known as the "vitriol acrostic"—yet another puzzle for the uninitiated. The vitriol acrostic is surrounded by a caduceus, which is the symbol of Hermes, the traditional patron deity of alchemists. The two snakes are crowned king and queen, another traditional alchemical dualism and an echo of the idea that Hermes himself was secretly hermaphroditic. The center also spells "AZOT," the name of the elusive universal solvent; and the large "A" recalls the Greek signs for "fire" (a triangle with the crossbar) and "air" (the same, without the crossbar). The center ring of snakes has a circle, a triangle, and a square, images of one-, two-, three-, and fourfoldness. "VITRIOL" is encompassed by the circle, and "AZOT" is bounded by the square, echoing the idea of sequence from square to circle, from fourfoldness to unity. At the top is the small symbol that also appears in the vessel held by Nature, this time with an extra bar signifying another substance known as the "crocus of Mars."

The right-hand "hieroglyph" is a fusion of four kinds of diagrams. First it is a map or compass, since it has markings and a round border. Then it is a cosmic chart, like a map of the solar system, because it has concentric circles orbiting a central dot. It is also like an astrological chart, at least the kind that was cast in those days, which was square with lines crisscrossing the middle. The little symbols scattered around the middle are the signs of planets. And the "hieroglyph" is a diagram of the Greek elements, which are named around the outside. (The Greek "qualities," which accompanied the Greek elements, are named in the adjacent "hieroglyph." They are hot, dry, cold, and moist, "HEISS," "TRVCKEN," "KALT," and "FEVCHT.")

All this may seem excessive, but it only scratches the surface. Much more could be said about these diagrams, relations to the other parts of the picture, and about this picture's relation to the three that follow it in the book. But this is enough to show how these things work. After you learn a few symbols, you can find your own way. Mystical and alchemical emblems pull all sorts of images together, and they can achieve an amazing density of meanings. Even in this brief tour I have mentioned symbols and signs, diagrams, "hieroglyphs," heraldry, microcosmic-macrocosmic schemata, acrostics, maps, compasses, cosmic charts, and horoscopes. People who are drawn to images like this one love the subtle play of half-glimpsed meanings.

People who are repelled by them prefer their information to be straightforward, with no hedging. Either way, these are among the most intricate pictures ever produced—the exact opposite of a graph in *Time* magazine.

how to look at
special effects

Movies are full of special effects, and so are television shows and advertisements. Some are easy to spot, and others are seamless and elusive. People who are involved in images and in digital manipulation notice special effects that most of us don't; to them, movies and advertisements are more like puzzles or diagrams, full of telltale signs of how they were made. I notice most special effects and as a result, I'm not usually taken in by horror movies, dinosaur epics, or space operas. But increasingly the effects are so elaborate and sophisticated that I can't tell how they were done. The movie *Titanic* was a turning point for me, because it was the first time I saw effects I couldn't explain. Partly that was because the effects were so elaborate. In one sequence an entire digitized, animated ocean, with real dolphins splashing in it, was pasted onto a life-size model of half of the *Titanic*, superimposed against a real-life sky. When that much money is poured into a scene, it becomes nearly impossible to tell real life from fiction. (At the same time, I could tell *something* wasn't right, because the scenes had the over-ripe glow of a Maxfield Parrish poster.)

Simpler effects are easier to spot, and once you know something about how they are made, you will see movies and advertisements with a different eye. In this chapter I've chosen just one kind of special effect: the software that is used to build impossible landscapes—prehistoric swamps, spiky mountains, scenes on other planets. Invented landscapes are ubiquitous in television advertisements, science fiction movies, video arcade games, computer games, and magazine advertisements. Sometimes the landscapes are really collages assembled from several different real landscapes and "sewn to-

gether" in the computer. If there's a car ad in a magazine with an impossibly lovely chain of mountains or a huge waterfall next to the ocean, chances are it's digitally manipulated, and the car was actually in someone's parking lot. Cigarette and beer ads also use collaged landscapes. The way to spot a fake collaged landscape is to look for signs of the *size* of the landscape—trees, boulders, paths—and notice, as you look farther into the distance, that the scale suddenly changes. In one recent ad, a car perches on a mountaintop, and a road snakes back and down into an endless idyllic landscape. It all looks right, and even breathtaking, until you follow the road; one turn has trees on either side, and then the very next turn has boulders the size of houses, and then, farther on, the same trees, but this time gigantic—and so on. The weirdnesses are the result of patching together different photos and reusing the same photo for parts of the road that are nearer or farther away. Normally the graphics design people in the ad agencies will have corrected for lighting and color, but they tend to overlook scale differences because they are so hard to fix. (That is, they are hard to fix unless you just go ahead and *paint* the entire landscape, the way that artists did in past centuries when they wanted imaginary landscapes. Unfortunately today the art of illusionistic landscape painting is largely forgotten.)

There is another kind of digitized landscape that I find even more interesting, and that is landscapes made from scratch in the computer. The software draws the mountains, the sky, and the ocean, and even puts in houses and trees. Nothing is taken from photographs and nothing is painted by hand. Those entirely digital landscapes can also be found in places such as computer games and magazine ads, and also in magazines such as *Scientific American* and *National Geographic,* in which computers are used to simulate Earth as it existed in the distant past or to generate a panorama of some other planet.

The software that produces such images is getting more sophisticated each year, partly as a result of better programming and improved processor speed, and also because of the increasing visual and artistic skills of some programmers. Digital landscapes that aren't so well made tend to look kitschy, with green moons and magenta skies; that is not because the software is limited, but because the programmers and users are not trained artists, and have not studied naturalistic phenomena or the history of naturalistic art.

The misty landscape in Figure 15.1 was made with a few clicks of the mouse. One click generates the wireframe mountain shown in Figure 15.2, and then the user tells the computer what colors should cover the wireframe to make the appearance of a solid mountain. The mountain is created using "fractal geometry," which means that one click can generate a reasonable-looking crumpled mountain. If the shape is too spiky, the user can change it in various ways; in the program I used to make these pictures, it

is possible to "erode" a mountain into a hill, or give it cliffs, or make it spiky and high. The fractal routines in the software mimic the results of actual erosion or geologic uplift. When I am satisfied with the shape of the mountain, I can choose the colors to go over it, and those too can be modified in a number of ways. The color that covers this mountain is actually a composite of three elements: a set of horizontal brown stripes, a set of whitish streaks, and a "bump map." The grainy texture of the mountain is the result of hundreds of tiny bumps that are added to the smooth wireframe, following a pattern that can be modified in the software.

Another click of the mouse creates an infinite flat plane, which appears in the wireframe, Figure 15.2, as a checkerboard pavement. (The computer draws only part of it, but it actually extends to the horizon, which is the blue line.) Textures can be assigned to the flat plane, and I chose a strange texture that the makers of the software call "oily bronze." (It is typical of the science fiction feel of so much computer graphics.) The next step would be to lower the mountain onto the plane, but I have left it hovering in order to show that the "oily bronze" is really only a flat coat of paint, and not the

figure 15.1

Digital landscape of a mountain.

figure 15.2

Wireframe model of Figure 15.1.

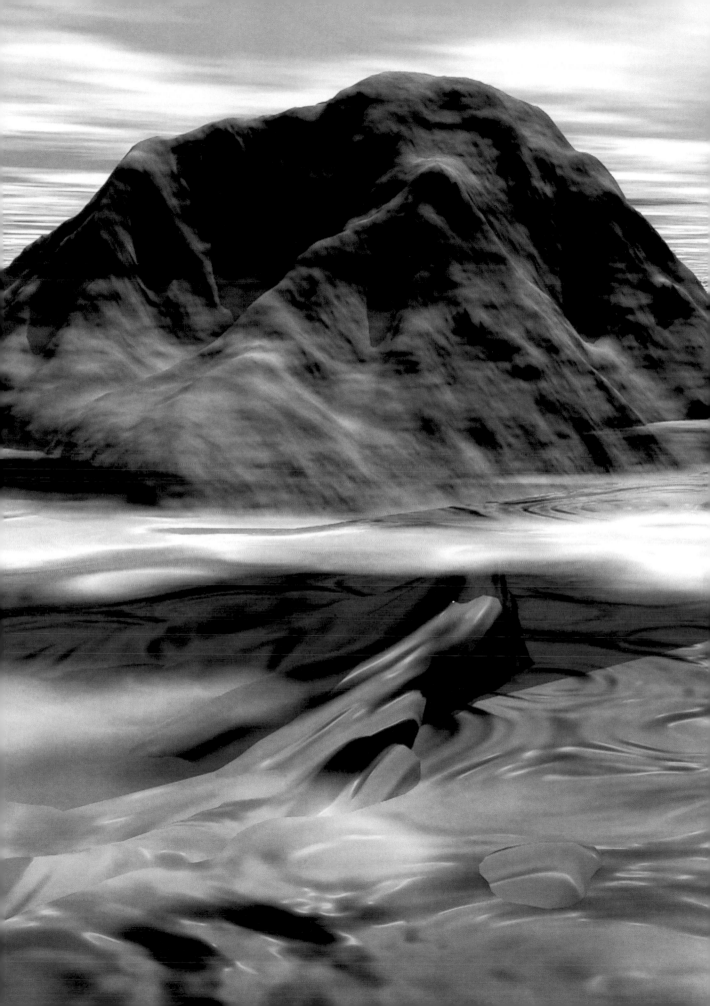

swirling morass it seems to be. If you look at the shadow cast by the mountain on the right side of Figure 15.1, you'll see it is a perfectly straight line. The infinite plane is flat, even though the shading makes it look three-dimensional.

Just under the mountain I have created a set of hills, which are painted in the same oily bronze pattern. They actually continue beneath the infinite plane, but I have brought them up so that some protrude above the plane like islands. By carefully comparing the wireframe with the painting, you can see the outline of the hills and how they cast shadows onto the infinite plane. The hills and the plane are nearly seamless, and unless you knew what to look for, you wouldn't guess that most of the plane is flat.

Atmosphere is also easy to create in these programs. In this picture I've created a cloudy sky and set the sun about overhead so it would cast visible shadows. Users can manipulate the color of the sky, the colors of the clouds, their density, and their frequency. The clouds look reasonably like normal cirrus or stratus clouds, but as far as the computer is concerned they are infinitely high: no plane or spaceship could ever fly through them. For that reason they do not cast shadows on the ground, and they do not show up in the wireframe diagram.

figure 15.3

Digital landscape of hills and a lake.

figure 15.4

Wireframe model of Figure 15.3.

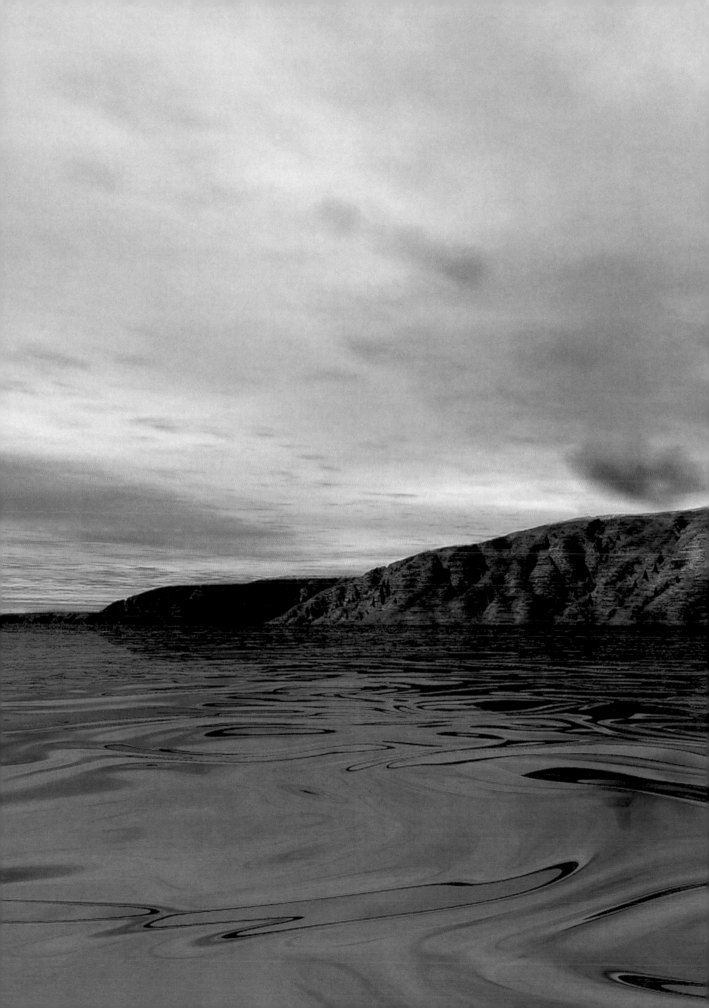

It is also possible to create horizontal planes and various heights and "color" them with clouds, as if they were sheets of glass with clouds painted on them. I put one such plane in this picture, a little above the base of the mountain. Notice the cloud near the bottom of the mountain, on the right: it intersects the mountain along a nearly straight line, despite the fact that the mountain has a bumpy texture; that is because the cloud plane recognizes only the fractal wireframe, and not the "bump map" that gives the mountain its rocky feel.

This landscape is fairly unrealistic, like the fantastic landscapes in some video games. More realistic landscapes can be more difficult to spot (Fig. 15.3). The hills in this scene were built from several different fractal mountains, which were eroded to make them smoother and lower. The wireframe, Figure 15.4, shows that there are actually three different hills, some with fairly complicated topographies. (The middle hill, for example, has a distant ridge that is just barely visible in the finished picture.) The color and texture of these hills are also more complicated than in the first example, consisting of horizontal bands of tan and brown mixed with green and superimposed on a system of vertical lines that look like gullies and cliffs, superimposed on a bump map. The actual surface of the hills is fairly smooth, as the wireframe shows— all the shadows and sharp contours are added illusionistically in the paint.

The sky is also more complex. It has an infinitely distant plane of clouds, like the first example; that plane contributes the large white cloud masses. Then I added a cloud plane a little above the level of the hills, visible in the wireframe as a floating checkerboard. It contributes the larger gray clouds and the speckled clouds in the distance. And there is also a third kind of cloud, which is created as a wireframe balloon (there are two of them in the wireframe). These balloons can be filled with clouds—either dense, cartoony clouds, or very subtle puffs of smoke. The smaller purple cloud in the wireframe resulted in the round gray cloud that hovers just above the hill on the right. (The purple is just a random color assigned so that the wireframe is easier to read.) The larger reddish wireframe produced the much subtler little gray clouds that tend diagonally upward.

The water in this picture is just another painted infinite plane. All these substances— water, clouds, rock—can be adjusted to very exacting criteria. The user controls the amount of reflection, the frequency and height of the ripples, the color of the glints and gleams of the water, the color of the depth of the water, the water's opacity, and so forth.

This is a fairly simple example, and it is easy to see how complex skies, landscapes, and water can get. Even so, it has proved very difficult for programmers to approximate the intricacy of even an average scene in nature. Several telltale signs give this away as a digital landscape. First, the water is not quite liquid. It still looks a bit viscous and a little too opaque. But with some tweaking, it could be nearly perfect. It would be

more difficult to mimic the normal wave patterns of a lake, where long-frequency waves from one direction often intersect shorter-frequency waves from another direction. Those things are not beyond the mathematics of such programs, but they would require special programming. There is also a problem where the water meets the land, because the shoreline is almost perfectly straight. In real life we are very sensitive to such boundaries, and we would always pick out little spots of color and changes of contour. The computer just draws the intersection between the perfectly flat "water" and the very smooth wireframe hill. (Not the textured hill, but the smooth hill that it is built upon.) Also, the right-hand hill has a suspiciously *even* texture throughout. The V-shaped gullies on the left look too much like the larger V-shaped gullies on the right. That is a typical failing of fractal landscapes—within any given landform, the colors and textures obey uniform patterns. The programmers have tried to get around that by making colors that are sensitive to height (they change as the altitude increases) and to slope (so that white "snow" can gather in crevices and hilltops and naturally "fall off" steeper slopes). This is such a color, but it is still too uniform. It works best when it is obscured by distance, as it is in the farther hills.

To get around this problem, graphic designers have to make each part of the hill a separate object, so it can be colored distinctly from the forms around it. In close-ups, the designers have to make dozens of rocks, each different from every other. Even then, the temptation is to make one rock, then copy it exactly to make the next rock. The user can shrink the rock, or distort it, or "erode" it, or rotate it in any direction, but it will still look like a copy of the first rock. Digital landscapes in magazines such as *Scientific American* and *National Geographic* have this kind of fault—the landscape looks as though it was cloned from itself.

The sky is the best part of this picture, but it also has two faults that are typical of these programs: the little round cloud is just a little *too* round, as if it were part of a smoke signal; and the clouds in the distance line up a little too neatly into straight lines. That last problem occurs because the computer is basically drawing an infinite plane that is "colored" with clouds in a certain pattern. If the pattern has stripes, they will become very evident with increasing distance.

So here are five telltale signs you can use to spot digital landscapes in movies and advertising:

1. Water is too regular—all the waves move in one direction.
2. Water and land intersect along straight lines or perfect curves.
3. Water, land, and sky have even, repetitive patterns.
4. Rocks or hills look as though they were cloned from each other.
5. Sky looks as though it was painted on a huge, flat pane of glass.

The more expensive the production values, the better the landscapes will look, but there is still the limitation of the designers' and programmers' skills in observing the natural world. The best programs and the best designers are either amateur naturalists or naturalistic painters. These pictures are purely digitized, but I could have taken them into a photo manipulation program and "retouched" them by painting or by pasting in photographs. With a little painting, a picture like Figure 15.3 can suddenly look much more like a photograph—and of course it would also be possible just to paste in a photograph and blend it to fit in with its fractal surroundings.

If you had just opened this book at random, would you have said Figure 15.5 is a photograph? I doctored it in a photo manipulation program to show how it is possible to get nearly photographic realism from an entirely computer-generated image. This version has higher contrast and a different color balance to simulate the effect of a typical snapshot taken without a sky filter. The image is cropped to avoid the worst of the "oily" water and most of the repetitious green-and-ochre cliff. I doctored the part of the right-hand cliff that remains to get rid of the overly regular stripes. I also added some very small irregularities to the shoreline, so that the water does not meet the land along a perfectly straight line. The skyline has some new details: a puff of smoke on the distant hill, and a high escarpment on the horizon at the right. For realism's sake, it is important not to make shapes like those too big. We are used to seeing little anomalies in real landscapes: we hardly pay any attention to them, but they contribute to our sense of reality. If I had made a whole new hill or a big column of smoke, the image would once again have looked artificial.

The water itself was the hardest part; here it is improved somewhat by several distorting operations called "shear," "wind," and "blur." A slightly higher contrast helps the water look more watery and less greasy. But even photographs of real water are odd to look at, and the longer you look, the more unnatural they appear; the best strategy seems to be to make water that does not draw attention to itself. Figure 15.5 is an improvement, but still there are clues that it is digital—especially the water along the lower left margin, which is entirely made of horizontal stripes. Still, when I have shown it to people without comment, they have taken it to be an ordinary photo. The "realism"— the affinity to a snapshot—isn't perfect, because the original software was designed with

figure 15.5

Version of Figure 15.3, manipulated to resemble a photograph.

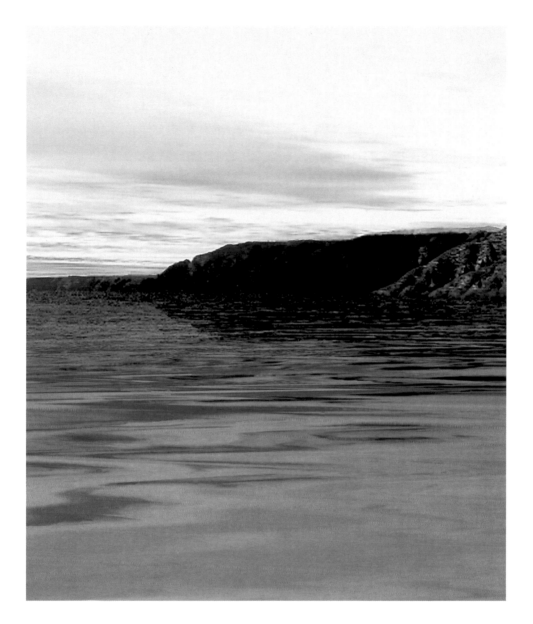

a certain aesthetic in mind—the person who wrote it is interested in American landscapes of the Hudson River School type and in psychedelic or science fiction effects. But it can be tweaked into different kinds of realism, including snapshot realism.

The first artists who tried to make naturalistic paintings, back in the Renaissance, used the laborious techniques of linear perspective to make their paintings look real. Over the centuries, the techniques have improved, but the art world has turned away from simple naturalism. Most people in my profession of art history are no longer interested in ways to make pictures look real. But the techniques live on in new and more amazing forms, in fractal design software and proprietary special effects packages. The results are all around us—and they have gotten so good that we seldom notice that what we are seeing is actually entirely nonexistent from the first pixel to the last. (There is another digitized landscape in this book, and after looking at these, you should have no trouble spotting it.)

how to look at
the periodic table

The periodic table of the elements that hangs on the wall of every high school chemistry classroom is not the only periodic table. It is the most succesful of its kind, but the elements can be arranged in many different ways, and even now the periodic table has its rivals. In other words, it doesn't represent some fixed truth about the way things are.

The table arranges the chemical elements into periods (the horizontal rows) and groups (the vertical rows). If you read it left to right, top to bottom, as if it were a page of writing, you will encounter the elements in order from the lightest to the heaviest. The top left number in each cell is the element's atomic number, which is the number of protons in its nucleus and also the number of electrons that orbit the nucleus. If you read any one column from top to bottom, you will encounter elements that have similar chemical properties.

Figure 16.1 is a version of Dmitri Ivanovich Mendeleev's periodic table, the one that has become the standard. It serves many purposes well, but it is also full of drawbacks. Just looking at it, you can see that it has an unsatisfying lack of symmetry. There is a big gap at the top, as if a chunk had been taken out of it. And at the

figure 16.1

The periodic table.

Periodensystem der Elemente

de Gruyter Naturwissenschaften
Genthiner Str. 13 · D-10785 Berlin
Telefon: (030) 2 60 05-176

Legende (Beispiel):

Protonenzahl (Ordnungszahl)	25	Relative Atommasse[1]	54,94
Elektronegativität (nach Allred u. Rochow)	1,6	Symbol[2]	**Mn**
Siedetemperatur in °C	2032	Name	Mangan
Schmelztemperatur in °C	1244	Elektronenkonfiguration	$[Ar]3d^5 4s^2$

[1] Der eingeklammerte Wert bei radioaktiven Elementen ist die Nukleonenzahl (Massenzahl) des Isotops mit der längsten Halbwertszeit

[2] rot: gasförmig — grün: flüssig — schwarz: fest bei STP ($\triangleq 0\,°C$ und $1{,}0\,bar$)
licht: alle Isotope radioaktiv

Für die Elemente 104 und 105 sind die folgenden Namen und Symbole vorgeschlagen worden: Rutherfordium Rf (nach Ernest Rutherford) und Hahnium Ha (nach Otto Hahn). Für die Elemente 107 – 109 sind die folgenden Namen und Symbole vorgeschlagen worden: Nielsbohrium Ns (nach Niels Bohr), Hassium Hs (nach Hessen; lat. Hassia) und Meitnerium Mt (nach Lise Meitner); eine Bestätigung durch die IUPAC steht noch aus.

Hauptgruppen und Nebengruppen

Z	EN	Siedetemp. °C	Schmelztemp. °C	Rel. Atommasse	Symbol	Name	Elektronenkonfiguration
1	2,2	-252,9	-259,1	1,008	H	Wasserstoff	$1s^1$
2		-268,9	-272,2	4,003	He	Helium	$1s^2$
3	1,0	1347	180,5	6,941	Li	Lithium	$[He]2s^1$
4	1,5	2970	1278	9,012	Be	Beryllium	$[He]2s^2$
5	2,0	3660	2300	10,81	B	Bor	$[He]2s^2 2p^1$
6	2,5	4827	3550	12,011	C	Kohlenstoff	$[He]2s^2 2p^2$
7	3,1	-195,8	-209,9	14,007	N	Stickstoff	$[He]2s^2 2p^3$
8	3,5	-183,0	-218,4	15,999	O	Sauerstoff	$[He]2s^2 2p^4$
9	4,1	-188,1	-219,6	18,998	F	Fluor	$[He]2s^2 2p^5$
10		-246,1	-248,7	20,180	Ne	Neon	$[He]2s^2 2p^6$
11	1,0	883	97,8	22,990	Na	Natrium	$[Ne]3s^1$
12	1,2	1107	651	24,305	Mg	Magnesium	$[Ne]3s^2$
13	1,5	2467	660,4	26,982	Al	Aluminium	$[Ne]3s^2 3p^1$
14	1,7	2355	1410	28,086	Si	Silicium	$[Ne]3s^2 3p^2$
15	2,1	280(P₄)	44(P₄)	30,974	P	Phosphor	$[Ne]3s^2 3p^3$
16	2,4	444	114,6	32,07	S	Schwefel	$[Ne]3s^2 3p^4$
17	2,8	-34,6	-101,0	35,453	Cl	Chlor	$[Ne]3s^2 3p^5$
18		-185,7	-189,2	39,948	Ar	Argon	$[Ne]3s^2 3p^6$
19	0,9	774	63,7	39,10	K	Kalium	$[Ar]4s^1$
20	1,0	1487	845	40,08	Ca	Calcium	$[Ar]4s^2$
21	1,3	2832	1539	44,96	Sc	Scandium	$[Ar]3d^1 4s^2$
22	1,3	3260	1675	47,88	Ti	Titan	$[Ar]3d^2 4s^2$
23	1,5	3380	1890	50,94	V	Vanadium	$[Ar]3d^3 4s^2$
24	1,6	2672	1857	52,00	Cr	Chrom	$[Ar]3d^5 4s^1$
25	1,6	2032	1244	54,94	Mn	Mangan	$[Ar]3d^5 4s^2$
26	1,6	2750	1535	55,85	Fe	Eisen	$[Ar]3d^6 4s^2$
27	1,7	2870	1495	58,93	Co	Cobalt	$[Ar]3d^7 4s^2$
28	1,8	2732	1453	58,69	Ni	Nickel	$[Ar]3d^8 4s^2$
29	1,8	2595	1083	63,55	Cu	Kupfer	$[Ar]3d^{10} 4s^1$
30	1,7	907	419,6	65,38	Zn	Zink	$[Ar]3d^{10} 4s^2$
31	1,8	2403	29,8	69,72	Ga	Gallium	$[Ar]3d^{10} 4s^2 4p^1$
32	2,0	2830	937,4	72,61	Ge	Germanium	$[Ar]3d^{10} 4s^2 4p^2$
33	2,2	subl.		74,92	As	Arsen	$[Ar]3d^{10} 4s^2 4p^3$
34	2,5	685	217	78,96	Se	Selen	$[Ar]3d^{10} 4s^2 4p^4$
35	2,7	58,8	-7,2	79,90	Br	Brom	$[Ar]3d^{10} 4s^2 4p^5$
36		-152,3	-156,6	83,80	Kr	Krypton	$[Ar]3d^{10} 4s^2 4p^6$
37	0,9	688	38,9	85,47	Rb	Rubidium	$[Kr]5s^1$
38	1,0	1384	769	87,62	Sr	Strontium	$[Kr]5s^2$
39	1,2	3337	1523	88,91	Y	Yttrium	$[Kr]4d^1 5s^2$
40	1,2	4377	1852	91,22	Zr	Zirconium	$[Kr]4d^2 5s^2$
41	1,2	4927	2468	92,91	Nb	Niob	$[Kr]4d^4 5s^1$
42	1,4	4825	2610	95,94	Mo	Molybdän	$[Kr]4d^5 5s^1$
43	1,4	4880	2200	(98)	Tc	Technetium	$[Kr]4d^5 5s^2$
44	1,4	3900	2310	101,07	Ru	Ruthenium	$[Kr]4d^7 5s^1$
45	1,4	3730	1966	102,91	Rh	Rhodium	$[Kr]4d^8 5s^1$
46	1,4	3140	1552	106,4	Pd	Palladium	$[Kr]4d^{10}$
47	1,4	2212	962	107,87	Ag	Silber	$[Kr]4d^{10} 5s^1$
48	1,5	765	320,9	112,41	Cd	Cadmium	$[Kr]4d^{10} 5s^2$
49	1,5	2080	156,6	114,82	In	Indium	$[Kr]4d^{10} 5s^2 5p^1$
50	1,7	2270	231,9	118,71	Sn	Zinn	$[Kr]4d^{10} 5s^2 5p^2$
51	1,8	1635	630,7	121,76	Sb	Antimon	$[Kr]4d^{10} 5s^2 5p^3$
52	2,0	990	449,5	127,60	Te	Tellur	$[Kr]4d^{10} 5s^2 5p^4$
53	2,2	184,4	113,5	126,90	I	Iod	$[Kr]4d^{10} 5s^2 5p^5$
54		-107	-111,9	131,29	Xe	Xenon	$[Kr]4d^{10} 5s^2 5p^6$
55	0,9	678	28,5	132,91	Cs	Caesium	$[Xe]6s^1$
56	1,0	1640	725	137,33	Ba	Barium	$[Xe]6s^2$
57	1,1	3454	920	138,91	La	Lanthan	$[Xe]5d^1 6s^2$
72	1,2	5200	2230	178,49	Hf	Hafnium	$[Xe]4f^{14} 5d^2 6s^2$
73	1,3	≈5430	2996	180,95	Ta	Tantal	$[Xe]4f^{14} 5d^3 6s^2$
74	1,4	5657	3410	183,84	W	Wolfram	$[Xe]4f^{14} 5d^4 6s^2$
75	1,5	≈5630	3180	186,2	Re	Rhenium	$[Xe]4f^{14} 5d^5 6s^2$
76	1,5	≈5030	3045	190,2	Os	Osmium	$[Xe]4f^{14} 5d^6 6s^2$
77	1,6	4130	2410	192,2	Ir	Iridium	$[Xe]4f^{14} 5d^7 6s^2$
78	1,4	≈3830	1772	195,-	Pt	Platin	$[Xe]4f^{14} 5d^9 6s^1$
79	1,4	2810	1064	196,97	Au	Gold	$[Xe]4f^{14} 5d^{10} 6s^1$
80	1,4	356,6	-38,9	200,59	Hg	Quecksilber	$[Xe]4f^{14} 5d^{10} 6s^2$
81	1,4	1457	303,5	204,38	Tl	Thallium	$[Xe]4f^{14} 5d^{10} 6s^2 6p^1$
82	1,6	1740	327,5	207,2	Pb	Blei	$[Xe]4f^{14} 5d^{10} 6s^2 6p^2$
83	1,7	1560	271,3	208,98	Bi	Bismut	$[Xe]4f^{14} 5d^{10} 6s^2 6p^3$
84	1,8	962	254	(209)	Po	Polonium	$[Xe]4f^{14} 5d^{10} 6s^2 6p^4$
85	2,0	340	300	(210)	At	Astat	$[Xe]4f^{14} 5d^{10} 6s^2 6p^5$
86		-61,8	-71,2	(222)	Rn	Radon	$[Xe]4f^{14} 5d^{10} 6s^2 6p^6$
87	0,9	677	26,8	(223)	Fr	Francium	$[Rn]7s^1$
88	1,0	1140	700	(226)	Ra	Radium	$[Rn]7s^2$
89	1,0	3200	1050	(227)	Ac	Actinium	$[Rn]6d^1 7s^2$
104	1,2	-	-	(261)	Rf	Rutherfordium	$[Rn]5f^{14} 6d^2 7s^2$
105		-	-	(262)	Ha	Hahnium	$[Rn]5f^{14} 6d^3 7s^2$
106		-	-	(263)	Sg	Seaborgium	$[Rn]5f^{14} 6d^4 7s^2$
107		-	-	(262)	Ns	Nielsbohrium	$[Rn]5f^{14} 6d^5 7s^2$
108		-	-	(265)	Hs	Hassium	$[Rn]5f^{14} 6d^6 7s^2$
109		-	-	(266)	Mt	Meitnerium	$[Rn]5f^{14} 6d^7 7s^2$

* Lanthanoide

Z	EN	Siedetemp. °C	Schmelztemp. °C	Rel. Atommasse	Symbol	Name	Elektronenkonfiguration
58	1,1	3257	798	140,12	Ce	Cer	$[Xe]4f^1 6s^2$
59	1,1	3512	931	140,91	Pr	Praseodym	$[Xe]4f^3 6s^2$
60	1,1	3127	1010	144,24	Nd	Neodym	$[Xe]4f^4 6s^2$
61	-	2700	1170	(145)	Pm	Promethium	$[Xe]4f^5 6s^2$
62	1,1	1778	1072	150,4	Sm	Samarium	$[Xe]4f^6 6s^2$
63	1,0	1597	822	151,97	Eu	Europium	$[Xe]4f^7 6s^2$
64	1,2	3233	1312	157,25	Gd	Gadolinium	$[Xe]4f^7 5d^1 6s^2$
65	1,2	3041	1360	158,93	Tb	Terbium	$[Xe]4f^9 6s^2$
66	1,2	2335	1409	162,50	Dy	Dysprosium	$[Xe]4f^{10} 6s^2$
67	1,2	2720	1470	164,93	Ho	Holmium	$[Xe]4f^{11} 6s^2$
68	1,2	2510	1522	167,26	Er	Erbium	$[Xe]4f^{12} 6s^2$
69	1,2	1727	1545	168,93	Tm	Thulium	$[Xe]4f^{13} 6s^2$
70	1,1	1193	824	173,04	Yb	Ytterbium	$[Xe]4f^{14} 6s^2$
71	1,1	3315	1656	174,97	Lu	Lutetium	$[Xe]4f^{14} 5d^1 6s^2$

** Actinoide

Z	EN	Siedetemp. °C	Schmelztemp. °C	Rel. Atommasse	Symbol	Name	Elektronenkonfiguration
90	1,1	4790	1750	232,038	Th	Thorium	$[Rn]6d^2 7s^2$
91	1,1	4030	1840	231,036	Pa	Protactinium	$[Rn]5f^2 6d^1 7s^2$
92	1,2	3818	1132	238,023	U	Uran	$[Rn]5f^3 6d^1 7s^2$
93	1,2	3902	640	237	Np	Neptunium	$[Rn]5f^4 6d^1 7s^2$
94	1,2	3200	64	(244)	Pu	Plutonium	$[Rn]5f^6 7s^2$
95	1,2	2610	1000	(243)	Am	Americium	$[Rn]5f^7 7s^2$
96	1,2	-	1340	(247)	Cm	Curium	$[Rn]5f^7 6d^1 7s^2$
97	1,2	-	990	(247)	Bk	Berkelium	$[Rn]5f^9 7s^2$
98	1,2	-	900	(251)	Cf	Californium	$[Rn]5f^{10} 7s^2$
99	1,2	-	-	(252)	Es	Einsteinium	$[Rn]5f^{11} 7s^2$
100	-	-	-	(257)	Fm	Fermium	$[Rn]5f^{12} 7s^2$
101	1,2	-	-	(258)	Md	Mendelevium	$[Rn]5f^{13} 7s^2$
102	-	-	-	(259)	No	Nobelium	$[Rn]5f^{14} 7s^2$
103	-	-	-	(260)	Lr	Lawrencium	$[Rn]5f^{14} 6d^1 7s^2$

Gruppen: Ia · IIa · IIIb · IVb · Vb · VIb · VIIb · VIIIb · Ib · IIb · IIIa · IVa · Va · VIa · VII · VIIIa

Fig. I.1 (continued)

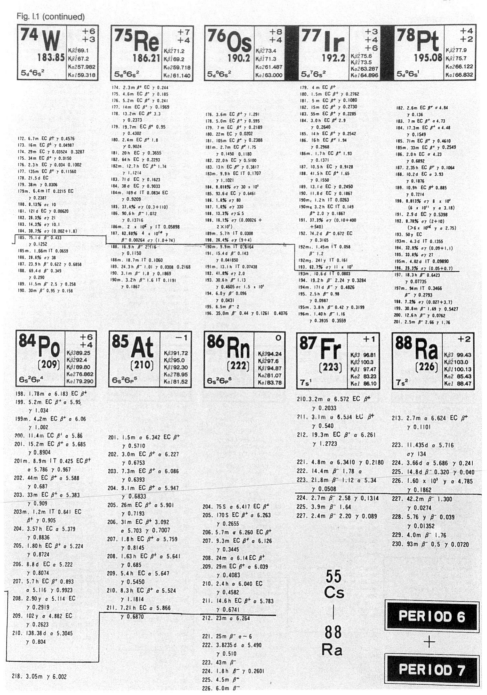

figure 16.2

Detail of a portion of the periodic table.

figure 16.3

J. P. de Limbourg, an affinity table of substances and elements.

bottom there are two extra strips of elements that couldn't be fitted onto the table. They would attach along the thick red line toward the lower left. So really the table is not two-dimensional—rather, it is two-dimensional with a flap attached near the bottom.

From a physicist's point of view, the periodic table is only an approximation. A chemist looks at elements for how they behave in test tubes; a physicist looks at them for what they say about the exact arrangements and energies of the electrons in the atoms. When electrons are added to an atom, they can occupy only certain "shells" (orbits) and certain "subshells" within those shells. (That information is given at the lower right of each cell.) A physicist might say the periodic table should really be separated into three blocks, comprised of the left two columns, the middle ten, and the right-hand six. Then each row would represent a single subshell in an atom, and if you were to read left to right across one row of one of the blocks, you would be seeing electrons added, one by one, to a single subshell.

A tremendous amount of information could potentially be added to this simple arrangement. This table distinguishes elements that are ordinarily solid (printed in black) from those that are liquid (green) and gaseous (red), and it notes which are radioactive (white). Each box has a fair amount of information: the key names atomic number, electronegativity, boiling point, melting point, atomic mass, and electron configuration. Yet if this chart were bigger, it would be possible to add much more. Figure 16.2 is a small section from an expanded periodic table with even more detail.

Before modern chemistry and physics, no one had an inkling of such complexities. The forerunners of the periodic table were "affinity tables" (Fig. 16.3). The idea was to list substances across the top and then group other substances underneath them according to how much "affinity" they had—that is, how easily they would combine. This affinity table by J. P. de Limbourg begins with acids at the upper left and runs through a miscellany of substances, including water (denoted by the inverted triangle ∇), soap (◊), and various metals. Affinity tables have a logic, since any higher symbol will displace any lower one and combine with the substance given at the head of the column. They were criticized by Antoine Laurent Lavoisier for their lack of any real theory, but it has also been said that they were not intended to exposit any single theory.

In the late eighteenth century, there were a growing number of proposals for tables that would capture some underlying theory. People began to want something

figure 16.4

Charles Janet's helicoidal periodic table.

that was rigorously true and could not be shifted and rearranged like the affinity tables. We have settled on a version of Mendeleev's table, but many others continue to be proposed. There are polygonal tables, triangular "scrimshaw" graphs, three-dimensional models, and even old-fashioned-looking schematic trees.

Charles Janet's "helicoidal" classification, proposed in 1928, is a typical elaboration (Fig. 16.4). He imagines the elements all strung together on a single thread. The chain spirals upward as if it were wrapped around a glass tube, and then it leaps to another glass tube, winds around a few more times, and leaps to a third tube. Janet asks us to imagine the three tubes inside one another. At first the helix is confined to the smallest tube, but it spirals out to the middle tube and occasionally the largest tube. The diagram gives the helix in plan, as if the three tubes were squashed flat. Actually, he says, it is very neat because the three imaginary glass tubes all touch on one side (as they would if they were laid on their sides on a table). The problem is that to draw them, he has to cut the chain—hence the confusing dotted lines. In Figure 16.5, the whole thing is spread apart, as if the glass tubes had been removed and the chain were splayed out on a table. That makes it clearer that all the elements are on a single thread wound around three different spools.

It looks odd, but Janet's periodic table has the virtue of being a single piece instead of a stack of blocks like the familiar periodic table. The beginning of Mendeleev's periodic table is at the center of Janet's smallest spool, in Figure 16.4. If you follow the thread, you encounter the elements one after another in the same order as in Mendeleev's table. The middle spool is the middle "block" of the periodic table, separated from the others the way a physicist might do it.

Why don't people adopt schemes like Janet's? Partly from force of habit, because we are all accustomed to Mendeleev's chart. Maybe knots and helices are intrinsically harder for people to imagine. (I certainly have trouble thinking about Janet's helices and trying to picture how they work.) Still, there seems to be an inbuilt notion that something as elemental as the elements should obey some appropriately simple law. It's a hope that animates a great deal of scientific research. The periodic table, in all its incarnations, appears to be a glaring exception to that hope. It seems that when it came to the elements, God created something massively complex and very nearly without any satisfying symmetries at all.

figure 16.5

The same, spread out.

16

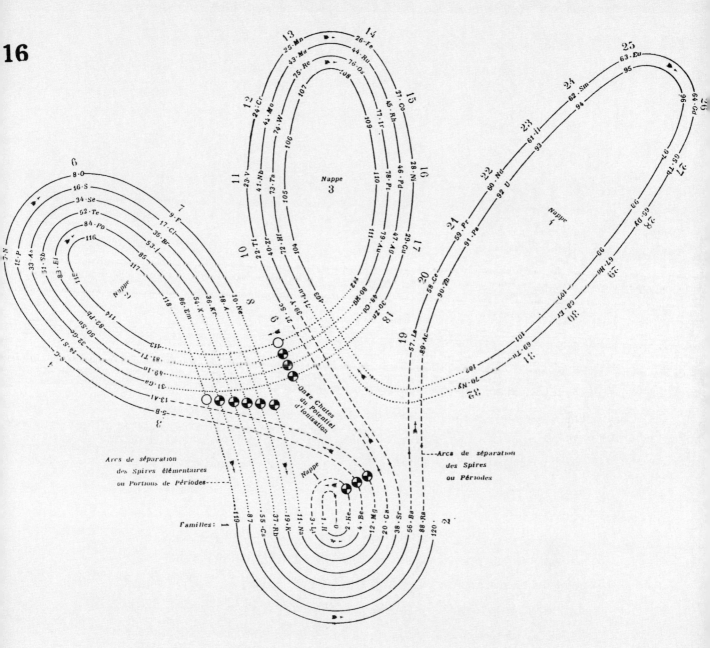

how to look at
a map

Modern maps are rigidly organized according to geometric rules. Latitude and longitude lines are taken care of by mathematical equations and drawn by computer. Even the curving lines of countries, rivers, and roads are put in by computer in unyielding fidelity to the geometric projection. Cartographers choose the projection, but then everything follows the underlying geometry.

Some modern maps try to get away from this tyranny of the geometrical by omitting the grid of lines. Tim Robinson is an English cartographer who has made maps of western Ireland, detailing every fence and pasture but omitting the familiar grid lines. His idea is to encourage people to experience the landscape, and to let each place have its individuality. Some of his maps even have tiny annotations, like little bits of his diary hidden in the landscape. But they are still drawn "to scale" and they obey the tyranny of the invisible grid.

Premodern maps are quite different. They are unconstrained by longitude and latitude, so they have more to say about how people imagined the shape of the world. On the following spread is an example among thousands: a strange map of the world in the shape of a cracked egg (Fig. 17.1). This is a Buddhist map made in nineteenth-century Burma. So it is probably not *your* world, but it was the world—and still is—for many people.

In Buddhist, Jain, and Hindu thinking, the universe is disk-shaped. At the center is Mount Méru, and there are four continents arranged around it like the slices of a pie. This is a map of the Southern Continent, called Jambūdīpa, rounded into an egg.

Jambūdīpa is where all people live. Mostly it is India, but it includes present-day Myanmar (Burma), Pakistan, Bhutan, Nepal, and Tibet. At the very top—which is the center of the universe—is the sacred *jambu* tree, where the Buddha sits, watching the world of men. Below it is a vast area covered by the Himalaya mountains. The map depicts the main features of the Southern Continent as they are described in Pali Buddhist texts: the seven great lakes (represented by little white circles) including Lake Anotatta, with a lotus in its middle, surrounded by four spiraling rivers; and the jewelled Mount Méru, ringed by seven mountain ranges.

The lower portion of the map (Fig. 17.2), below the Himalayas, is the part of the world that the Burmese mapmaker actually knew. It depicts the flood plains of India and Burma, crisscrossed with rivers. Because the person who drew this map was Burmese, the rivers might all be the Irrawaddy, or they could be the Ganges, the Irrawaddy, and other rivers all combined. It seems the mapmaker was not thinking of tracing the course of any single river, as a westerner would do, but rather in showing the *idea* of a land filled with rivers.

In the center of the inhabited land are the Buddhist holy sites, including the Bó tree where the Buddha received enlightenment. At the bottom, the egg cracks into five hundred pieces: the five hundred islands that Buddhists thought were inhabited by inferior peoples who came from across the Samudrá Ocean (the Indian Ocean).

All these features are in Buddhist scriptures, but their arrangement on this map is not orthodox. It is unusual to see Mount Méru off center and the seven lakes scattered around as they would be on some Western topographic map. In earlier Indian maps these features are all perfectly symmetrical like spokes on a wheel. In fact, this entire map was influenced by Western maps. The mapmaker had apparently seen some eighteenth-century European maps, because he (or she) has tried to mimic the Western way of imagining the landscape. The sacred region of the Himalayas is rendered in European fashion as an "aerial view," as if we were looking at it from a great height. The Buddhist holy sites are "quaintly shown," as one writer puts it, "by small red squares and circular patches," as if the Buddha had been born in a small village in France. The mapmaker has even picked up the European custom of marking the map with geometric lines—there is a faint, dashed Equator line and another that might be the Tropic of Cancer, but neither one is where it should be, and it seems the mapmaker was just imitating the practice without understanding it. Strangest of all are the colored divisions of land, which are completely arbitrary; they aren't named and they do not correspond to any real divisions in the Indian subcontinent. There are even dotted boundaries inside the colored regions (and some that overspill them). It seems the mapmaker liked the piebald pattern and didn't realize that it was a way of symbolizing different countries.

figure 17.1

Anonymous, map of the Southern Continent. Burmese. Undated.

The map is a compromise, like any map: it is still an egg, and it still has at least a few of the sacred symmetries. The Buddha's *jambu* tree at the top of the world is directly above his Bó tree, in the middle. But the rest of it is falling apart. The world is literally crumbling under the pressure of the naturalistic European way of thinking about geography. There are even little European-style boats sailing among the five hundred islands.

The history of cartography is full of wonderful images like this one. Each country, each century has its ways of picturing the world. Even National Geographic Society

f i g u r e 1 7 . 2

Detail.

and Rand McNally have their customs and conventions. (Among other things, they both keep north to the top, they both avoid the little pictures this mapmaker likes, and they both adhere rigidly to mathematical grids.)

What if this map of India were your world? What if you looked north and saw an inaccessible, mythical realm of high mountains and spiraling rivers with Buddha at its exact apex? What if you looked south and saw the land itself disintegrating, falling into an endless, unknown ocean?

THINGS MADE BY NATURE

18

how to look at

a shoulder

One of the reasons the living, moving human body is so beautiful is that it shifts and changes and never quite looks the same. A mannekin moves, too, but it always has predictable shapes. Its joints rotate and swivel, but they do not compress or stretch the limbs, and there are no muscles working underneath the skin, continuously altering its shape.

The shoulder joint is especially intricate and very flexible, and when we move our arms around, the muscles on the back are pushed and pulled into a wide variety of shapes. Basic anatomy gives the essential facts that make it possible to see order in the chaos. The rib cage is essentially egg-shaped, and the bone of the upper arm (the humerus) does not connect to it (Fig. 18.1). Instead it fits into a socket on the shoulder blade. The humerus is tied to the shoulder blade by tough connective tissues and by muscles, such as the one that I have numbered 1 in Figure 18.1. The back of the shoulder blade is hollow, and there is a "spine"—a ridge—along the top. The spine goes out over the top of the humerus, where it connects to the collarbones. On Figure 18.1, the collarbones (clavicles) are visible at the very top, curving around to the front of the chest (number 2).

figure 18.1

Skeletal structure of the back, with deep muscles. 1747, lettering added.

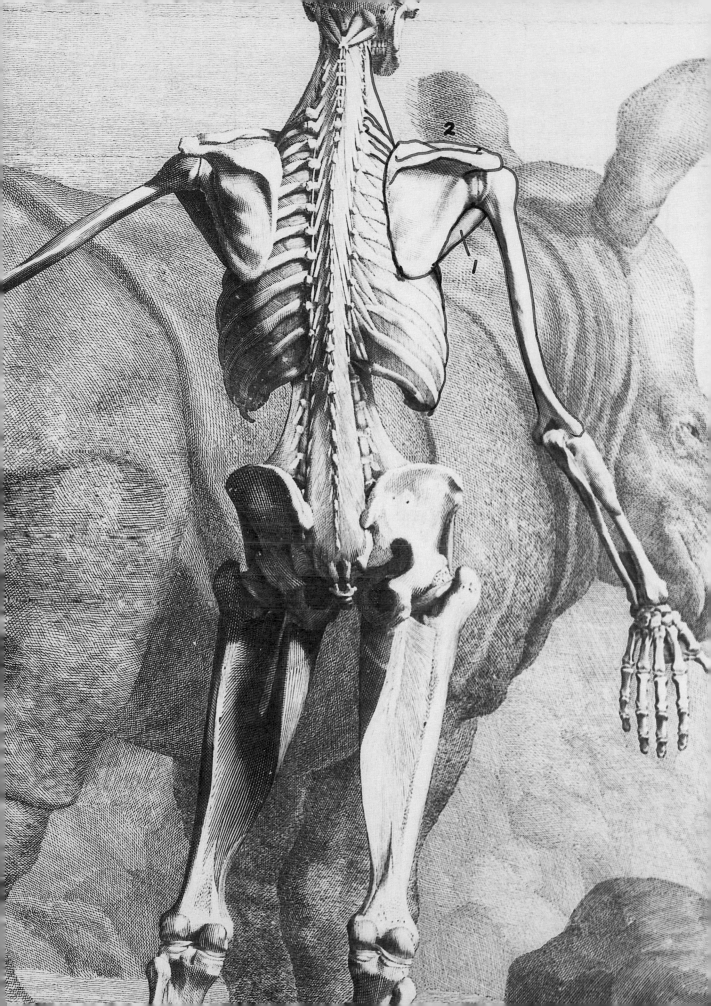

Muscles often come in groups and layers, and Figure 18.2 shows the deeper muscles of the shoulder. They include:

- The serratus anterior (number 3), which binds the bottom of the shoulder blade to the ribs.

- The rhomboids (4), which link the back edge of the shoulder blade to the spine. On a living person, it is often possible to see and count the spines of the vertebrae (5, 6, and 7) to see where the muscles attach.

- Deep neck muscles (8 and 9); some of them pull the shoulder blade up, and others steady and turn the neck.

- Deep back muscles (10), which wrap the rib cage and help straighten and flex the spine. Notice that these come in several layers; some are already shown in Figure 18.1, and Figure 18.2 adds another two layers.

- The triceps (11 and 12), the big muscle on the back of the upper arm, opposite the biceps. The triceps attaches in several places; one "head" goes to the deep surface of the shoulder blade, and another binds to the humerus.

- Muscles of the shoulder blade (13, 14 and 15), which fill in the hollow surface above and below the spine of the shoulder blade. They all attach to the humerus, strengthening its attachment to the shoulder blade. The most important is the teres major (the lowest number 14), which is a thick muscle, and tends to be prominent in life.

I am giving some anatomical names and omitting others, because in anatomy there is a point of no return, where names begin to clog the attention and distract from the essential structure. It is more important to see the arrangement of the parts than to name small muscles that are rarely visible in life. The construction of the shoulder ends with the superficial layer of muscles (Fig. 18.3):

figure 18.2

Deep muscles of the back.

- The deltoid (1 and 2), which is the large muscle of the shoulder. It attaches to the spine of the shoulder blade at the back and is usually strongly divided into different portions. Ten or more strands can be visible in very muscular people.

- The trapezius (3, 4, and 5), a very large flat muscle that attaches to the whole upper half of the spine and then runs to the side, where its strands gather together and attach on the top surface of the spine of the scapula. Every muscle in the body has a fleshy part (the red muscle, the part that weight lifters try to grow) and a tendon. The trapezius is unusually complex and has flat tendinous areas (technically, aponeuroses) around the vertebrae at the base of the neck (left of number 3), again at the edge of the spine of the shoulder blade (4), and also at the bottom (5). People with strong trapeziuses have hollows in those places, because the tendons stay flat while the muscle gets larger.

- The latissimus dorsi (6 and 7), a huge muscle that wraps around the whole lower half of the rib cage like a beach towel. Notice how the top edge of the latissimus dorsi just barely covers the bottom of the shoulder blade, and notice too how the latissimus dorsi and the trapezius cross one another right near the inside edge of the shoulder blades.

At the bottom, the latissimus dorsi binds to the back of the pelvis and the lower vertebrae (8, 9, 10, and 11). There are a few other muscles, but this is the essential list. (A prominent neck muscle, number 12, can also be seen from the back: it's the big muscle on either side of the front of your neck, and it has the polysyllabic anatomic name of sternocleidomastoideus.)

There is a little triangle on each side of the back (13) with the latissimus dorsi below, the trapezius on the side near the spine, and the shoulder blade on the other side. The triangle is a spot where the muscles are especially thin. In life, it can look like a little triangular depression; it's also a good place to put a stethoscope to listen to the lungs.

figure 18.3

Superficial muscles of the back.

Many of these muscles are variable: the deltoid divides naturally into three parts (front, side, back), but it can display ten or more strands. The trapezius is especially variable. The aponeurosis (thin tendinous part) along the spine is sometimes quite wide and has an irregular margin. In other people it's thin and straight. Like other muscles, the trapezius begins to organize itself into strands if it is well developed, and everyone has slightly different strands. It helps to divide the trapezius into three portions: the upper portion, which attaches to the spine of the scapula; the middle portion, which converges on the end of the spine of the scapula (Fig. 18.3, number 4); and the lower portion, underneath. But each person is different, and often the trapezius divides into seven portions. This is an aspect of medicine that is largely ignored in the twentieth century; very few books even mention the fact that different people have differently shaped muscles. As long as a muscle begins and ends where it should, most doctors are content.

With this information in mind, you can start observing people's shoulders and seeing how well developed their muscles are. Often the best physiques for seeing muscles and bones are not those of bodybuilders, but of people who have worked hard and steadily for many years and have kept thin. Older men in their fifties and sixties are the best subjects; some of them are like living anatomy lessons. Serious weight lifting and steroid use exaggerate some muscles and make others invisible, and most people who work out have too much superficial fat, so the contours of their muscles are blurred.

Years ago I taught art anatomy to painters and sculptors, and I found that it was easier to go back to artists like Michelangelo than it was to find a model who had a clearly articulated physique. Michelangelo's drawings are very beautiful and also tremendously complex (they would take more than these few pages to explain). The sculptures and paintings are simpler, but they still have all the essential anatomy; the back of the sculpture called the *Giorno* ("day") in the Medici Chapel in Florence is a good example (Fig. 18.4). The right shoulder blade is pulled forward, and the left is crowded back against the spine. Pulling the arm forward brings out the outline of the shoulder blade, and you can see the muscles that cover it (compare with Figure 18.2, numbers 13 and 14). The lump along the bottom of the shoulder blade

figure 18.4

Michelangelo, **Giorno.** *Florence, Medici Chapel.*

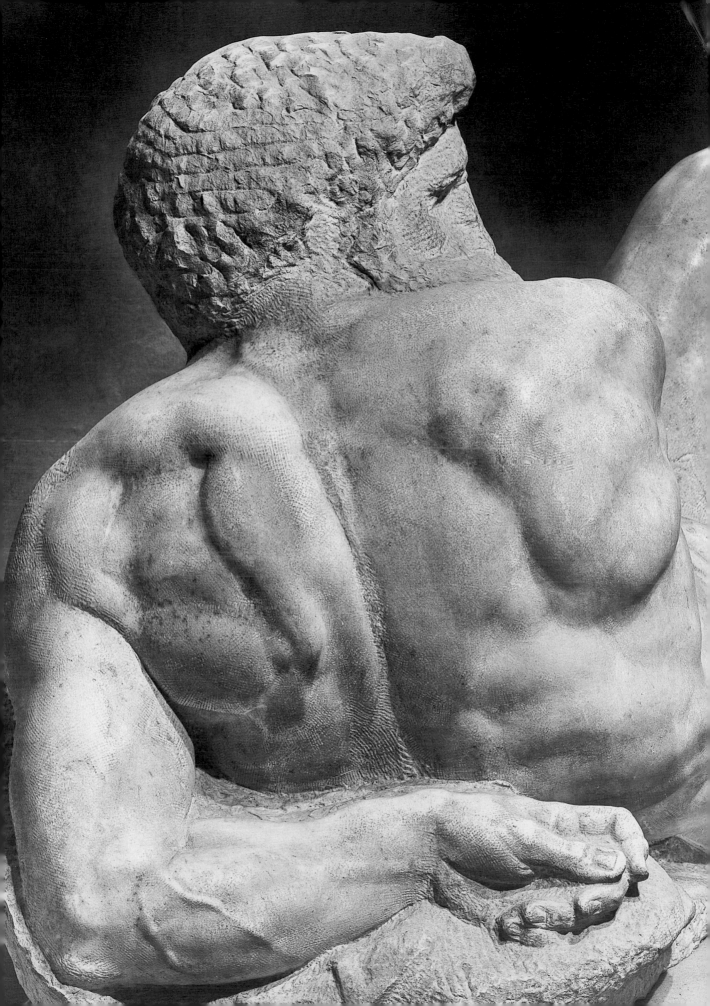

is the latissimus dorsi, which wraps the bottom corner of the shoulder blade and helps keep it from popping out away from the rib cage (compare with Figure 18.3). Also on the right side, you can see the shadowy triangle of the trapezius (compare with Figure 18.3, numbers 4 and 5).

On the left side, where the muscles are bunched up, you can see where the fleshy parts of the muscles turn into flat tendons along the spine: notice that the bright rolling contour of muscles stops a fraction of an inch short of the spine itself (as in Figure 18.3, left of number 3). At first it is hard to understand the strange shape on the left shoulder blade, because it is formed by muscles that are tensed and compressed. It helps to locate the shape of the shoulder blade underneath the muscles. The depression has a peculiar shape:

The curve from number 1 to number 2 is the spine of the shoulder blade, and the muscle that is bunched up over it is the trapezius (as in Figure 18.3, between numbers 3 and 4). The rectangular notch that is marked number 2 is the small tendon of the trapezius, just at the end of the spine of the shoulder blade (as in Figure 18.3, number 4). The trapezius is also the muscle that causes the large arc between 2 and 3. On the *Giorno* itself, you can see a fainter depression just beyond the arc 2–3 that is the actual edge of the shoulder blade. The bigger roll of muscle between that depression and the spine itself is the combined trapezius and rhomboids (as in Figure 18.2, number 4). The very sharp corner at 3 is the little triangle marked 13 on Figure 18.3. From there to number 4, the big muscle is the teres major, one of the muscles that covers the flat face of the scapula (see Figure 18.3, and also Figure 18.2, the lowest number 14). The curve from 4 to 5 is also formed by muscles over the shoulder blade, pushed back by the arm; and the curve from 5 back to 1 is the deltoid (compare Figure 18.3, number 1).

There is no limit to how carefully you can look at shapes like these and how much you can see. The first roll of muscles just left of the spine has a gently undulating contour—a curve that begins up near the top of the shoulder, and another very subtle one, and then a still longer one that turns down toward the wrist. Those

arcs are the outlines of the rhomboids; as shown in Figure 18.2, number 4, the rhomboids generally split into pairs, and Michelangelo has marked the contours very carefully. In the depression itself, just where I have put the number 5 on the little outline drawing, there is a thin but unmistakable swelling: it is caused by one of the heads of the triceps (see Figure 18.2, number 11) pushing up the muscles that are above it.

Michelangelo was an extremely acute observer, and in the years that I worked on this material, I found only a handful of cases where he might have invented something. Usually he distorted his figures and he simplified their outlines, as in the *Giorno,* but time after time I found that the strange shapes he depicted actually exist. Still, to understand the body it's necessary to do more than just look at art, even if that art is the record of some of the best observations that have ever been made. The physiques of older men are entirely different—very little like Michelangelo's work—and they show other forms that have rarely been represented in art.

I chose the photos on the next few pages from an old German anatomy text because newer photos and live models rarely show as much. Anatomy texts for medical students and for artists simplify things to make them easier to see. But the body isn't schematic, and it was the unsimplified forms that held Michelangelo's attention. Think of these photos as puzzles first try looking at them without consulting the outlines or the keys. Find the important muscles and bones, and then look at smaller and more puzzling features. Often the line between one muscle and another is very subtle, and even in this man's unusual physique, it is not easy to pick out the borders between different parts. The best strategy is to look blankly at a single area until something emerges. At the same time, don't frame a part in your mind or sequester it from what is around it; try to continue seeing the back as a whole. When one part reveals its contours, then let your eye move on. The keys provide full explanations, but you will see the most if you find the forms yourself.

The shoulder is complicated, and this is only the beginning. Even though we live in a culture that cares a great deal about bodies, most of us are scarcely aware of the astonishing amounts of detail that the body can show us.

No.	Explanation	The Form Is Also Shown In:
1, 2, 3	Sections of the deltoideus	Figure 18.3, numbers 1 and 2
4	Triceps	Figure 18.2, numbers 11 and 12
5	Teres major	Figure 18.2, bottom number 14
6, 7	Two muscles covering the flat face of the scapula just above it	Figure 18.2, numbers 13 and 14
8	Top edge of the latissimus dorsi	Figure 18.3
9	The little triangle between muscles, showing a deep muscle over the ribs (erector spinae)	Figure 18.3, number 13
10	A rhomboid	Figure 18.2, number 4
11, 12	Strands in latissimus dorsi	Figure 18.3
13	The thin nonfleshy portion of a scapular muscle	Figure 18.2, left of the middle number 14
14	The bottom corner of the scapula	Figure 18.1
15	The end of the spine of the scapula	Figure 18.1
16	The collar bone (clavicle)	Figure 18.1, number 2
17	The spine of the scapula	Figure 18.3, up to number 4
18–end	All parts of the trapezius	Figure 18.3
18	Upper part of the trapezius	Figure 18.3
19	The neck muscle sternocleidomastoideus	Figure 18.3, number 12
20–23	Strands of the middle portion of the trapezius leading to individual vertebrae	Figure 18.2, numbers 5–7
24	The lower portion of the trapezius	Figure 18.3, leading to number 5
25	The thin, nonfleshy aponeurosis of the trapezius	Figure 18.3, number 4
26	Thinner part of the middle portion of the trapezius	

figure 18.5

Muscles of the back, arm extended to the side, c. 1925.

figure 18.6

Outline of the forms on Figure 18.5.

Note: In this picture I have also labeled the vertebrae, which can often be counted. "CVIII" is the seventh and last cervical vertebra; it is usually prominent and easy to find. Counting down from there, "TI" through "TXI" are thoracic vertebae.

No.	Explanation	The Form Is Also Shown In:
1	Upper portion of the trapezius	Figure 18.3
2	Flat, aponeurotic portion of the trapezius	Figure 18.3 and also Figure 18.4
3	Middle portion of the trapezius	
4	Lowest part of the upper portion of the trapezius	Figure 18.3, from number 4 up
5	Continuation of number 2, called the ligamentum nuchae	
6	Beginning of a division within the upper portion of the trapezius	
7	The flat aponeurosis at the bottom of the trapezius	Figure 18.2, number 5
8	Deltoid: strands in the middle portion	Figure 18.3, number 2
9	Deltoid: back portion	Figure 18.3, number 1
10	One of the heads of the triceps	Figure 18.2, number 11
11	Latissimus dorsi: note the thin top edge of the muscle, crossing over the shoulder blade	Figure 18.3, left of number 13
12	Latissimus dorsi: the lateral edge	Figure 18.3, right of number 7
13	Latissimus dorsi: the thin top edge of the muscle, crossing over the deep back muscles	
14	A muscle of the flank (obliquus externus)	Figure 18.3, lower right of number 7
15	A deep muscle of the back (erector spinae) showing through in the little triangle	Figure 18.3, number 13; Figure 18.6, number 9
16	Muscles of the flat surface of the shoulder blade	Figure 18.2, numbers 13 and 14
17	Spine of the scapula	Figure 18.3, from number 4
18–19	End of the spine of the scapula; deltoid on the outside, trapezius on the inside	Figure 18.3
20	Fold in the trapezius, as it changes direction going up the neck	Figure 18.3, number 3
21	Furrow between the rhomboids	Figure 18.2, number 4 (compare both sides)
22	Latissimus dorsi: strands with possible slips (small connections) to the shoulder blade	
23	Neck muscle (sternocleidomastoideus)	Figure 18.3, number 12
24	Bottom of rhomboid (it is also barely visible on the right)	Figure 18.3, left of number 13; Figure 18.2, number 4

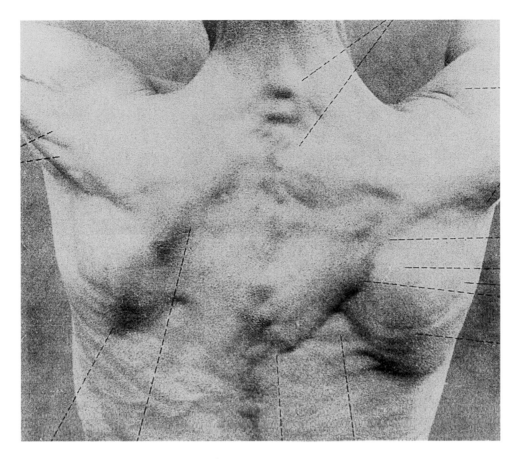

figure 18.7

Muscles of the back, arms raised. c. 1925.

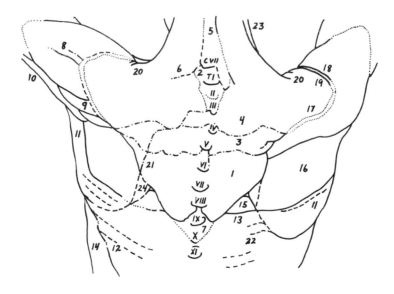

figure 18.8

Outline of the forms on Figure 18.7.

19

how to look at
a face

What we know as the face is a thin mask of frail, interconnected muscle fibers attached to a layer of fat and skin. What we recognize as the emotions and beauty of the face depend entirely on this mat of tissues. Most muscles in the body link bone to bone and are strong enough to help us sit up or walk. There are muscles like that on the face, such as the one that hinges the jaw to the skull. But the majority of facial muscles have nothing to do but pull the skin into different expressions. They are weak and stringy, and they do not usually show up on the face the way a biceps curls on an arm or a pectoral lifts a man's chest. What we see on a face are the lumps of compressed skin and the folds in between them.

Because we attend so closely to people's expressions, the face is full of names. Many skin folds have names, and there is a term for every curve in the ear and each turn of the nostrils. By comparison, other parts of the body are terra incognita. There is no name, for example, for that large fold that forms in front of the elbow, or the even bigger one behind the knee. (The *areas* have medical names, but not the folds.)

It is interesting to encounter some of names for facial features, because they turn the face into a kind of map. Also, they aid the memory. Once you know a few

figure 19.1

Michelangelo, study for the Cumaean Sibyl on the Sistine Ceiling.
Torino, Biblioteca Reale.

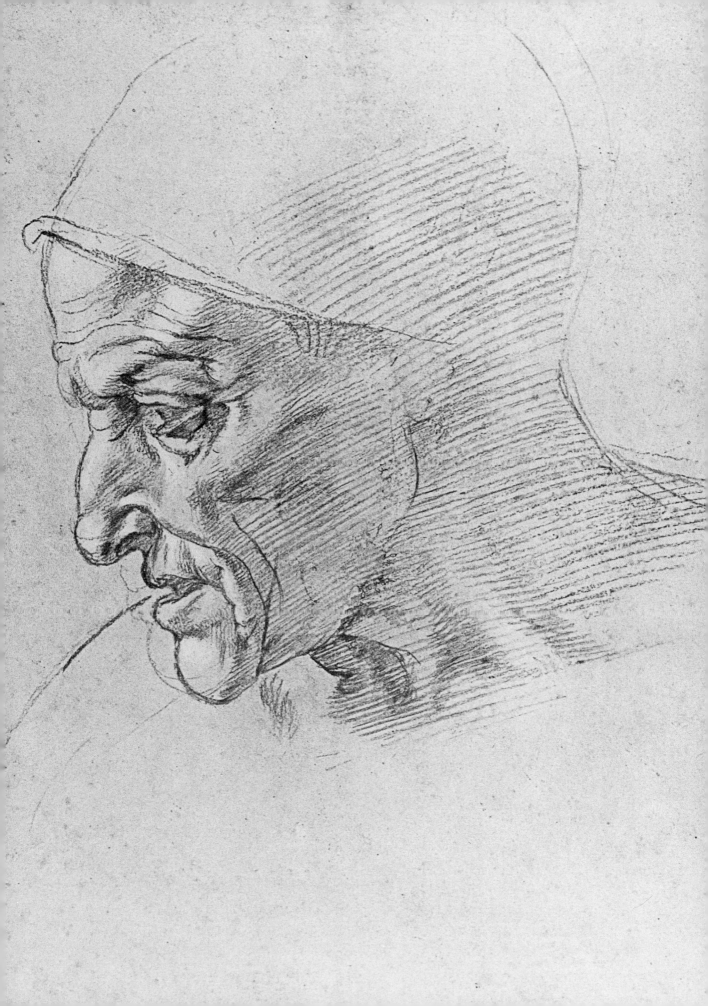

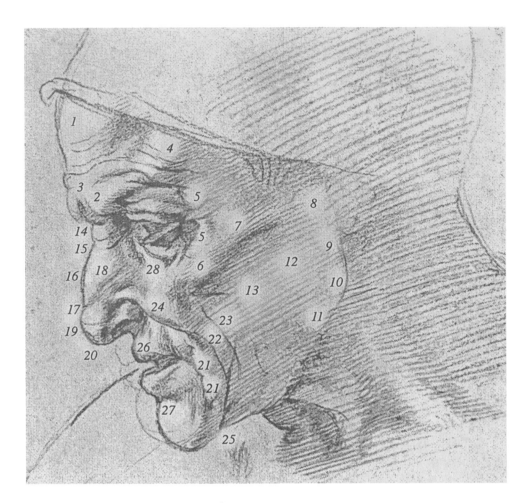

f i g u r e 1 9 . 2

Diagram for Figure 19.1.

terms, it becomes easier to remember how a person looks. You'll see someone smile, and you'll spot the creases that mark their smile apart from everyone else's. You'll notice someone's ear and remember it because you know the name of the little clefts and hooks of cartilage. Without names it is much more difficult even to *see* the face, much less remember it; and that is a good general moral for this book.

Here, then, are some names for parts of the face. The underlying architecture is provided by the skull, which is especially strong on this wonderful drawing of an old woman (Fig. 19.1). The bulge of the forehead is the *frontal eminence;* it's the gentle curve that turns into a shining dome as the hair recedes (marked number 1 in Figure 19.2). It dips down and then bulges into ridges above the eyes, called *superciliary arches* (2). The *glabella* is the space between them, and it has a curve of its own (3). At either side of the forehead is a more or less abrupt change in contour called the *temporal crest* (4). In this drawing everything behind the temporal crest is thrown into

shadow. The drawing shows very beautifully how the horizontal skin folds of the forehead bunch up over the superciliary arches and how they flow down and around the temples. Like the lines in a topographic map, they suggest the underlying geology without quite delineating it.

You can also feel all these things on your own face, and if you move your fingers down past your eyebrows and keep pressing in, you'll feel the place where the bone gives way and turns inward into the eye socket. That is the *supraorbital margin.* It is hidden in life but obvious on skulls. The only part of the eye socket that is visible in life is the outside rim, technically the *orbital margin of the zygomatic bone* (5–5). Here it is crossed by two crow's feet. This is a typical older person's face, and it is easy to see how the soft tissues have collapsed a little into the eye socket and how the bone has become more prominent.

There is a bony arch on the side of the face, called the *zygomatic arch.* The heavy muscle used for chewing attaches to it. The bulk of the muscle, called the *masseter,* swells her cheek slightly (12). In this drawing, it becomes visible where it begins on the *maxilla* (6), and you can follow it back to its highest point (7) and from there to the ear (8). You can also feel the zygomatic arch on your own face, even if you're very young and it isn't really visible. If you press hard enough, you'll feel the softer muscles above and below it, and you will sense that it is an arch. This woman has lost some of the fat that conceals the arch in younger people, and there is a shadow beneath the arch, and even a small skin fold (below number 6). In the front portion of her masseter muscle (12) there is a little hollow (13), typical of old age. It was once filled with *deep buccal fat,* and as the fat has been metabolized, her face has gained an extra contour. Babies have a lot of that fat, and so do healthy young people.

The jaw bone, or *mandible,* has a very subtle contour. Near its hinge it is concave (9), then it comes to an angle (10). Its *inferior border* is once again concave (11).

Her nose is especially clearly articulated. The *nasion,* where the nasal bones meet in front, is a low point (14). The nasal bones themselves show their vertical upper surfaces (14–15) and their sloped inferior surfaces (15–16). The nose is an assembly of little bones, cartilage plates, and softer connective tissue. The *upper later nasal cartilages* go from the change in contour (16) to the area where connective tissue takes over from cartilage (17). You can even see the edges of the cartilages, their *lateral borders* (18). The *greater alar cartilages* each have two surfaces—one from 17 to 19, and another from 19 to 20. The rest of the nose is made of connective tissue and cartilage that is molded into the round shapes of the nostrils and the *alae* (wings) of the nose.

In the nineteenth century, a French anatomist and sculptor named Paul Richer named most of the folds around the mouth and cheek. Some of his terms also exist

in English and others don't, so some folds have only French names. Anatomists call the folds at each corner of the mouth, where the lips fuse, the *labial commissures*. Often they run into an accessory fold, as they do here (21–21). Next comes the *sillon jugal*—in English that would be the "jugal fold," meaning fold of the jugal or cheek bone—and beyond it the *sillon jugal accessoire* (22 and 23). The very prominent fold that comes down on either side of the nose is the *nasojugal fold* (24). Everyone has a nasojugal fold, and many people have a nasolabial fold, which goes from the nose to the corner of the mouth. (One is present here, but it is not well developed.) Only older people have the three other folds numbered 21, 22, and 23. They can merge and separate in different ways. On this woman, the *sillon jugal* and *sillon jugal accessoire* (22 and 23) come together in a V and merge with the fold under the chin, which Richer calls the *sillon sous-mentonnier* (25). When people have double chins, the fold under the second chin tends to connect with the *sillon jugal accessoire* (23). This woman has only a flat stretch of skin where the second chin would go (to the right of 25).

You might not think so, but the part of the face where the shape is determined most by muscle, and not by fat or bone, is the lips. The *philtrum* is the little channel that connects the nose to the center of the "Cupid's bow" on the upper lip (26). The whole area around the philtrum—the upper lip, the lower lip, and the area between the lower lip and the *mentolabial fold* (27)—is sculpted by muscle.

The eyelids are very delicate thin muscles, like the skin on a custard; they float over the eyeball and over the fat and muscles that pack the eyeball into the eye socket. So it is no wonder that when they wrinkle, they form many tiny folds. The *malar fold* is often doubled into two folds, as it is on this woman (28). Above it are the "bags" of the eyes, which are often corrugated into tiny rumples and creases. It is not too pleasant to think about, but the little rumples appear when the delicate underlying sheet of muscle degenerates and small hernias of orbital fat break through it.

This drawing would be a perfect visual dictionary of the forms of the face if Michelangelo had drawn in the ear. Its parts are shown well enough on another drawing (Fig. 19.3). The outer *helix* wraps around the inner *antihelix*. The earhole itself is called the *external auditory meatus*. The outer helix begins just above the meatus, in the *crus*, continues up and around the ear, forming a little inward projection called the *Darwinian tubercle* (marked number 1 on Figure 19.4), and flattens out to form the earlobe (*lobule*). The inner *antihelix* starts in two parts, the *crural*, which are separated by a triangular depression, called the *fossa triangularis*. The furrow between the helix and antihelix is known as the *scapha*. The antihelix continues down, bulges out a little into the wonderfully named *antitragicus* (2), dips back in the *intertragic incisure*, and then out again in the *tragicus* (3). Above the tragicus, but

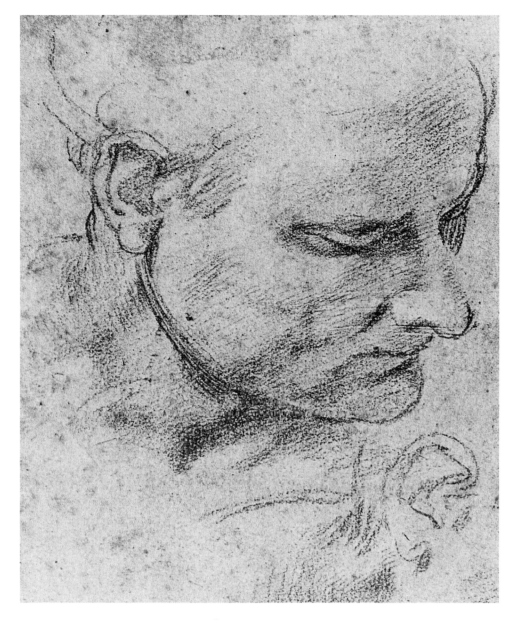

f i g u r e 1 9 . 3

Michelangelo, study for the head of an old man. London, British Museum.

not visible in this drawing, are the *supratragic tubercle,* the *anterior incisure,* and then the beginning of the helix. Inside, nearest the meatus, are the *cavum conchae* and the *cymba conchae,* two little projections that look like a third helix in the xzmaking.

It seems silly to have so many names for such an unremarkable part of the body, but they can help you to take in the ear's complicated shape and remember what you see. (And if you want to see more, there are at least six other names I have not mentioned.) These little parts are always preserved in differently shaped ears, and

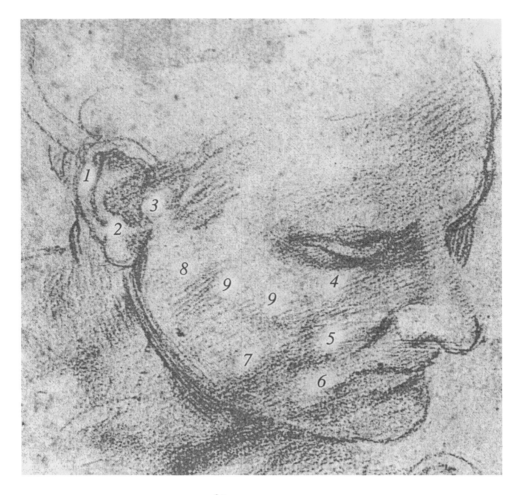

f i g u r e 1 9 . 4

Diagram for Figure 19.3.

by learning them you can start to see that ears are not just "pointed," "flat," or "long." They come in infinite variations.

I reproduce this second drawing in order to make some sad observations about aging. On the face, the skin is loosely anchored to the bone underneath by the muscles that produce expressions and by a series of sheets of tissue called *fascia*. They are like little hammocks tied at one end to the skin and at the other to the skull. Often they run between two muscles, separating them. Skin folds are usually formed where the fascia attach to the skin; they pull the skin down like the buttons in upholstery. As a person ages, the muscles atrophy and the fat migrates, slumping downward until it comes to rest on a fascial sheet. The bags and flabby folds of old age are like fat people slumping in hammocks. This man's face shows all the signs of impending age. The tissues under his eye (4) have sagged down onto a fascial sheet underneath the eye, and the tissues and muscles underneath them have sagged onto

the nasojugal fold (5). The deep buccal fat to the side of the mouth, and its associated tissues, have fallen down onto the fascia that form the labial commissures (6).

Large muscles such as the masseter (chewing) muscle have fascia on all sides. Here the superficial layer of fat over the muscle itself has slumped down onto a fascial sheet that is in front of the muscle (7), and the fat that is farther back over the parotid gland has fallen down onto the sheet that is at the edge of the muscle (8). (These fascial sheets all have names; this sheet is the *fascia parotideomasseterica*.) A bar of fatty tissue (9–9) rests on the fascia that are connected to the zygomatic arch and a smaller gland called the accessory parotid gland.

This is what it means to say that gravity takes its toll. Gravity pulls the fat down, revealing the underlying fascia. What was once a network of tissues becomes a series of slumps and slides ending in hammocks of fascia. All the signs of aging are already present in a young man (Fig. 19.5), if you look carefully—and of course the same applies to women. If you are brave enough, take this book to the mirror and you'll find all the signs of age—no matter how young you are, you have the fascial sheets in place and the folds waiting to form.

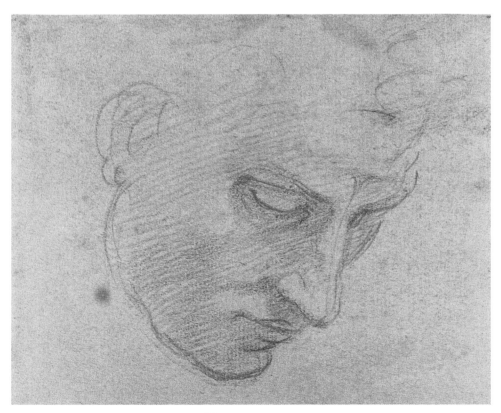

figure 19.5

Michelangelo, study for the head of a young man. Florence, Casa Buonarroti.

how to look at
a fingerprint

Fingerprints are slightly too small to see with the naked eye. In just the right light you can discern the curving lines, but not closely enough to tell one finger from another. Printing the pattern helps, but is not easy to make a print that is clear enough to show every line, and even if you do, you'll need a magnifying glass to really study it. It's as if fingerprints were designed to be just out of the range of normal human vision. That is probably why they were not noticed until the seventeenth century (the age of telescopes and microscopes), and not classified until the twentieth century. But if you know how, it is easy to ink your fingers (and your toes, too—they also have fingerprints) and analyze the results.

The official FBI publication *The Science of Fingerprints* is not an especially easy book to read, and it has some grisly bits, such as photographs demonstrating how to snip hands off corpses and how to inject dead people's fingers with preservative. But the basic facts can be distilled into a couple of pages. There are three kinds of fingerprints: the arch, the loop, and the whorl (Fig. 20.1, numbers 1, 2, and 3). The last two can be measured exactly so that each finger gets a number. To do that,

figure 20.1

1. A plain arch. 2. A loop. 3. A plain whorl. 4. The pattern area in a fingerprint.
5. Examples of locating the core.

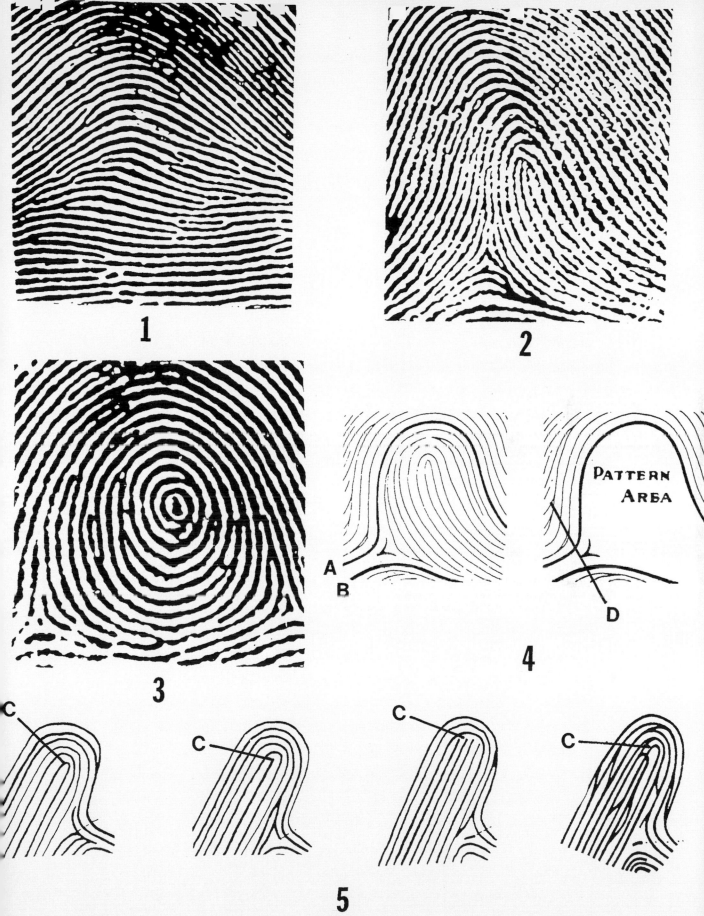

1

2

3

4

PATTERN AREA

A
B

D

5

C

C

C

C

imagine that the ideal finger is made entirely of horizontal lines, sweeping past from one side to the other. The *pattern area* is the part in the middle where the flow is disrupted, like a stream that flows around a rock or eddies into a whirlpool. Arched fingerprints (number 1) don't have anything that seriously interrupts the flow, and almost every line enters on one side and exits on the other. (It does not matter if the lines break or split: it's the flow that counts.) Loops and whorls have some lines that do not flow from side to side; they get trapped and swirl around in circles, or else turn and go back to the side they came from. The eddying movements can be easily seen in numbers 2 and 3. Such lines comprise the pattern area.

The first thing to do in looking at a fingerprint is to find two lines that start out flowing parallel to one another, and then diverge and go around the pattern area, like A and B in Figure 20.1, number 4. Those lines are called *type lines,* and the place where they diverge is the *delta.* (If you want, think of the pattern area as a lake fed by a stream.) The delta is the point that is closest to the place where the type lines diverge. In the diagram, the line D finds the delta, which is the tip of the little V-shaped ridge. If the fingerprint has one set of type lines and one delta, it is probably a loop, as in number 2. (The type lines there come in from the far lower left corner of the print area.) If the fingerprint has two deltas, one on each side, it is a whorl, as in number 3.

The next thing is to look inside the pattern area and find the *core,* which is the part farthest inside the pattern area—or, in the technical language of fingerprint analysis, "upon or within the innermost sufficient recurve." This is a complicated business because it is artifically imposed on what nature has given us—fingerprints are not naturally evolved as pattern areas, deltas, and cores. FBI analysts have re-solved the ambiguous cases by introducing a number of ancillary rules. A glance at number 5 will give a sense of how the core is located when it is not immediately ob-vious. These are pictures of pattern areas without the rest of the prints. The first is the simplest: the core is at the end of the innermost recurving line. When the inner-most ridge doesn't curve back on itself, the core is at its end (as in the second draw-ing). If there is an even number of lines in the middle, the core is the farther one of the central pair. And if a ridge comes down on top of the innermost recurve, then that recurve is "considered spoiled," and the core has to be found outside the inner-most recurve (shown in the last drawing).

Once you have located the delta and the core, it is a matter of drawing a straight line between the two and counting the ridges in between. A typical fingerprint clas-sification might be "loop, ridge count 5." You can test yourself using Figure 20.2, which gives some counts for different fingerprints. A line in the first picture shows how it is done. To analyze your own fingerprints, you will need very clear impres-

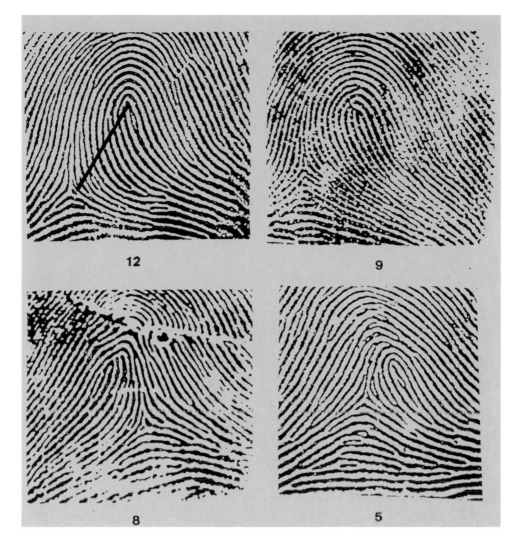

f i g u r e 2 0 . 2

Examples of ridge counts.

sions. Ink your finger and then roll it once across the paper. It's essential to roll the finger and not just press it, because you need the full range of detail from left to right. Roll several more times, as the ink gets lighter, and one of the impressions will probably be adequate. Don't press hard, don't go back over it, and try not to smudge anything. When you get a reasonably clear print, make several photocopies of it, enlarging it until it's clearly visible—say about half the size of a normal sheet of paper. Then you can use a colored marker to find the delta and the core, and a ruler to draw a line between them.

Fingerprints get tricky for two reasons: finding the delta and core; and deciding the difference between a loop and an arch. Technically, a fingerprint cannot be a loop unless it has three traits: (1) a *sufficient recurve,* meaning a ridge inside the type

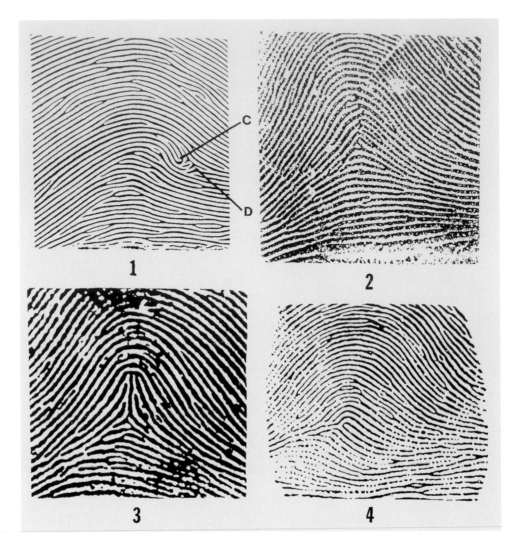

1. A minimal loop. 2. A tented arch with an angle. 3. A tented arch with an upthrust.
4. An arch that lacks one of the three traits of a loop.

lines that has no bridges connecting it to the type lines; (2) a delta; and (3) a ridge count. Figure 20.3, number 1 is a very small loop that still satisfies these criteria. If you look at the right margin, you can see the two type lines entering parallel to one another and then diverging and running around the pattern area. (Again, it doesn't matter if they break, as long as you can trace a continuous direction.) The delta is just where the type lines diverge at D. A ridge comes in from the left and loops back on itself, and inside it there is a little ridge. The end of that ridge is the core, marked C. This is a proper loop because it possesses all three traits, and its ridge count would be four.

Arches, loops, and whorls each subdivide into further types. There are actually two kinds of arches: *plain arches,* where every line enters on one side and exits on the other; and *tented arches,* where there are a few isolated lines in the center. Tented

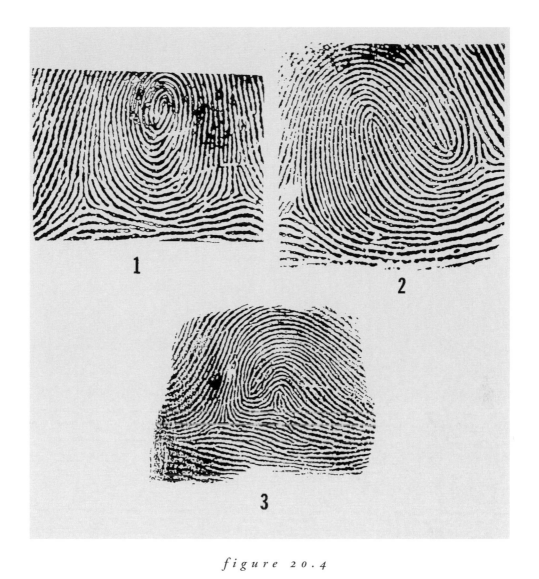

f i g u r e 2 0 . 4

*1. An outer central pocket loop. 2. A double loop. 3. An "accidental pattern"
comprised of a whorl and a loop.*

arches, in turn, come in three varieties: those where the central lines form a definite
angle, as in Figure 20.3, number 2; those where the central ridges form an *upthrust,*
as in number 3; and those that are almost loops, but lack one of the three essential
criteria for a loop. An example of the last kind is number 4. This fingerprint has the
first characteristic of a loop, a sufficient recurve; it's the loop that comes in and goes
out again from the right. The core would be on the innermost recurve, but since
there is only one recurve, the core is right where it turns. This finger also has type
lines—they come in from the left and flow around the recurve—and it has a delta,
which is the very same recurve. The problem is that the core *is* the delta, and the
problem with that is that this finger has no ridge count. Hence it fails the third of
the three criteria for a loop, and it is a tented arch.

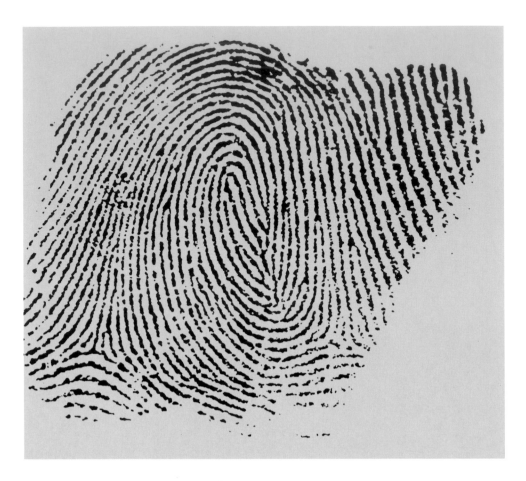

figure 20.5

An "accidental pattern."

Whorls come in different types as well. A *central pocket loop* is a whorl in which some ridges make perfect closed circles. Figure 20.4, number 1 is that kind of whorl. If you draw a line from one delta to the other, it does not cross any of the lines that make the circles; which is the technical requirement of a central pocket loop. Whorls have to be counted differently from loops. To count a whorl, find the two deltas, and then trace the ridge that starts from the lower side of the left-hand delta. Follow it around until you get as close as you can to the other delta. If the ridge peters out, skip down to the next ridge. If you end up inside the right-hand delta, then the whorl is an *inner whorl,* and if you end up outside the right-hand delta, it is an *outer whorl.* Count the ridges from the place you end up to the right-hand delta, and you get the ridge count for the whorl. By those criteria Figure 20.1, number 3 is an inner whorl with a ridge count of two, and Figure 20.4, number 1 is an outer whorl with a ridge count of four. To count this inner whorl (number 1), start at the little dot that is the left-hand delta, and skip down to the type line. Keep following it around to

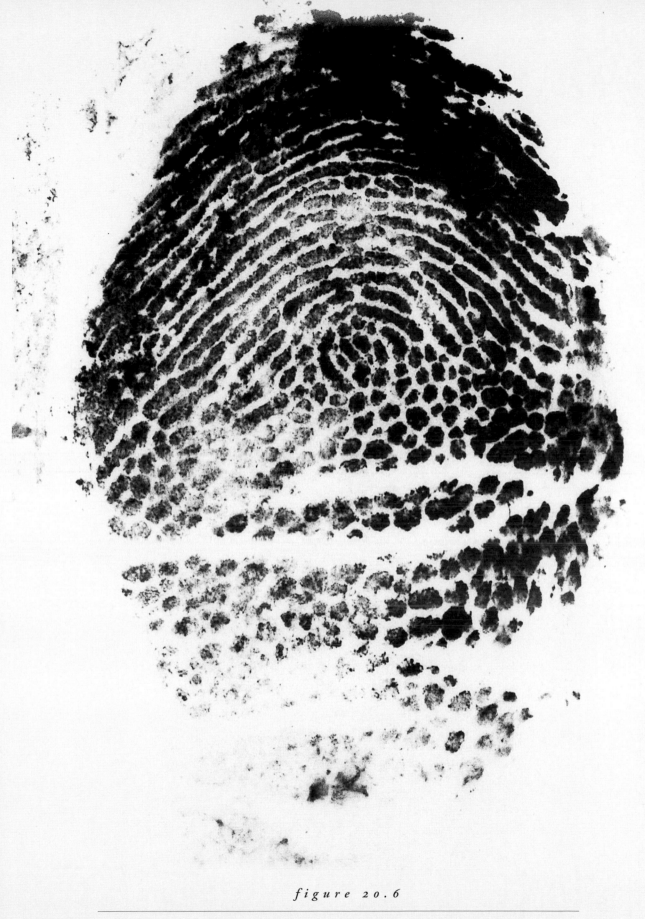

figure 20.6

A koala bear fingerprint—the pinkie of the right hand.

the right until you have to skip down again. Stop when you're just below the right-hand delta, and count up to it. There are four ridges between (including the delta itself).

You see how this can get very involved—and this is only the beginning. Still, with this much information you can analyze all your fingers and toes. It is not uncommon to find something exotic—a *double loop,* as in number 2, or an *accidental* like number 3, which has a loop over a tented arch. You can also make palm and footprints, and parts of them will have loops and whorls, but they are not usually counted by fingerprint analysts. Who knows—you may even find a really exotic pattern like this one that a student of mine found on one of his fingers (Fig. 20.5). You might wonder, though, if your fingerprints look like Figure 20.6 or Figure 20.7—the one is a koala bear, the other a chimpanzee.

(Koalas are an interesting case because they have been on a different evolutionary tree from humans for a long time and have evolved fingerprints independently of humans. It seems that fingerprints are an optimal structure for both holding and climbing, provided you have an opposable thumb. For just plain climbing it is enough to have the nubbly texture, called warts, which is apparent at the bottom of the koala's fingerprint.)

These days fingerprint analysis is done by computer, though there are still people who are trained in visual classification. Most fingerprints at crime scenes are only "partial prints," lacking important features like deltas and cores. In that case the analysts look at the little accidental features of the fingerprints: the places where ridges meet or divide, or the little scars and flaws that most of us have. (People who have done a fair amount of manual labor will usually have deeply scarred fingerprints that are fairly easy to identify.)

Learning about fingerprints made me skeptical of lawyers' claims to be able to identify fingerprints once and for all. I have taken fingerprints from about a hundred people so far, and I have found that it can be very difficult to get a legible print even in the best conditions. If I am ever on trial and the case turns on fingerprints, I am going to want to have a look at the evidence myself.

figure 20.7

A chimpanzee fingerprint from a 46-year-old female.

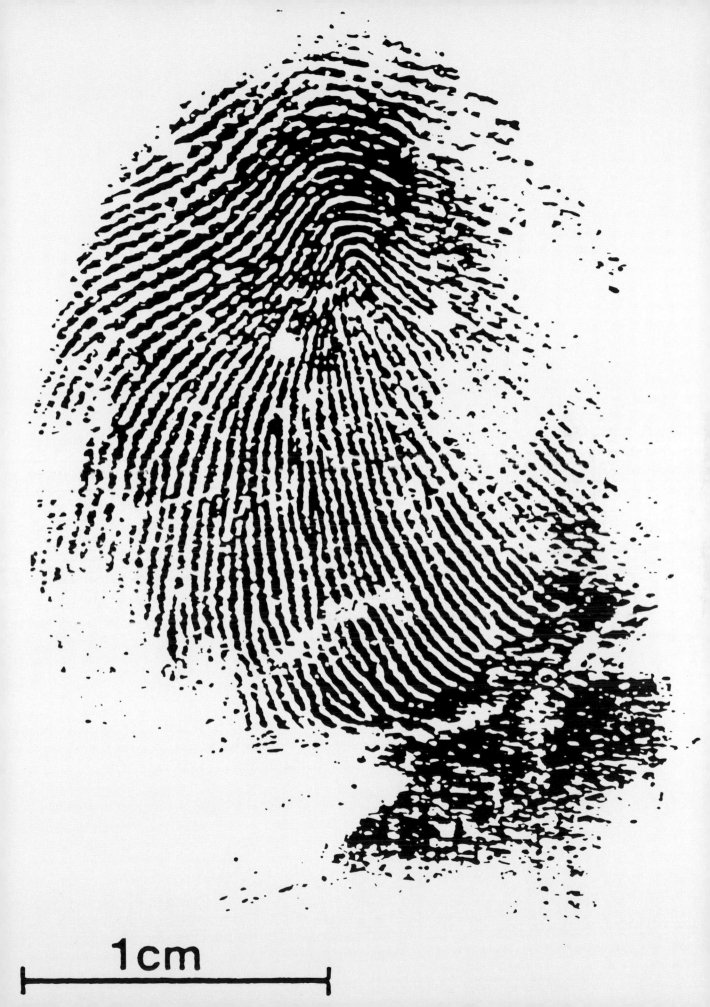

1cm

how to look at

grass

Most people who love animals prefer large, furry animals. We love dogs and cats and, from a distance, lions and tigers. In the same anthropomorphic fashion, people who care about plants tend to like large, gaudy plants. They prefer roses and chrysanthemums and larger things like oak trees and sequoias. But as in the animal kingdom, smaller plants are far more common. Grass is a lovely example of an overlooked plant. It would be hard to imagine something more commonly underfoot or more universally unnoticed. It has been estimated that grass covers one fourth of the earth's surface; grasses (*Graminae*) are the largest family of flowering plants, with somewhere around two thousand species in North America alone. All the grains we eat are grasses, from oats to barley and wheat. Bamboo is a grass, and so is corn, and so is sugarcane. Yet even those large grasses are almost entirely unknown to people who aren't farmers. I wonder what percentage of people in the developed countries could identify a field of oats, or rye, or wheat.

Grass is as nearly universal as any visible life form gets, aside from people and insects. Chances are good that no matter where you live, if you are reading this book

figure 21.1

Grass. Dalgan Park, County Meath, Ireland.

figure 21.2

Sheep's fescue (**Festuca ovina**).

between April and August, you can find at least one of the five grasses I describe here.

Figure 21.2 is a drawing of one of the most common grasses, a fescue. Sheep's fescue (*Festuca ovina*) is a typical roadside grass; it is found from Greenland to New Guinea, though as a genus it is essentially European.

Figure 21.3 shows sweet vernal-grass (*Anthoxanthum odoratum*). It is named for its springlike smell and is found throughout Europe, from northern Scandinavia to North Africa, and—as one author says—"in the Caucasus, Siberia, Japan, the Canaries, Madeira and the Azores, Greenland and North America." In some cases grasses have emigrated from Europe and then immigrated back again, following human movements.

Figure 21.4 is Timothy (*Phleum pratense*), which was brought to America in 1720 by someone named Timothy Hansen for use in grazing. Later it was brought back to Europe in a different form. During its stay in America it had mutated—technically, it had developed a polyploid strain—and the British got it back in an even more useful form than when it left.

Figure 21.5 is the famous Kentucky bluegrass (*Poa pratensis*), which is also a European native. It was recorded most famously by Albrecht Dürer in the watercolor known as the "The Great Piece of Turf," a lovely myopic look at a few square feet of roadside grasses and weeds.

As in any branch of natural history, it helps to know some names for parts of what you're looking at. Some are demonstrated on a sample of a fifth species, Orchard grass (*Dactylis glomerata*) in Figure 21.6. Grasses have stems (called *culms*), labeled A, and branches, labeled B. In this picture the culms are cut so the plant fits

better into the picture. A sheaf (C), called the *prophyllum,* links the stem to the branch so it won't snap off. Grass leaves are long and narrow, and they start out wrapped around the stem. After an inch, or a fraction of an inch, they split and veer off the stem; the portion that is wrapped around the stem is called the sheath and the free portion is the *blade* (D).

Those are the structural elements. The parts that you need to attend to in order to identify grasses are the flowers. Flowers come in groups, called *spikelets;* one is magnified at the lower right of Figure 21.6. The easiest way to tell grasses apart is by noticing how the spikelets are arranged. In Kentucky bluegrass the spikelets are in a loose, pyramidal shape known as a *panicle* (Fig. 21.5). In Sheep's fescue, the top of the stem undulates to make room for a spikelets on one side and then on the other (Fig. 21.2). Such an arrangement is called a *two-rowed spike.* One of the Orchard grasses in Figure 21.6 has a thin, tall panicle (labeled E); the other has a triangular panicle. Its lower branches are spread out horizontally like fingers—hence the Latin name, *dactylis,* meaning "finger."

The spikelets themselves have most of the information that a botanist cares about. If you look closely at a spikelet, you'll see that it is made of a series of *florets* (labeled F). If you pluck them all off, you'll be left with a thin, zigzag stem called a *rachilla.* Botanists pay special attention to the *glumes,* the first pair of "leaves" at the base of the spikelet, and to the shapes of the *bracts,* the "leaves" that cover each of the florets in the spikelet (G, at the top right). By gathering several grasses and picking them apart, you can see how the glumes and bracts differ. Several of the drawings show typical spikelets, florets, and glumes.

This is all minutiae until you start to experience grasses in everyday life. Sweet vernal-grass is among the first to appear in the spring. It is well named in English and in Latin (*odoratum*), because it *is* the typical smell of springtime. The scent is strongest after a rain, or where fields have been freshly mowed. Vernal-grass is also the sweet part of the smell of hay.

f i g u r e
2 1 . 4

Timothy
(*Phleum*
pratense).

f i g u r e
2 1 . 3

Sweet
vernal-grass
(**Anthoxan-**
thum
odoratum).

figure 21.5

Kentucky bluegrass (**Poa pratensis**).

Kentucky bluegrass is another early grass. When I was young I sometimes pulled it up and put the stalk in my mouth as if I were some character from *Tom Sawyer*. It didn't taste particularly good, and though I didn't know it, I would have been happier with vernal-grass. Kentucky bluegrass blooms in early to mid-June, so it is prominent before most other grasses. Its panicles have a delicate look, as if they were tender springtime leaves. Orchard grass is another early grass, but it is much bigger and hangs around all summer. It grows especially well in the shade and is common by the edges of fields, where it hides in the shade of trees and bushes. They are easy to tell apart: Kentucky bluegrass is tender and slim; orchard grass is tall and coarse.

Both vernal-grass and Kentucky bluegrass are finished blooming by the time the other grasses come up. To me, the fescues have the look of summer. When I was growing up, I didn't know their names but I picked them absentmindedly, like any child, and I saw them in the corner of my eye everywhere I went. Somehow they became part of what summer is, and even now, when I see a picture of one, I feel the onset of hot days and summertime air. The spikelets are a mixture of green and purple, as if they were already feeling a little burnt by the sun.

Timothy grows in the same fields and blooms just a little later. It is a grass of high summer, when the days are hot and cicadas and grasshoppers are singing. Timothy is also called cat's tail grass, because it looks like a smaller, mauve version of the swamp cattail.

All this may seem very romantic to you if you grew up in a city or in the suburbs, where all the grass grows lush on fertilizer and is cut when it gets over half an inch high. But if you grew up with real meadows, fields cultivated with Timothy, woods and streams and places that are not mowed or paved, then the grasses have always been part of your sense of place and season. Vernal-grass, bluegrass, orchard grass, fescue, and Timothy may be new names, but they are not new experiences.

Grasses have a reputation for being hard to identify. Even Charles Darwin thought they must be difficult. When he identified his first grass, sweet vernal-grass, he wrote: "I have just made out my first grass, hurrah! hurrah! I must confess

figure 21.6

Orchard grass (Dactylis glomerata).

that fortune favors the bold, for, as good luck would have it, it was the easy *Anthox-anthum odoratum;* nevertheless it is a great discovery; I never expected to make out a grass in my life, so hurrah! It has done my stomach surprising good!" It can be exhilirating to look closely, study the manuals, and finally get to know an anonymous plant. But more than that, it is a wonderful thing to put a name to something you have seen without knowing it, thousands of times from your earliest infancy to the present moment.

how to look at
a twig

No one looks much at trees in the winter. Their bare branches are just an index of cold, and every tree looks about the same. Trees in winter are things you rush by; you hurry past them to get back indoors or you zip by them on a ski slope or in a warm car.

Yet it is possible to tell one tree from another in the winter by looking at the bark and the general shape of the tree. People who are expert at such things have usually been taught by other people who are expert. It seems to be very difficult to describe bark patterns or tree shapes well enough that you could take a book outdoors and identify trees. (In that sense bark is harder to comprehend than the cracks in oil paintings or pavement.)

It is easier to look at twigs. They don't yet have the corrugated bark of the older branches and the trunk, but a smooth *periderm* dotted with small *lenticels,* little holes that let air in to the living tissues inside. (Periderm and lenticels are two nice words: the one means "around the skin," the other "little lentil.") In Figure 22.1, the reddish twig at the lower right has orange lenticels. Depending on the tree, a

figure 22.1

Winter twigs of elm, oak, and two other species.

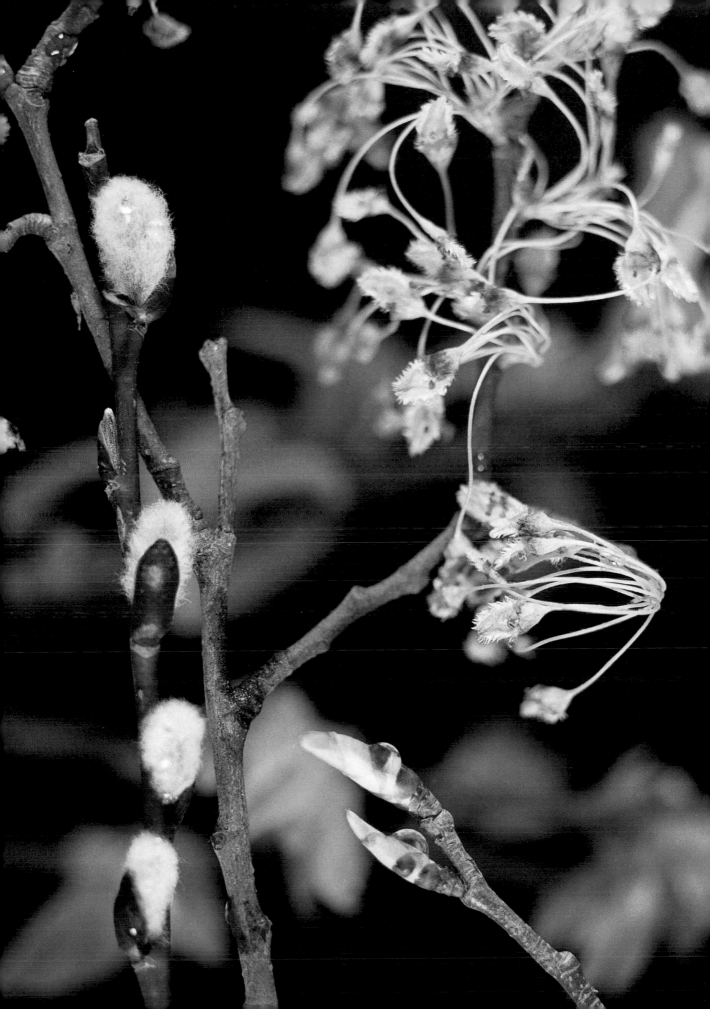

23

how to look at *sand*

I have a lovely collection of microscope slides of sand from all around the world (Fig. 23.1). Some are from places near where I live and others are from places I will probably never visit. (I especially like the sand from Saint Helena Island, where Napoleon was exiled. I can imagine him pacing up and down on the rough, dark beaches, looking out over the ocean.) The slides are lovingly prepared in the nineteenth-century fashion, and the sand is sealed in pools of glycerine. When I tip them on end, the sand slowly tumbles down as if in a tiny snow dome.

I'm not sure I ever would have paid attention to sand if it weren't for my sister. She is a geologist, and the guest author of this chapter. The sand I had seen was more or less white. I had been to White Sands National Monument and even Coral Pink Sand Dunes, and I had seen the black sand beaches of Hawaii on television. But I suppose I thought that sand came in only a couple of varieties, and that was that.

Sand is formed when rocks are ground down by weather or when they simply dissolve. Many of the commonest rocks are actually made of small crystals; if you pick up a stone at random and look at it closely, chances are you'll see small bits

figure 23.1

Collection of sand from around the world.

and pieces of slightly different colors. Different minerals dissolve at different rates, so rocks that are exposed to the air will gradually start looking like sponges, with tiny pits and holes where some minerals have dissolved away. Other rocks are ground down by rivers or cracked by ice or abraded by the wind, and slowly pummelled into smaller and smaller pieces.

The sand you see on a beach or in the desert might have been freshly extracted from some mountain nearby or it might have been brought there by a river or an ocean that has long since disappeared. One of the wonderful things about sand is how far it reaches into the past.

To get to know sand, you need a strong pocket lens. (A big Sherlock Holmes–style magnifying glass is not strong enough: you need a little pocket magnifier of the kind that is sold in camping supply stores.) Through the lens sand looks entirely different—the little grains become big rocks, each one different from the others (Figs. 23.2 and 23.3).

Without a specialist's knowledge and some fairly expensive equipment, you cannot identify every mineral you see. (Most of it is quartz anyway.) But you can be fairly exact about the shapes of the grains. In geology, *shape* is the overall look of a grain—whether it is round, cylindrical, rhomboid, disk-shaped, or flat like a sheet. *Roundness,* on the other hand, is a measure of the angles and the sharpness of the edges. Imagine drawing a circle around a sand grain so that the whole grain is included inside the circle. (See the upper right of Figure 23.3, where I have drawn a dashed circle around a single grain.) The ratio between the area of the grain and the area of that circle is the *shape.* Then imagine drawing another circle inside the grain, as large as you can make it while keeping it inside the grain. Also picture drawing little circles that fit tightly into the corners of the grain. (I have not drawn those, because they would be too small to see clearly.) Then *roundness* is the ratio between the radius of the corner circles and the radius of the large inscribed circle. In this case, the shape is about 0.75 and the roundness is about 0.5.

When a grain is freshly liberated from its rock it can sometimes be identified by shape. When minerals are still in their original rocks they frequently are crystallized into very angular shapes. Since each mineral has its characteristic crystal shape, it is sometimes possible to identify minerals just by looking at their shapes. One of the

figure 23.2

Sand from Provincetown.

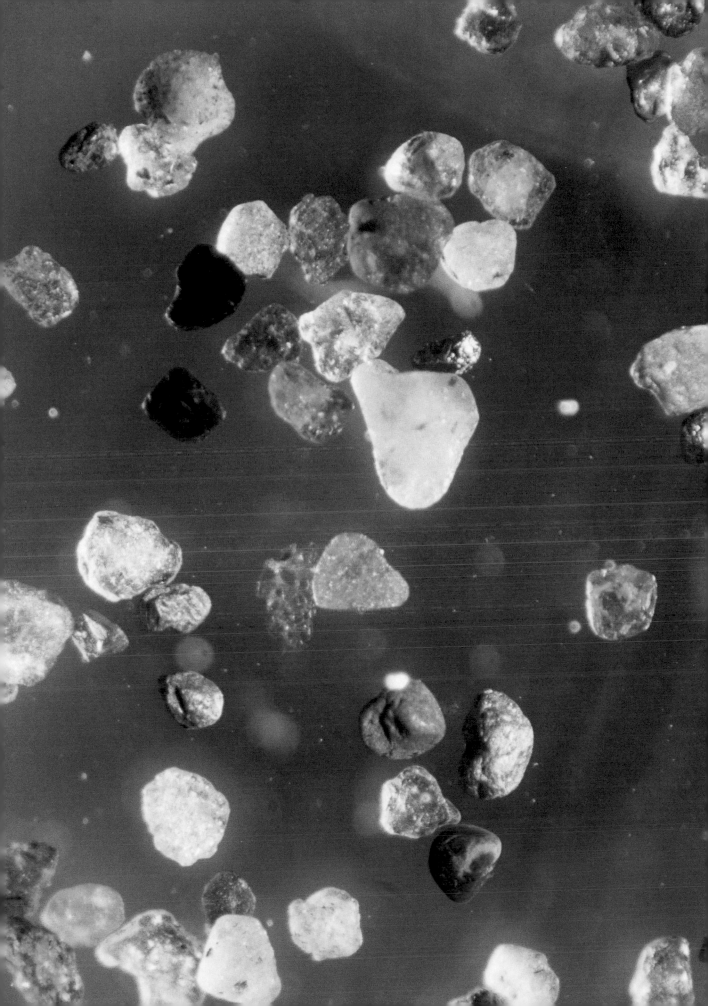

most common of all minerals in the Earth's crust is feldspar; a piece is visible in this sample (Fig. 23.3, F). Feldspar can come in many colors although it is mostly grayish; it typically forms skewed rectangles (rhomboids). Pieces of feldspar tend to have planes at right angles, like skyscrapers with lots of terraces and asymmetric blocks. The grayish grains at the upper right may also be feldspar. Quartz is the most common mineral in sand, and most of the grains in this sample are quartz. Some of the yellower, vitreous grains may be quartz that has been stained red with iron (grains labeled Q). Quartz forms spherical grains and also very thin "pencils" and "blades." Mica, another common mineral, forms thin sheets. Sand can be very simple—all round quartz, or all blocky feldspar—or it can contain virtually any mineral. Here the dark grains may be ilmenite, rutile, or magnetite (lodestone, the famous natural magnet), and the green grains may be olivine (grains labeled G). Some sands are made entirely of the shells of microscopic organisms, and with a hand lens you can pick out the ribs and curves of the shells. Oolitic sand, like that at the bottom of Figure 23.1, is made of tiny spheres of limestone.

The sharpest grains in Figure 23.2 are the ones most recently dislodged from their parent rocks. There is an especially sharp little piece of quartz at the center left margin, labeled Q! It looks pristine and unscratched, as if it had only been out of its rocky matrix for a year or two. Other grains are well rounded, well on their way to being spheroids, like the one labeled R.

It used to be thought that sand grains became round by rubbing against each other in the surf or by being tumbled together in riverbeds. Recently, geologists have realized that it takes millions of years of abrasion even to begin to round a sand grain. That means that a well-rounded grain, like the green one in Figure 23.2, may have gone through several "cycles": first it was a crystal in a rock, then it was dislodged and ended up on a beach or in a riverbed. It may have been tossed around in the ocean for a couple of million years. Eventually, it settled somewhere—say at the bottom of a lake. As smaller grains of dust and dirt settled around, it became impacted and eventually hardened into stone. A few more millions of years and the lake might have dried up, exposing the lake bottom. Again the little grain would have sprung free and been washed away to some other beach. Again it would have been tossed around and gotten a little rounder.

figure 23.3

Diagram of the sand from Provincetown.

A round grain like the one labeled R might have lain about on different beaches three or four times over the course of a hundred million years—an amazing thought. It would have sat on a beach long before there were dinosaurs and then again millions of years after the dinosaurs vanished, and then one last time in the late nineteenth century, when an amatuer naturalist scooped it up and put it on a microscope slide. The smaller the grain, the more slowly it becomes rounded. A really tiny round grain could have been at the bottom of a lake and then—in the scale of time that only geologists can appreciate—it could have been slowly lifted up into a giant mountain range, and then broken off the mountain, washed down to an ocean, stuck in a deep sediment, turned again into a rock, and so on . . . at least for me, the aeons are too long to imagine. "Sand grains have no souls but they are reincarnated," is how one geologist puts it. He says that the "average recycling time" is around two hundred million years, so that a grain of sand that was first sprung free of its first rock 2.4 billion years ago could have been in ten mountain ranges and ten oceans since then. Even the giddy numbers of Buddhist reincarnations (some deities live billions of years) can't bring home eternity for me in the way this simple example does. Think of it next time you hold a grain of sand in your palm.

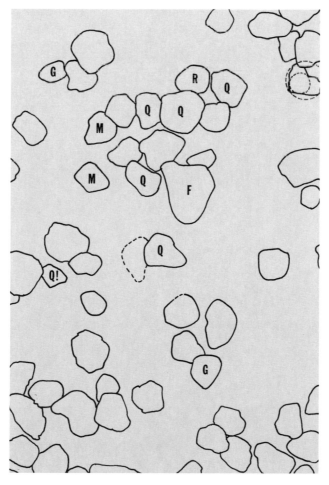

how to look at
moths' wings

Chances are that the little brown moth that flies into your light or lies dead and dried up on the windowpane isn't brown at all. Its wings are probably a mixture of faint tans, greens, yellows, mauves, grays, and blacks all swirled together like a chip of bark or a heap of dead leaves—which is probably what the moth is mimicking. The patterns are complex but they are not random. They derive from a simple "ground plan"—a kind of template that is shared, more or less, by all butterflies and moths. If you can read the ground plan, you can decipher the wing patterns of almost any moth or butterfly. What once seemed senseless will reveal itself as a specific distortion, a particular variant on the basic plan.

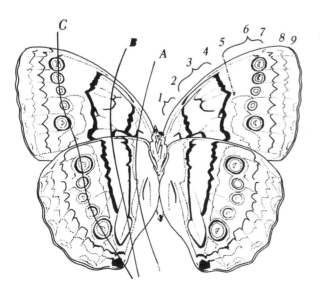

figure 24.2

Diagram of Figure 24.1. 1. Position of basal symmetry system. 2. Central symmetry system, proximal band. 3. Central symmetry system, discal spot. 4. Central symmetry system, distal band. 5. Ocellary symmetry system, proximal band. 6. Ocelli. 7. Ocellary symmetry system, parafocal element. 8. Submarginal band. 9. Marginal band. A, B, C. Approximate axes of symmetry for the basal, central, and ocellary symmetry systems.

figure 24.1

The morpho butterfly Stichophthalma louisa
(Nymphalidae: Morphinae) from Thailand. Underside.

It is best to start with butterflies, because many of them are bigger and more colorful. The "basic Nymphalid ground plan," as it's called, is shown in Figures 24.1 and 24.2. (This is the underside of the famous iridescent blue Morpho butterflies.)

The wings are patterned according to symmetry systems marked A, B, and C. Line B is the axis of the "central symmetry system"; right on the axis there is a central element called the "discal spot" (number 3) and symmetrical lines on either side (numbers 2 and 4). Ideally, the discal spot would be a symmetrical spot, and the lines 2 and 4 would mirror one another perfectly across the axis B. But when it comes to butterfly and moth wings, this is fairly good symmetry. A few species are very geometrically accurate, but most have rough symmetries, and you have to search for them.

Axis C is another symmetry system; it was once called the "ocellary symmetry system," because its central axis is typically a row of eyespots called *ocelli.* Here the eyespots are very well developed, but the flanking lines, numbers 5 and 7, are not as easy to see. The proximal line does not even begin until partway down the front wing; I have drawn an arrow from number 5 to the place where it starts. The distal line, which is also called the *parafocal element,* is much better defined. It's easier to see this symmetry system if you look for elements 5, 6, and 7 on the hind wings, where they are more continuously marked.

There is also a third symmetry system, marked A, but it is hardly present on this butterfly. All that is left of it is a single line just above the hind wings. On other butterflies it can be just as developed as the central symmetry system (axis B). There are also stripes and other shapes on the outside margins of the wings; they are called *submarginal* and *marginal bands* (numbers 8 and 9).

The terminology is confusing because it is not quite uniform. I find the schema easy to visualize if I concentrate on the three symmetry systems A, B, and C, and don't bother as much with smaller details. Each of the three symmetry systems can get extremely complex, but they tend to remain symmetrical; a butterfly might have a green stripe to the right of line 2, but if it does, it will likely have another green stripe to the *left* of line 4. In other words, the features develop as if the lines A, B, and C were places where mirrors had been laid down onto the wings. No matter how many features there are, they tend to be symmetric.

Two things complicate this simple ground plan. For one thing, entire symmetry systems might atrophy or disappear entirely, like the basal symmetry system in this species (axis A). Also, the patterns can shift right and left along the veins of the wings until they are so far out of alignment that it's difficult to find them. On this butterfly, the ocelli are already a little out of line. By and large, however, these are

f i g u r e 2 4 . 3

Butterflies, mostly from the Upper Huallaga Valley, Peru.
Clockwise from center left: Patroclu ovesta, *Peru;* A. avernus, *Peru;* Egyptiani polyxena,
Peru; T. albinotata, *Peru;* C. prometheus, *Peru;* Pyronia Bathsheba sondillos, *male,*
Costa Brava, Spain; center: Elymnia nelsoni, *Sapora Island.*

figure 24.4

The "Beloved Underwing" moth Catocala ilia, *variety* uxor *(Noctuidae).*
Natural color (top), and modified to bring out the pattern (bottom).

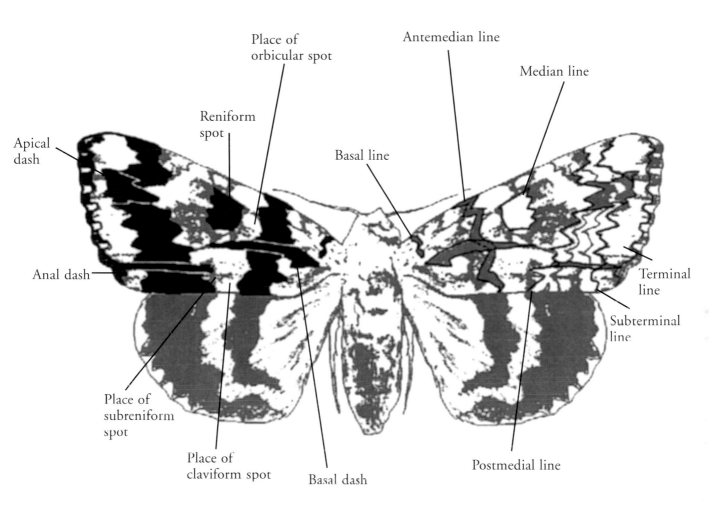

Apical dash

Reniform spot

Place of orbicular spot

Antemedian line

Median line

Basal line

Anal dash

Terminal line

Subterminal line

Place of subreniform spot

Place of claviform spot

Basal dash

Postmedial line

Spots and Dashes

Lines

f i g u r e 2 4 . 5

The "Beloved Underwing" moth. Diagram of the key features.

the essential elements of all butterfly and moth wings. Figure 24.3 is a selection of other species. The large, dark butterfly at the center left is like the one in Figure 24.1, but some elements are missing. The ocelli are there, and they are flanked, very unevenly, by white lines on the left and right. (It is as if the ocelli had been pushed to the left, so they are up against the proximal line. The distal line is farther off, toward the edges of the wings.) There is a reddish submarginal line, and an ocher-colored marginal line. The central symmetry system (numbers 3, 4, and 5 in Figure 24.2) is harder to locate: the central discal spot is the bluish stripe, and it is flanked by a fainter blue spot and a double yellow line on the forewing.

Each species is a puzzle in itself. The butterfly at the upper left has very tiny, faint ocelli on its upper wing, but they are enough to fix the ocellary symmetry system. The little butterfly at the lower left has almost nothing left of the central symmetry system—only a single little streak on its forewings. The butterfly at the center right has a central symmetry system, but it is reduced to a deep brown triangle. The one on the lower right has a few ocelli on its upper wing, but they are pushed far out toward the edge of the wing. Most of the forewing is taken up with a lovely tracery of lines, all broken-up versions of the two symmetry systems A and B and the lines 1, 2, 3, and 4 in Figure 24.2. The owlet butterfly at the upper right has a single huge eyespot (complete with a fake reflection in the pupil), but once you know to look for a *row* of ocelli, you can find two others, and the dark area surrounding them that comprises the symmetry system, just as in Figure 24.2.

Wing patterns get especially hard to locate when the butterfly or moth is mimicking leaf litter. The small purple butterfly in Figure 24.3 is a case in point. On that butterfly the marginal and submarginal bands are still visible but the rest has disappeared into a forest of confusion.

And what about little brown moths? The one in Figures 24.4 and 24.5 is a typical example. The upper wings are camouflaged, and the lower wings have bright "disruptive" coloration. The moth sits with the lower wings hidden and flashes them when it feels it's in danger. The result is startling—I've seen it at work—and it probably disorients the birds who are looking for an easy meal. Moth forewings have a slightly different pattern from the standard Nymphalid ground plan. The whole point of a camouflaged wing is to hide the symmetry patterns, and so it can be hard to pick them out. I have tried several strategies in Figures 24.4 and 24.5. First I traced the major lines and altered the color, and then, in Figure 24.5, I traced individual lines (on the right) and also colored in the major features (on the left).

In moths, one symmetry system often predominates. In this species the bright white spot is on the axis of symmetry, and there are two dark patches on either side. They are easiest to see on the left of Figure 24.5. Coloring them makes it clear that they are part of the same pattern as the bright stripes of the hind wings. Each dark patch can subdivide and become a symmetry system in its own right. The right half of Figure 24.5 brings out some of the individual lines that comprise the two dark patches; and a close look at the moth itself shows that the outer patch is actually subdivided into four lines: two dark ones on the outside and two lighter ones on the inside.

The bright white spot is one of four spots that commonly occur in the center of the wing. The others, which are not present on this specimen, are named on the left of Figure 24.5. Sometimes a single line runs down the very middle, separating the spots on either side; it is the *median line,* and only a little of it is present in this species (Fig. 24.5, right).

In addition, moths often have "streaks" crossing the symmetry system at right angles. This one has a "basal dash," an "apical dash," and an "anal dash." (The not-so-poetic name "anal dash" just means that the dash is toward the rear.)

It takes practice to pick out the symmetries in some moths, because their camouflage is so advanced. Every once in a while, you'll find a butterfly or moth with a truly incomprehensible pattern; that's a sign that it has evolved to the point where its ocelli, spots, streaks, lines, and dashes have dissolved into the chaos of the forest undergrowth.

how to look at halos

Ice halos are the exotic winter cousins of rainbows; both are caused by water suspended in clouds, but ice halos appear when the water freezes into tiny hexagonal crystals. There is one fairly common halo; the 22° halo that forms around the sun (Fig. 25.1). It appears mostly in the wintertime when it is bitter cold, but as the picture shows, it can also happen in warm climates as long as the clouds that cause it are high enough that they are made of ice.

The 22° ice halo is very large; it is very different from the aureoles and brownish-blue coronas that sometimes form just around the sun or moon. Twenty-two degrees is double the spread of your hand at arm's length, so the halo is a little overwhelming, as if it were somehow very close to you.

People who spend time outdoors are used to the 22° halo, which appears fairly often in the winter. It is formed only where there are clouds with the right-shaped ice crystals, so often parts of it drift in and out of focus as the clouds pass by. By far the commonest parts of it are the two bright areas at either side, which are called

figure 25.1

The 22° halo. Los Angeles, June 1995.

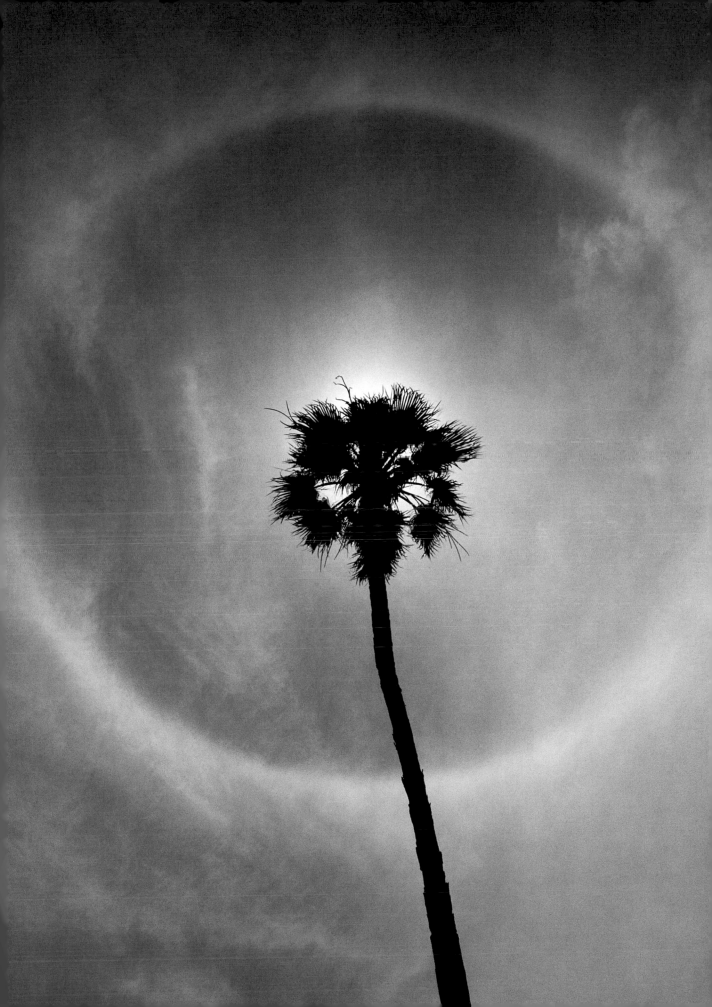

the 22° parhelia, or "sun dogs." Next time you're out on a very cold winter day, and the sun is shining brightly through thin high clouds, look left and right of the sun—two palms' lengths on either side—and more often than not you will see brilliant small spots of light. Sun dogs are usually little spectra, with all the colors of the rainbow but in light metallic tints. In my experience, people miss sun dogs mostly because a winter afternoon sky filled with high, shining cirrus clouds can be too bright to look at. But if you make a point of it, you will be amazed. Rainbows have a soft glow, but sun dogs are scintillating and iridescent.

The 22° halo and its sun dogs are only the common members of a whole family of ice halos. Some are not very rare. I have seen the 46° halo, which forms outside the 22° halo and practically fills half of the sky. (The first figure in chapter 27 is modified—and artifically enhanced—from a close-up photograph of part of the two halos. The sun is out of the picture, up above. Not all of them are this beautifully colored; the ones I have seen were dull white. Notice, too, that wherever the clouds are thicker, the halos are brighter, as at the lower left.)

Other halos are common in places where it is desperately cold. Most photographs of ice halos are taken in places like Alaska and Antarctica. I have assembled a selection of them in Figure 25.2. The 22° halo, the 46° halo, and the sun dogs come first (numbers 1, 2, and 3). In places like Alaska, the 22° halo is festooned with an upper tangent arc (10), and I have also seen the "sun pillar," a vertical line of light that can shine all the way down to the horizon and even below it, so that it looks like it is floating over the ground. The sun pillar ends at the bottom with another bright light, called the "subsun" (number 6).

From here, things get more exotic. In the Renaissance and afterward, large displays of halos were thought to be divine signals—not a surprising conclusion when you have seen them. Halos can be really disturbing to look at; it's almost as if God has written something in the sky and it needs to be deciphered. The most extensive halos were very rare—one or two would appear over Europe each century.

Figure 25.2 is just a selection, but it includes a couple of the more amazing halos. The *parhelic circle* (number 13) is a faint circle that passes through the sun and

figure 25.2

A view of the whole sky showing some of the rarer ice halos.

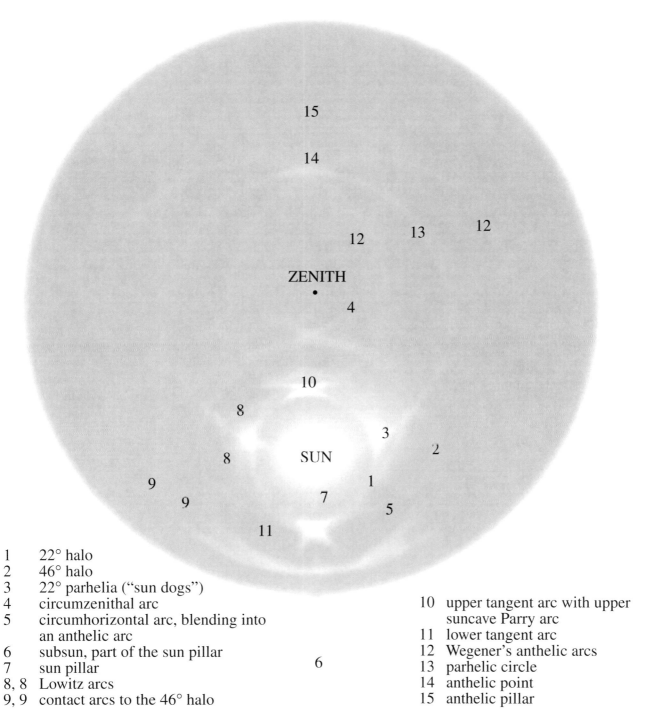

1 22° halo
2 46° halo
3 22° parhelia ("sun dogs")
4 circumzenithal arc
5 circumhorizontal arc, blending into
 an anthelic arc
6 subsun, part of the sun pillar
7 sun pillar
8, 8 Lowitz arcs
9, 9 contact arcs to the 46° halo

10 upper tangent arc with upper
 suncave Parry arc
11 lower tangent arc
12 Wegener's anthelic arcs
13 parhelic circle
14 anthelic point
15 anthelic pillar

SOME HALO PHENOMENA

continues around the entire sky at the same level, as if the sky were a dome and someone had dropped a ring down onto it. At the other side of the sky, away from the sun, there can be a bright spot called the *anthelic point* (number 14). Even more rarely, the whole sky overhead can be striped with other arcs linking the sun to the anthelic point (number 12). The anthelic point can even have its own sun pillar, called the *anthelic pillar* (number 15). Closer in to the sun there is a whole family of exotic little arcs crossing here and there: four Parry arcs (two of them blurred together at number 10), four Lowitz arcs (number 8), several contact arcs (number 9). In some photographs it looks like the sky has turned into a lace doily.

Many of these arcs have been documented in good color photographs, but no photograph captures them all. Some are so rare they have been seen only once, and others may not exist at all (they may have been hallucinated by the people who claimed they saw them). Physicists have made clear line diagrams of many of them, but I drew this picture instead, to give a sense of how hazy and faint many of the arcs can be. They depend on the clouds and the shapes of the ice crystals. There will probably never be a sky that has all of them together.

A number of physicists have worked on understanding ice halos, and in 1980 Robert Greenler wrote a book that explains virtually all of them. The 22° halo can appear whenever the ice crystals are shaped like little hexagonal columns. Sun pillars are made of light reflected off the top or bottom of thin, pencil-like crystals. Sometimes the light bounces around inside the crystals, following a complicated path of reflection and refraction. Greenler's book is a kind of scientific triumph; time after time he manages to program his computer to produce certain kinds of ice crystals, and the results are a perfect match for halos people have photographed in nature.

But in the end, it is a little sad to see nature explained so efficiently, so ruthlessly. My favorite parts of the book are the moments when he admits defeat. He looks at a very intricate drawing made by Tobias Lowitz in St. Petersburg in 1790, and he admits that his computer can't match some of the things Lowitz saw. It can match the Lowitz arcs—the ones named after his observation—but it is helpless to account for some other exquisitely fine arcs and lines that Lowitz also saw.

Over the desk in my office I have a reproduction of a woodcut made in 1551 showing a skyful of halos that appeared over Wittenberg, Germany. I have framed it along with a color photograph of a halo display that was seen in Antarctica, and the two almost match. They share several of the arcs in Figure 25.2, but the old woodcut also has two tiny cup-shaped arcs that would be just over number 10 in my drawing. Those arcs are not in the photograph, and they are not in any book that I know.

That is the real beauty of halos, as far as I am concerned—some of them are so fabulously rare that no one knows how they are formed. Even in five centuries of observing, only a few people in Wittenberg ever saw the arcs that are recorded in that woodcut. It may take another five centuries before someone manages to photograph them—and then I hope they are never explained.

26

how to look at

sunsets

When there are clouds in the air, sunsets can be any color. Occasionally a cloud might even be bright apple-green. But when the sky is cloudless, the colors follow a certain sequence. It was worked out, with typical precision, by several German meteorologists in the 1920s. Figure 26.1 summarizes their results.

During the day, the sky is blue above and white at the horizon (top left). About a half hour before sunset in the west, the sun begins to affect the color of the sky just below it (second picture down, on the right). The light at the horizon begins to turn faintly yellow; in the next few minutes it will often differentiate into horizontal stripes. The stripes are due to layers in the atmosphere, which you see nearly edge on. At the same time the sun may develop a dull brownish halo, which I have outlined because it is too faint to show up well in reproduction. At sunset the sun is surrounded by a bright whitish glow with bluish-white above. If there is orange and red in the sunset sky, this is when the colors are at their most intense.

If you look to the east away from the sun just at sunset, you will see the *counter-twilight* or *antitwlilight arch,* which soon differentiates and brightens into various

figure 26.1

Colors of the cloudless sunset.

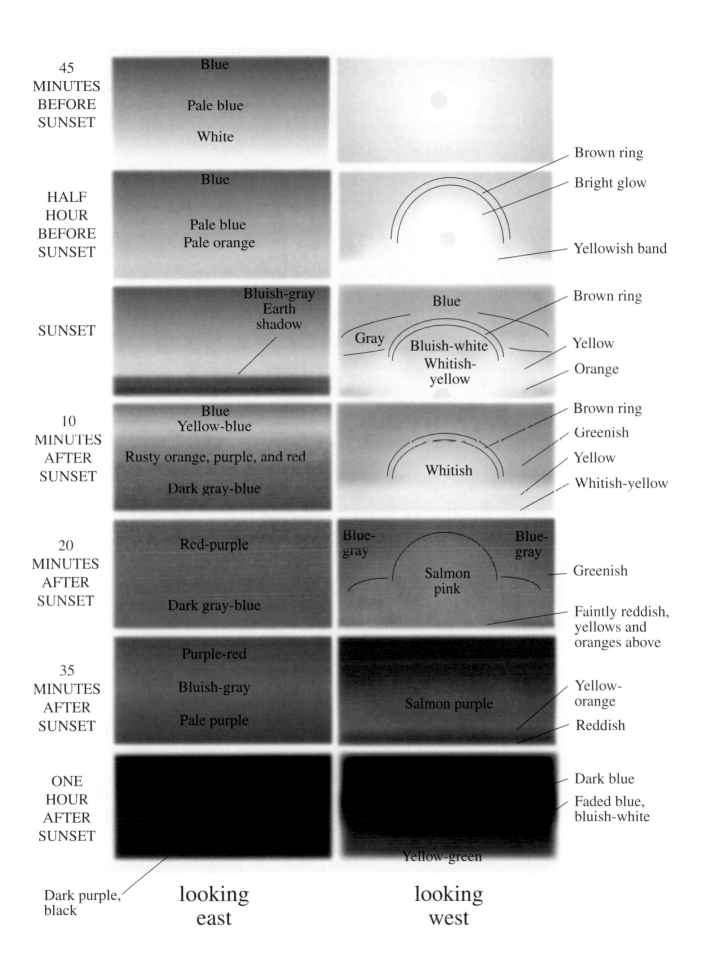

colors (third and fourth pictures down, in the left row). At its fullest the counter-twilight is orange or reddish below and cooler above, which shows that it is not a simple reflection of the sunset in the west. The explanation is that some colors are scattered more than others by the atmosphere; blue is scattered most easily and most thoroughly, which is why the sky looks blue in the daytime. Red is scattered least, which means it can penetrate very far through the atmosphere. As the sun sets, its light travels through increasingly greater thicknesses of atmosphere, so the top of the countertwilight reflects light that has traveled through less atmosphere, and the bottom reflects light that has traveled the farthest. It stands to reason, then, that the bottom of the countertwilight is reddish, and the top cooler. In effect, it is a spectrum of the sun produced by the natural prism of the atmosphere.

A few moments before the sun sets, the dark *Earth shadow* begins to rise in the east. The Earth shadow is easily one of the most awe-inspiring sights in nature, and also one of the most rarely noticed. It is nothing less than the shadow of the entire Earth, cast upward onto the atmosphere itself. Figure 26.2 shows a typical scene: the Earth shadow is the dark gray-blue portion of the sky. As the sun disappears below the horizon, the Earth shadow slowly rises and becomes less distinct. People who climb mountains sometimes see the shadow of the mountain that they are on, cast far away across the landscape and even up onto the clouds. But mountain shadows are tiny compared to the Earth shadow. You can see the Earth shadow in nearly every sunset, though it is most spectacular when there is some haze in the air. (The air-driven dust gives more of a backdrop for the shadow.) I have been amazed by the Earth shadow several times. The first time I saw it was over Lake Michigan, and as it rose, it was as if I could see the waters of the lake casting their shadow up onto the sky. Another time I saw it over the Great Plains, and I felt as if I could sense the Earth pivoting silently under my feet, turning downward toward the shadow.

The Earth shadow is one of two sublime events of the sunset. The other is the *purple light* or *purple glow,* which appears roughly fifteen or twenty minutes after sunset. (Figure 26.1, five pictures down, on the right side.) At first it looks like an isolated bright spot fairly high in the sky over the place where the sun has set, and

figure 26.2

Looking east shortly after sunset: the Earth shadow and the antitwilight arch.
December 14, 1978.

then it quickly expands and sinks until it blends with the colors underneath. The purple light is a large, diffuse, bright area of salmon- or magenta-colored light. It can be quite startling, as if there were a huge fire over the horizon. It is caused by a layer of fine particles between 6 and 12 miles up in the air; even after the sun no longer illuminates the place where you are standing, it still shines far up in the atmosphere, and the purple glow is the reflection of that light.

Since it was first described, the purple light has been the subject of several debates. It seems to be very difficult to describe its exact color. To me it looks magenta, as I have painted it in Figure 26.1. Other people describe it as "salmon pink," which I think of as a warmer tone. I wonder if some of the controversy might not stem from the fact that the purple glow contains reddish light from both ends of the spectrum: true red from the long-wavelength end near the infrared, and also magenta or purple from the short-wavelength end near the ultraviolet. The purple light itself is short-wavelength light, but it may well be mixed with long-wavelength light from the earlier sunset.

In the east at the same time, the Earth shadow rises, softens, and finally dissolves (third picture from the bottom, left-hand row). Above it is the *bright reflection* of the sunset, lingering on after the antitwilight arch has also scattered. It sometimes reflects the light of the purple glow, as I have shown it in Figure 26.1. On other evenings it carries an echo of the spectral colors of the antitwilight arch. In the photograph, the rust- or meat-colored band just above the Earth shadow is the lower portion of the antitwilight arch. In a few more minutes it will grow darker and sometimes more purplish (reflecting the purple glow), and eventually it will disperse into the general haze of the bright reflection.

Like the Earth shadow, the purple light can be an amazing sight. When it is strong, it gives a warm, light-violet tint to rocks, trees, and sand, and it has been reported that it can make buildings in a city look purplish if they face west.

In temperate latitudes the twilight does not end until 45 to 60 minutes after sunset. At that point the purple light diminishes, leaving a dark bluish-white *twilight glow,* which reaches a height of 20° above the horizon. That is the last tip of the illuminated atmosphere (bottom right picture in Figure 26.1). If you have ever tried to stay outdoors after sunset in order to finish something you were reading, you may have used the purple light. When it finally fades, the light diminishes rapidly, and that is probably when you gave up trying to read and went indoors.

Sunset colors can be hard to pick out because they all blend into one another. One observer recommends drawing imaginary lines between the colors, like the arcs

I have drawn in Figure 26.1. But at least in real life the colors are clearly visible. Even in this age of technological sophistication, no one has captured a satisfactory photographic record of the ordinary colors of the sunset. The range in brightness from the purple glow to the dark sky above is too great for most films, and naturally it is beyond the range of printed pictures. The best simulations are done on computer, because the screen has a range from black to white that is ten times the range of printed books. (Figure 26.1 looked quite realistic when I saw it onscreen before it was printed.) Most people would guess that the sun is fifty or a hundred times brighter than the moon, but it's actually a half million times brighter (and a million times brighter than the late twilight sky)—evidence of the amazing capacity of our eyes to adjust to light and dark. Figure 26.1 is just a guide; these things have to be seen with your own eyes.

If you live in the tropics, you'll know that the sunset happens very fast, because the sun sinks down almost vertically. Twilight is over in half the time. Conversely, beyond the temperate regions, these frames can be spun out into hours, and finally into days and months north of the Arctic Circle. Depending on the condition of the atmosphere, you may see much brighter colors, or much fainter ones. In Alaska north of the Arctic Circle I have seen very gray sunsets with just the faintest touches of color. On warmer vacations I have seen blazing sunsets with colors so bright they looked like retouched tourist postcards. The phenomena of later twilight are very sensitive to conditions in the upper atmosphere. The purple glow, in particular, comes and goes; one night it might be brilliant, and the next night almost absent. Dawns are very much like sunset, except in reverse, and they are said to be better for this kind of observation, because the air is generally less turbulent.

Things change, but these are the basics. With this information you can watch a sunset from beginning to end, feel the Earth rotating, and see the sky being lit—at first all around you, and then higher and higher, until only the thinnest air high up over the Earth is still illuminated. Even the colors of the sunset, so famous because they are nothing but pure meaningless beauty, can say a great deal about the Earth, the sun, and the path of the sun's light through the air. And it's also a wonderful way to spend an evening—looking into the air and trying to find invisible boundaries between colors that mutate slowly and continuously into one another, blending imperceptibly and growing imperceptibly darker.

27

how to look at

color

How many colors are there? Your computer monitor will probably tell you "millions," unless you are using an older computer, in which case it may say "thousands," or just "256." It is said that the human eye can distinguish over two million different colors, so I wonder if there might be more colors on your computer screen than you can actually see.

But on the other hand, there seem to be very few basic colors. The rainbow is normally said to have seven colors. When I was in school, they were counted using the mnemonic "Roy G. Biv": red, orange, yellow, green, blue, indigo, violet. But in school we also learned that three colors of paint can be used to mix any color: red, yellow, and blue. Which one is right? Or is the rainbow something special, different from paint?

In the West people have been writing about color for over twenty centuries, and there is still no agreement about the number of basic colors. The number of basic colors depends largely on who you ask: a neurophysiologist, a psychologist, a painter, a philosopher, a photographer, a printer, a stage designer, and a computer graphics expert will all have different answers. Here are some of the theories; you might want to see where yours fits in.

figure 27.1

Three sets of primaries, against a background of halos. Top: the subtractive or painters' primaries. Middle: the additive primaries. Bottom: the peaks of the three kinds of cone cells in the retina.

1. Rainbow "Primaries": Red, Orange, Yellow, Green, Blue, Indigo, and Violet

Ever since Newton used a prism to separate white light into the spectrum, there have been varying opinions about how many colors he found. Newton himself favored six, but he vacillated on that point. "Roy G. Biv" is seven colors; teachers find it useful because blue, indigo, and violet are hard to remember without some assistance. Historically, they are all interchangeable. In the Middle Ages, violet was sometimes spoken of as a light color, akin to white. Indigo is not a common color word in English, especially because it has connotations of the fabric industry and even slavery (since the dye was extracted using slave labor). It does seem that the rainbow has discrete colors, but what exactly are they?

2. Painters' Primaries: Red, Yellow, and Blue

This is a theory first developed in the seventeenth century by artists. The idea was to find a minimal set of colors that could be used to mix all other colors—but it didn't work. Contrary to what you might have been told in elementary school, there are many colors that cannot be mixed starting with the painters' primaries. If you mix red and yellow, you get orange, but the orange is ever so slightly less intense than another orange you might buy separately. That is because the intensity (chroma) of the color decreases slightly with each mixture. In Figure 27.1, the painters' primaries are shown at the top: they are still the most influential set of primaries, despite their shortcomings.

3. Printers' Primaries: Red, Yellow, Blue, and Black

You also can't mix very dark colors if you start with yellow, red, and blue. For that reason modern artists and printers add black. The set of four is usually abbreviated CMYK (for "cyan, magenta, yellow, black"). Many people would say that black doesn't count as a color (or that it doesn't start with "k"), but it is still indispensible and so, in a sense, it is one of the primaries.

4. Another Set of Painters' Primaries: Red, Yellow, Blue, Black, and White

One of the earliest formulations for painters' primaries is the same four plus white. (In printing, white ink is not as important, since the page is white.) This set of five primaries was codified first at the end of the Renaissance, and it became the basis of the first theories of primary colors in the seventeenth century.

5. Additive Primaries: Orange-Red, Green, and Blue-Violet

Painters and printers use the ordinary "subtractive primaries," but stage directors, computer graphics designers, and photographers use the "additive primaries." If you are mixing colored lights and not colored pigments, then the three colors orange-red, green, and blue-violet can make almost any color. *Almost* any color, because they have the same shortcoming as the subtractive primaries: they can't produce extremely high-chroma colors.

In Figure 27.1, the additive primaries are in the second row. It took a long time for the difference to become widely known, probably because additive primaries look and work so differently from subtractive primaries. If they are all mixed together, they make white light, but if you mix all the subtractive primaries, you get dull gray. Light added to light makes more light; but paint added to paint tends downward toward black.

6. Computer Graphics Primaries: Red, Green, Blue, Cyan, Magenta, and Yellow

Computer graphics software can translate freely between additive and subtractive primaries. The additive colors orange-red, green, blue-violet (simplified to red, green, and blue, and abbreviated RGB) are one option, but with the click of the mouse, a picture can be changed to CMYK. Most work onscreen is done with additive primaries because the screen is colored light, but the computer knows how to translate into individual subtractive colors.

In most painting and photo manipulation software, users are offered *six* primary colors: R, G, B, and their opposites cyan, magenta, and yellow. At first this seems wildly counterintuitive. Isn't cyan very much like blue? How can red be the opposite of cyan? But people who work with digital images get used to it.

Complementary colors are a relatively recent discovery; they date from Newton's invention of the color circle. It is easier at first to think of the colors in a triangle rather than a circle. If the ordinary subtractive primaries are arranged in a triangle—yellow at one vertex, red at another, blue at the third—then the "secondary colors" are clear: opposite yellow is violet, opposite blue is orange, opposite red is green. (If you sketch a little triangle, you will see how each secondary color is the mixture of two primaries.) To many people, those six colors make good sense, but can anyone really *think* in terms of red, green, blue, cyan, magenta, and yellow?

7. More Computer Graphics and Printing Primaries: Pantone, Tint, HLS, and CMY

In addition to RGB and CMYK, there are at least four other systems in use. People who work with them get used to them, just as painters get used to red, yellow, and blue, and eventually they come to seem natural. High-end software offers choices of many different systems, and artists who use computers tend to have their favorites. Strangely, it doesn't really matter whose primaries you use, because the computer does all the thinking when it comes to printing the image.

8. Ancient Greek Primaries: White, Black, Red, and Green

The impetus to reduce colors to their basics begins with the Greeks. Empedocles said that the four kinds of atoms—earth, air, fire, water—produce the colors. (It is unclear whether he thought yellow or green should be the fourth color.) This particular schema hasn't had much influence since Empedocles's time, but it is important as a reminder of how people have felt the desire to reduce colors to a manageable set.

9. Psychological Primaries: Yellow, Green, and Blue

What made Empedocles choose those four colors? If you ask whether or not a set of primaries makes sense, then you are stepping outside of science and technology and into the equally interesting domain of "psychological primaries." The question here is not which colors are scientifically capable of mixing all other colors, but which colors *feel* most elementary.

People who have thought about color this way often choose yellow, green, and blue, for two reasons. First, they are the only colors that do not change when the light dims. If you turn down the light on an orange, it will look browner, and if you turn up the light, it will get more yellow. Yellow, green, and blue are different: they do not seem to change color as the light changes. The second reason people choose these three colors is because they seem to be the most pure of all the colors. Scientists are not sure why we perceive some colors to be pure and others to be impure, but many people think they can discern purity and impurity. To some observers red looks like a mixture of yellows, browns, and oranges—even though red can be a pure spectral color, made of only one wavelength. Psychologically, yellow, green, and blue seem to be the most pure.

Science offers a number of surprising facts along these lines. All the colors of the spectrum are physically pure; that is, each one is made of light with only a single wavelength. But yellow, for example, can also be produced by mixing green and orange-red light, and there is no way for us to tell whether the yellow we see is pure

spectral yellow or a mixture of green and orange-red. Hence there is no way to know whether you are seeing a pure color, despite what you may feel. Some spectral colors cannot be made with any kind of mixture, so they are always pure. (Blue-green is an example.) And conversely, some mixtures of light can *only* make nonspectral colors—colors that are not found in the spectrum at all. Magenta, for instance, is not a color that is found in the light refracted by a prism or in a rainbow—it is a mixture of red and blue. It is strange to think that you can't tell a pure color from an impure one or that there are colors that have no place in the spectrum, but science proves it. The psychological primaries yellow, green, and blue are therefore doubly mysterious.

10. Psychological Primaries:
Yellow, Green, Blue, Brown, White, and Black

Other people have different lists of colors that seem most fundamental. Some add brown, even though brown is a nonspectral color made of a mixture of yellows, oranges, and reds. Others think of black and white as colors, despite the fact that our teachers always say that black is the absence of color and white is all colors. And there are many other answers as well.

11. More Painters' Primaries: Yellow, Green, Blue,
Red, Black, and White

At one point Leonardo da Vinci advocated a set of six primaries for painting; his choices were close to the psychological primaries, but with the addition of red. (In other texts he changed his mind and said that green and blue were also compound colors and not primaries.) We tend to think of intuition and technology as two very different endeavors, but before the twentieth century there was no clear demarcation between psychological primaries and scientific primaries. And by the same token, in a few centuries' time our science might turn out to be based on psychology: our CMYK and RGB systems might turn out to be founded as much on how we *feel* color behaves as on the ways that science proves that it behaves. Leonardo was scientifically minded by the standards of his time, but he was also a working artist. His six-color system of primaries serves both purposes.

12. Emotional Primaries: Dark Blue, Blue-Green, Orange-Red,
Bright Yellow, Brown, Black, and Gray

The psychologist Max Lüscher invented a test in which people were asked to rank colors in order of preference. In one version they were given seven colors, and Lüscher reports that they ranked them in the order I have given above.

In general, Lüscher found that blue is considered passive, inward-turning, sensitive, and unifying, and that it expresses tranquility, tenderness, "love and affection." Orange is thought of as active, offensive, aggressive, autonomous, and competitive. Historically none of this holds water, because Lüscher was clearly measuring the preferences of his time and place (mid-twentieth century, upper-class, educated Europeans). Many of his own ideas about color can be traced to philosophers such as Goethe and painters such as Kandinsky. But the emotional content of colors is important. For many people, the emotional associations of colors determine their number and their arrangement.

13. SYNESTHESIC PRIMARIES: "SHRILL" YELLOW, "DULL" BROWN, "MASCULINE" RED

One step further along this road and we arrive at synesthesia, the notion that *all* the senses might be involved in comprehending color. The number 3 used to seem brown to me, and I used to think that yellow had a kind of shrill, piercing sound to it. Synesthesics tend to think that their associations are just their own, but often enough it turns out that they come from the common culture. Kandinsky said that yellow is like a shrill-sounding canary, and he said it 50 years before I did. I wonder if it's luck that brown is number 5 on Lüscher's test—not far from 3.

If you associate colors with smells, images, tastes, textures, temperatures, sounds, animals, directions, or even times of day, then your list of primaries may be different from lists made by people who do not experience synesthesia—but don't be surprised if someone else has the exact same ideas you have.

14. PHYSIOLOGICAL PRIMARIES: GREENISH-YELLOW, ORANGE-RED, AND BLUE

There are also primary colors built into our eyes. Color vision is dependent on three kinds of color receptors in the retina, called the A, B, and C cone cells. Each kind is receptive to a range of light but most sensitive to just one wavelength. Those called A are maximally sensitive to orange-red; the B cells are most sensitive to green-yellow, and the C cells to blue.

What we experience as colors are actually particular ratios of responses from the three types of cone cells. If something appears orange, for example, it is because the

figure 27.2

The CIE diagram and the spectrum in a dark landscape.

A cone cells are absorbing 80 percent of the light, the B cone cells 20 percent and the C cone cells are not absorbing the light at all. This goes against what you might imagine—we do not have a sensor in the eye for each wavelength and, even more surprising, the "primaries" in the retina do not correspond to any of the primaries that I have listed. I have put them on the bottom row of Figure 27.1, so you can make a rough comparison with the subtractive and additive primaries.

The fact that the retina has its own set of primaries is a very deep mystery. If humans naturally tend to think that some colors are basic or primary and if we naturally group colors into a small number of color names, then why aren't those names and those colors the ones that we are actually built to perceive? If you're going to spend time wondering about color, this is an excellent place to start.

15. Ideal Primaries: Ideal Red, Ideal Green, Ideal Violet

Another scientific schema for color is the CIE system defined in 1931. It was inspired by the painters' and printers' problem of mixing high-chroma colors. Mixtures of the subtractive primaries red, yellow, and blue cannot make all visible colors, but it is possible to imagine extremely intense colors that *could*. Such colors are not real and we cannot see them, but they can be used to measure all colors that actually exist. That is the idea behind the CIE diagrams. One is shown at the bottom left of Figure 27.2.

The actual visible spectrum is bent around in a horseshoe shape, and red is connected with violet along the bottom edge. The whole shape is then set on a graph. The horizontal scale measures the degree of "ideal red," an imaginary, super-high-chroma red. At the end of the horizontal axis is 100 percent "ideal red." The right-hand side of the horseshoe points toward it, but we cannot perceive red that is more intense than the hue shown at the corner of the horseshoe. Ideal green is on the vertical axis, and again visible green stops short of it. (The third ideal primary, ideal violet, is calculated just as the remainder of the other two.) The center of the chart is "equal-energy white," a perfect mixture of all the spectral colors, and from there the colors get more saturated out to the curved border.

The CIE system is immensely useful. If you match a color sample to a spot in the horseshoe, you can calculate how it could be mixed by drawing a line from equal-energy white to the border of the horseshoe. CIE diagrams have also been used to visualize color changes. If you look at a very bright white light and then look away, you will see afterimages in various colors. First the light will look greenish-yellow, then pale pink, then reddish, reddish-purple, bluish-purple, and finally pale blue. The path is marked out by the curved line. I tried it by looking at a strong halogen bulb, and it works exactly this way.

All this is useful for color technology, but I wonder if "ideal red" or "ideal green" can ever seem intuitively right. Is it possible to imagine all visible colors as toned-down versions of intense, imaginary colors? The ideal primaries probably cannot make any more sense than the idea that the visible spectrum is just a small part of the longer electromagnetic spectrum (Fig. 27.2, bottom right). Who can really understand what it means that some wavelengths of light have color and others don't? The CIE diagrams may be the furthest that scientific theories of color have ever gotten from psychological primaries.

16. Linguists' Primaries: Black, White, Red, Green, Yellow, Blue, Brown, Purple, Pink, Orange, and Gray

Ever since the nineteenth century, linguists have studied the words for colors in different languages. The field is still in flux, but it seems clear that the words for color determine much of the *experience* of color as well as the various *practices* of painting and drawing. (If you don't have a word for something, you are not likely to notice it.) According to one study, each language progresses from the point where it has only two color terms—black and white—to the point where it has 11. Beyond that, the terms tend to get specialized: "chartreuse," "ocher," "bay," "madder," and thousands more come from particular fields. The linguists' supposition is that something around 11 terms characterize most English-language speakers' everyday sense of color. This is another sense of "primary colors"—the words you habitually use to structure your experience.

The desire to make systematic sense of color runs deep, but as the art historian John Gage points out, all this literature is somehow inconsequential, because what we really love are the myriad of unsaturated, unnameable colors, not the garish primaries. I painted the backgrounds of these pictures to get away from the dull parade of color boxes: and at least for me, the backgrounds are where the real interest lies.

how to look at
the night

Night is when most of us stop looking—after all, it's when there is nothing to see. The sky over a city glows dull orange or pale yellow all night long, winter and summer, and there is not much left of the heavens. Where I live, in Chicago, I am lucky to see 20 stars on a clear night. In downtown Los Angeles there are clear nights when no stars at all are visible. But if you are far enough away from a city, there are thousands of stars and several other, more exotic kinds of lights to be seen.

To see those fainter lights, the moon must be absent. Have you ever tried to look at the stars when a full moon is shining? It spreads a cool, bright haze over most of the sky, like a paler sun. Astronomers keep away from moonlit nights, just as they try to keep away from big cities. If the moon isn't around, then the sky is still lit up by the stars, but much more faintly. If you're in an unpopulated spot, and there is no moon in the sky, you can see between a thousand and five thousand stars, depending on your altitude; those are not very large numbers, and on an average night it can seem as if you might be able to count them all. Telescopes, especially in the twentieth century, have overturned that simple notion. Aside from cities, the

figure 28.1

The night sky as seen from Cerro Tololo, Chile.

moon, and the visible stars, the night sky is also lit by the myriad of stars that are too faint to be visible by the naked eye. What seems to be dark sky between stars is actually a very faintly shining fabric of thousands of millions of stars and galaxies. Astronomers say there are around ten billion stars in the galaxy, and between any two stars there are uncounted numbers of galaxies. Recently astronomers have even counted the average number of galaxies per patch of sky, right out to the end of the visible universe. Telescopes fill in the gaps between stars, but they also get rid of the poetry, the idea that things we cannot see still contribute their faint light. Taken all together, the light of the visible and invisible stars and galaxies is called the *integrated starlight.*

I think that one of the saddest things about city life is that so many people have never seen the Milky Way or even thought about seeing it. If you are out in the countryside, the Milky Way looks like a very pale, undulating, soft stripe crossing over the entire vault of the sky. Figure 28.1 is a picture of the whole sky taken in the Southern Hemisphere. This is a good view of the Milky Way, and you can even see the dark dust clouds braided in with the stars. (The two very small rectangular patches of light at the bottom of the photo are the Magellanic Clouds, two minor galaxies close to the Milky Way. They can be seen only from the Southern Hemisphere.) If you are out in the desert or on an island far from the mainland, the Milky Way can be genuinely astonishing. In its full splendor it is a scintillating, candent pathway across the sky, and it continues right down to the horizon. I have seen it plunge into the ocean, like a white waterfall.

So there are the moon, the visible stars, and the integrated starlight, which includes the Milky Way. Another source of light is the *airglow* or *nightglow.* It forms a continuous shining envelope around the Earth caused by the spontaneous recombination of molecules in the night air. The sun heats the sky, and some molecules split apart in the daytime. By night they recombine, giving off tiny amounts of light. It has been estimated that nightglow contributes a quarter to a half of the light in the night sky. That means that even the deepest dark nights, the ones when the Milky Way is the brightest thing in the heavens, are still lit by the weak light of the glowing sky itself. When astronauts say how dark space is, the light they are missing is the nightglow. There is a hint of the nightglow in Figure 28.1, because the sky gets a little brighter at the horizon. Often that is due to lights reflected from cities, but even in very isolated places you will still see a tiny increase in light at the horizon, and that is due to the atmosphere itself.

Even fainter is the *galactic light,* a diffuse glow that scatters off the dust in the space between the stars. It is said to account for an additional 6 percent of the light of the night sky, too faint to be distinguished from the integrated starlight and the nightglow.

Dust accounts for another of these nighttime lights, the *zodiacal light.* It is caused by the zodiacal cloud, the name astronomers give to the dust that orbits the sun along with the planets and asteroids. Sunlight that reflects off the zodiacal cloud is called zodiacal light. The zodiac is the path that the planets follow through the sky. In Figure 28.1, the zodiac starts at the right, at 3 o'clock, and arcs over to the left, crossing the Milky Way, to about 9 o'clock. (That means that in the daytime the sun would follow that same course.) An astronomy magazine can show you where to look for the zodiac in your locality, but you can also find it at night by noticing where the sun goes during the day, and then remembering that path when you go out at night.

Conditions have to be just right to see the zodiacal light; in Figure 28.1 it is the bright cone that rises from the horizon at 9 o'clock. The light reflects the sun, which is hidden behind the Earth. Later in the night, when the sun is even farther behind the Earth, the zodiacal light disappears—from then on it is too faint to be seen by the unaided eye. Like the galactic light, the zodiacal light comes from beyond the Earth's atmosphere, so it is more clearly visible from space. Astronauts say it is brilliant when it is seen from orbit or from the surface of the moon.

When the sun is directly underfoot and the night is at its darkest, some people say they can see an extremely faint glow directly overhead, just where the sun would be at noon. That last and weakest of the extraterrestrial lights is the *Gegenschein,* meaning "counterlight." It exists but it is nearly impossible to see with the naked eye. It is also caused by the dust in the zodiacal cloud, and the idea is that it shines brighter at the point diametrically opposed to the sun, just as a cat's eyes shine back at us when everything around is dark. I have never seen the Gegenschein, but people who have say that the best way to spot it is to sweep your eyes back and forth across the area where it should appear, keeping your vision slightly averted. It is the most elusive of the lights of the night sky.

The diffuse galactic light, the zodiacal light, and the Gegenschein are the last sources of light that come from beyond the Earth. Other lights closer to home subtly mark the time of night and the approach of dawn. The *night twilight glow* follows the sun, from west to east. If you are in the Northern Hemisphere, you can see the night twilight glow moving along the southern edge of the sky, and if you're in the Southern Hemisphere, it will move along the northern sky. The farther toward the poles you live, the higher the night twilight glow will be. In Greenland it reaches over halfway up to the zenith. The most perfectly dark nights are therefore in the tropics, where the sun sinks lowest beneath the horizon.

About two and a half hours before sunrise, the *early twilight glow* appears in the east and reaches the zenith about two hours before sunrise. After that, dawn begins.

There are also hidden lights in the sky—radiation of various wavelengths, from invisible heat to cosmic rays. If our eyes could detect infrared light, the Earth would be a very different place to live in, because during magnetic storms the entire sky is striped in invisible infrared arcs called *M-arcs* (or *red arcs,* or *SAR-arcs*). The light is very strong, but our eyes don't notice. Photographs of the M-arcs made with special film are spectacular—the whole sky becomes a zebra.

While you're outside, you might try looking around to see how things change in the dark. The night looks monochromatic because the eye's color sensors shut down, but actually the "rod cells" of the eye, which provide night vision, are not equally sensitive to all wavelengths. Their receptivity peaks in blue-green light, so we perceive blue-green dark things much better than red dark things. Find a tree or bush with red berries, and go out and look at it at night. The berries will be very dark, almost invisible. If you take note of the colors of objects in the daytime, you'll see how they seem relatively too light or too dark at night, depending on how much blue-green color they have. At night, your night vision is best when you do not look directly at an object but focus on a spot off to one side. I used to think that was an old wives' tale, but it turns out there are actually more night vision receptors around the center of the retina than there are right at the center. Amateur astronomers know that this is so, and you can test it yourself by looking at some especially faint stars. The very faintest ones will disappear when you look at them face on.

But please don't try any of this in a city or even in a big town. Where there is civilization, there isn't any real night. If you have been outside for half an hour and you still can't see your hand in front of your face, then you are experiencing a real night.

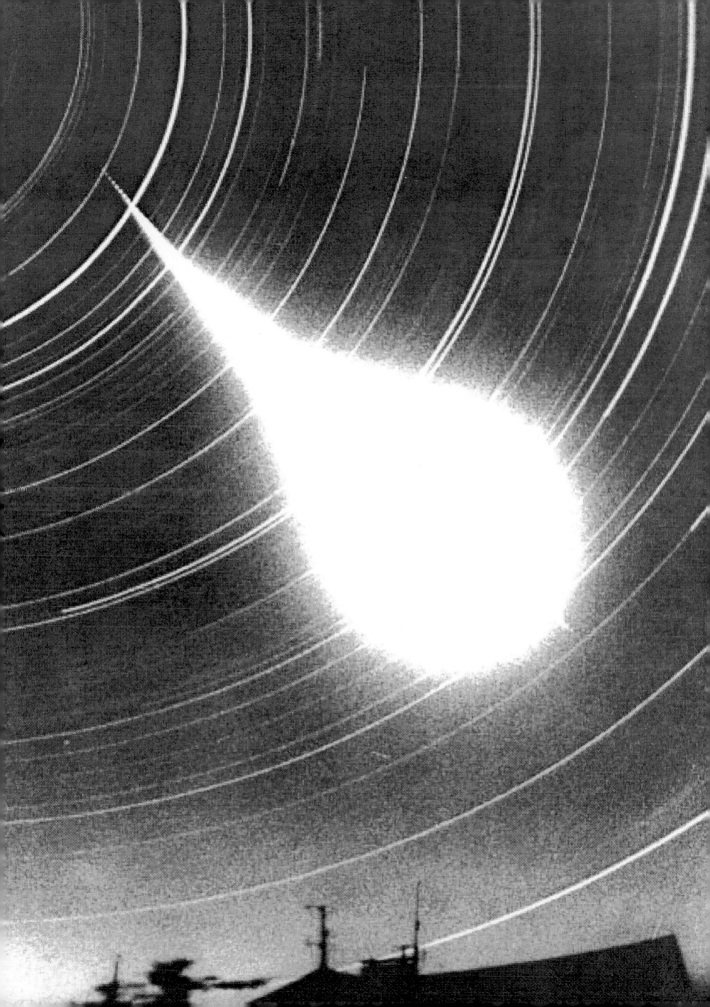

how to look at
mirages

Many people think mirages are in the eye of the beholder. If you are lost in a desert and you see a swimming pool and a waiter with an iced tea, you're probably hallucinating. But if you are lost in a desert and you see a shimmering lake on the horizon, it is as real to you as it would be to anyone lost in that same desert. And if you fall to your knees (like the characters in cartoons always do), and the pools come up closer until it looks as if you're on a little sandy island in a vast gleaming ocean, then your eyes are not deceiving you. Mirages are optical phenomena—properties of the light and air, not of frenzied minds.

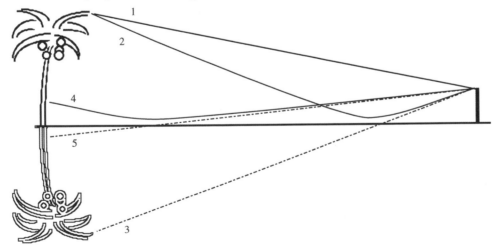

figure 29.1

An inferior mirage of a palm tree.

Mirages are also far more common than people tend to think. Anytime you're driving and you see the road ahead begin to shimmer as if someone has poured blue paint on it, you are seeing the same kind of mirage. Mirages also occur on vertical surfaces—if you put your head very close to a long wall that is heated by the sun, and sight down it, you may well see double and triple "reflections" of people who are walking near the wall. And most impressively, mirages occur in the wintertime, especially over long stretches of cold water. Where I live, in Chicago, there are mirages out over Lake Michigan nearly every day in the wintertime. Factories that shouldn't be visible loom up over the horizon; distant towns at the south end of the lake become impossible cities full of high-rise buildings; huge oil tankers steam by upside down, or glued to copies of themselves, or broken apart into little shards.

Mirages are caused by light that bends on its way to the eye. In school we're taught that light travels in straight lines, but this is seldom true. Light bends around galaxies and planets and even atoms, and it bends very strongly toward anything that is denser or colder than what it is traveling through. If a laser is shined into an aquarium full of sugar water, it bends sharply down to where the sugar is denser at the bottom. In the atmosphere, light bends toward colder, denser air and away from hotter, lighter air. The buildings in towns on the other side of Lake Michigan are normally out of sight, hidden by the curvature of the Earth itself. When I see them, it is because the light bends around with the curve of the Earth, and comes right over the horizon to my eye. It does that when the surface of the lake is freezing cold and the air above is warm; the light keeps bending down, away from the warmth, and stays close to the surface of the lake until it reaches me.

In the desert, where the sand is hot and the air slightly less so, the light bends up. Figure 29.1 shows a typical desert mirage. The observer standing at the right will see the palm tree, and also an upside-down mirage. Some light reaches her eye directly, like ray number 1. Light ray number 2 travels downward until it gets to the superheated half-inch or so above the ground, and then it curves away from the intense heat and up to the eye. Since the light ray comes up from below, the observer thinks it comes from an object down low, at number 3. (All we know about the world is what our eyes tell us: there is no way to see that the ray has curved.) A ray starting lower down on the trunk of the tree, at number 4, will bend just slightly, and so the observer will see the trunk below it, at number 5. There are no actual reflections in a mirage; the light never touches the ground and bounces off. It starts out straight and then turns when it hits a temperature gradient.

Since the mirage is below the original, these kinds of desert and hot-weather mirages are called inferior mirages. Mirages in which the mirage looms above the object,

figure 29.2

A complex superior mirage of a schooner.

5 as if it were floating in mid-air, are superior mirages. Figure 29.2 shows a superior mirage, in which a schooner appears half-sunk beneath the horizon, with an astonishing apparition just above it. The apparition is of a

4 copy of the schooner sailing on a compressed reflection of itself. In

3 typical mirage fashion, the three boats blur into one another. This

2 example may seem strange, but multiple superior mirages like

1 this are common. (Normally the parts will be much blurrier, so I have drawn them instead of using a photograph.)

In simple mirages (as in Figure 29.1), the air is hot on the ground and gets colder upwards, or vice versa. Multiple mirages are produced where the air is hot at ground level, then cooler, and then hot again, or vice versa; all such changes are called inversions. In Figure 29.3, the air is hot at lake level, then cool between the levels marked A and B, warm again between B and C, cool between C and D, and finally warm again above D. The half-sunken schooner at the base of the mirage is caused by rays like numbers 1 and 2, which go down to level A and then start to bend back up. (Note the numbers on Figure 29.2, which correspond to the rays on Figure 29.3.)

It goes against intuition, but these conditions imply that there are some parts of the actual ship that the observer cannot see, even though it is right there in front of her. If a light ray such as number 6 starts out toward the observer, it will be deflected and miss her entirely. As a result, the lower portion of the boat is invisible and can be seen only up above, in its mirage "reflection."

The lovely mirage in Figure 29.4 is common in the desert. A whole range of mountains is upended and fused to the actual mountaintops. Some of the mirages end up looking like impossibly high curved cliffs, and others tear free of their moorings in the land and hover in midair. The airy mountains are mirages of real mountains that are farther away from the photographer (in this case, up to 52 miles away, well beyond the horizon). In general, the higher and smaller the mirage, the more distant the object.

Diminishing mountains are an effect that is commonly reported by sailors. As an island recedes to the horizon, it seems to shrink *upward,* until it disappears in the air. It is shown in Figure 29.5, and explained in the two diagrams below the illustration. I have exaggerated the curvature of the Earth and raised the islands to impossible heights in order to bring out the relations. Say you're on the island at the right, looking down into the ocean toward point A. As you raise your eyes, you will come to a point where light rays from the distant island can be bent upward and reach your eye. (Closer in, the rays would have to bend too sharply.) At that point, you are seeing a mirage that looks as though it is in the direction I have marked by the dotted line. As you continue to raise your eyes, you will see mirages of the lower parts of the island, until you reach the point where you're looking at the base of the island itself. The situation here is the same as with the palm tree.

Now imagine the island is much farther away, partly hidden by the curvature of the Earth. As you raise your eyes, you will encounter the same point B, where the mirage begins. But then, as you continue to look upward, you'll quickly reach a point where the mirage cuts off (point C). Notice how little of the island can actually contribute to the mirage—only a small portion of the high cliff. The two limits to the mirage are called the vanishing line and the limiting line. The mirage itself is upside down, as in the palm tree, so it seems to begin at the limiting line and stretch *downward* to the vanishing line. Everything above the limiting line on the actual island is directly visible, and you will see it *above* the mirage.

Notice where the horizon is in these lower two diagrams. It isn't where you'd expect just by looking at the curvature of the Earth; it's much lower, just at the point where the mirage begins—on a straight line *down* from point B. Everything closer to you,

f i g u r e 2 9 . 3

Explanation of the mirage of the schooner.

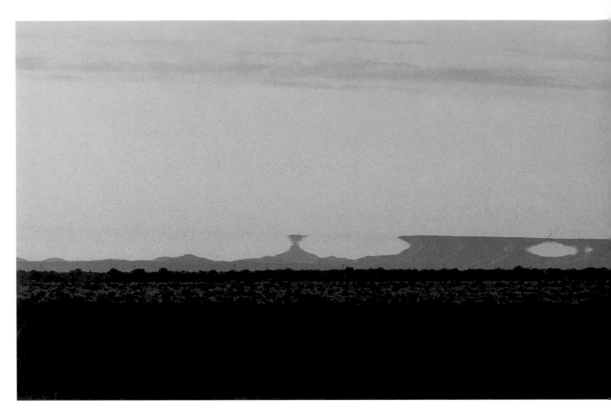

such as point A, looks like the surface of the ocean; everything higher than point B looks like part of the mirage or—in the bottom diagram—like sky. This is one of the most unexpected properties of mirages: the sky to the left and right of a mirage is also a mirage, and so is the horizon beneath it, even though they look for all the world like an ordinary sky above an ordinary horizon. In this example the sea is really much higher than it looks. The reverse can also occur. Here the horizon stays in the same position, but the island and its mirage appendage seem to shrink and to float higher and higher until they disappear when the vanishing line meets the limiting line. At that point, depending on the atmospheric conditions, the island might be well beneath the actual horizon.

The photograph of mountains in Arizona shows some mountains that are nearer than the horizon and others that are beyond it (Fig. 29.4). And it has a wonderful feature that is typical of mirages. A line of tiny telephone poles crosses the landscape from the left. The poles and wires are unaffected by the mirage because they are closer, and the light from them does not curve as drastically. Behind them looms the never-never land of curving bluish cliffs.

figure 29.5

An island mirage receding into the distance.

figure 29.4

A superior mirage in the Las Guigas Mountains, Altar Valley, Arizona. October 8, 1982.

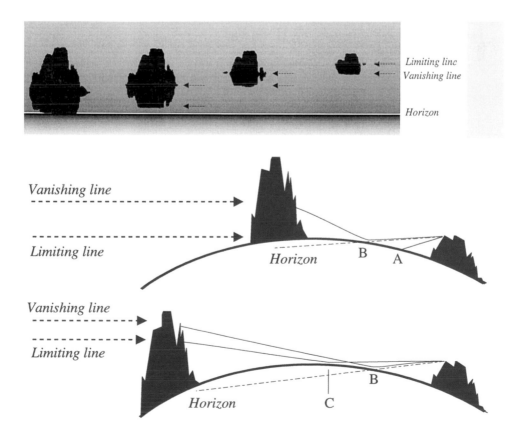

how to look at
a crystal

This is a box that I own, with a few large crystals, some copper (at the bottom), and a little geode—a rock with a cavity inside, filled with small crystals. The tufts of white mold on the large rock are tiny rodlike crystals of okelite, a mineral so fragile that it feels like rabbit fur—as I found out when I touched some, and permanently crushed it. The person who sold them to me said they are found in India, and that there are other specimens in the same mine that are so long and fragile that they cannot not be brought to the United States, even—so he said—if they are carried onto the plane and held the whole way in a courier's lap.

The large crystals are especially entrancing because they look so artificial, as if someone had made some random cuts in a piece of glass. Their facets seem to point in all directions without rhyme or reason. But crystals follow very strict and very beautiful laws, and with a little practice, it is possible to look at a crystal and see how it obeys those laws. When you can perceive the symmetries, the crystal is not just dazzling—it is interesting.

figure 30.1

A collection of crystals, including fluorite, calcite, quartz, and okelite.

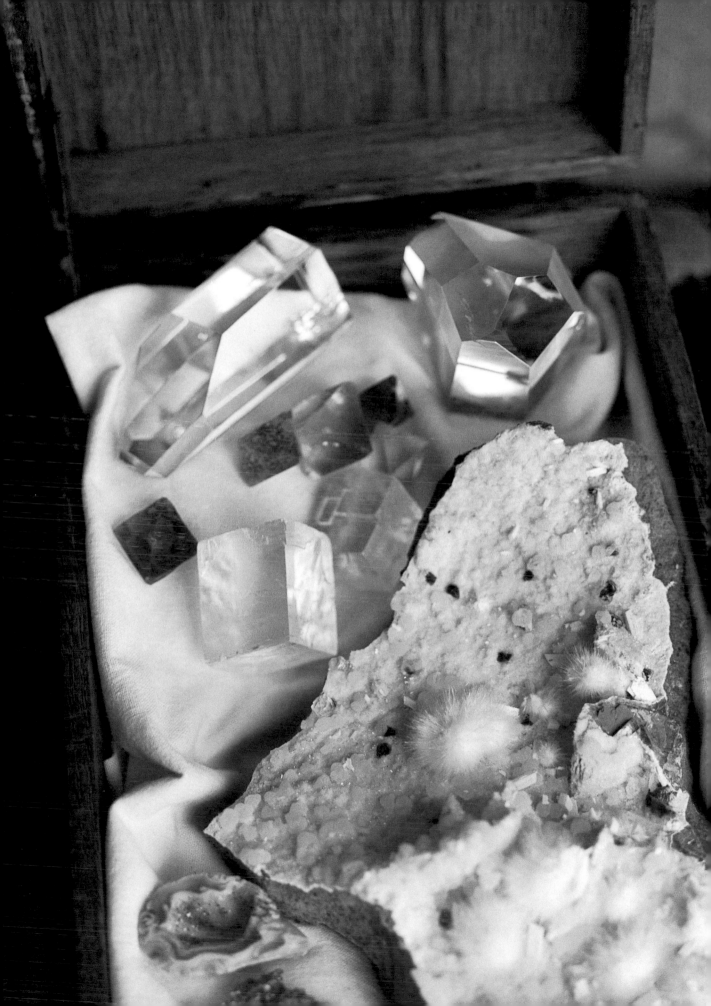

There are two ways to understand crystal forms. The first is to imagine that they are all cut away from some larger form, as you might sculpt a big block of wood by sawing off its corners. The trick is to look at an actual crystal and be able to visualize the simple, invisible shape that encloses it, from which it was cut. (Actual crystals grow from smaller ones, instead of being pared away, but this is a good mental exercise.) For example, you might start with a cube, as in the top left drawing in Figure 30.2. If you bevel each one of the eight corners, you get the next shape in the first row. That is clear enough, but if you keep going, planing away each corner equally, the next stop is a very unexpected shape (first row, third drawing). The original faces of the cube are still visible, and they are still square, but they are now all bordered by triangles.

In real crystals, the corners may not all be beveled simultaneously. Often only half of the corners will be affected (first row, fourth drawing). That "hemihedral" condition is clear enough when it first starts, but if you keep paring away those four corners, you arrive at an even more surprising result (second row, first drawing). And just a little more planing suddenly creates a pyramid (second row, second drawing). Where is the cube now? It takes some time to picture how this tipped-over pyramid fits inside the cube.

If we continue beveling the corners of the pyramid, the form gets smaller (second row, third and fourth drawings). What would the next shape look like? I leave this unanswered.

You might also shave off only two opposite corners, as shown in the third row. The result would be a very irregular-looking shape that looks like two pyramids (third row, third drawing). Paring two sets of opposite corners gives yet another look (third row, fourth drawing). Often a complicated-looking crystal has corners pared several times. It's as if one shape was made, and then *its* corners were pared away, and so on. Some examples are shown in the fourth row.

Some of the older mineralogy textbooks keep up this kind of exercise for pages on end—there are hundreds, almost thousands, of crystal forms you can learn to recognize by thinking this way. Many have outlandish names—pinacoids, brachy-domes, gyroidal tetartohedrons. In nature, crystals are far from symmetric like the examples in Figures 30.2 and 30.3. Often they are missing some faces, or others have been "pared away" more deeply than others. It can take some staring to recognize the hidden symmetries.

Picturing the hidden shapes is one way to understand crystals. The other is to imagine that they are built around three axes, as in Euclidean geometry. The first crystal in Figure 30.2 shows how it works: there is a vertical axis and two horizontal

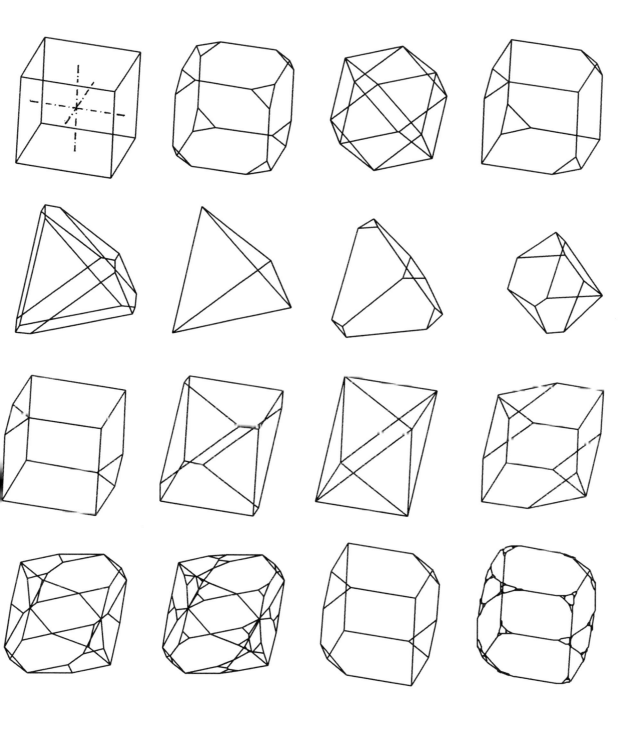

figure 30.2

Truncations of a cube. Top row, nos. 1–3: Beveling on all eight vertices. Top row, no. 4, and second row, nos. 1
and 2: Hemihedral beveling. Second row, nos. 3 and 4: Beveling on all vertices. Third row, nos. 1–3: beveling of
two opposite vertices. Third row, no. 4, and fourth row, no. 2: beveling of two adjacent vertices, repeated.
Fourth row, nos. 3 and 4: beveling of pairs of opposite vertices, repeated.

axes, and they meet at the center of the crystal. If the crystal is a cube, the axes touch the middle of each face. If it is an octahedron, as in Figure 30.3, the axes touch the vertices instead of the faces.

It turns out that all crystals have one of six different arrangements of the axes. All the ones I am showing here are in the *isometric* or *cubic* system: they have three mutually perpendicular axes, and each axis has the same length. In the box (Fig. 30.1), the four small purple crystals are fluorite, which crystallizes in the cubic system. They are octahedrons, just as in Figure 30.3, but stretched or pressed a little out of perfect symmetry.

The other five crystal classes are progressively more difficult to imagine. In the *tetragonal* system, the vertical axis is stretched or shortened. The cube would be pulled up into a vertical block or pushed

figure 30.3

Three steps in drawing a crystal.
First, the completed crystal.

down into a flat rectangle. Similarly, the octahedron would become high and skinny, like two tall pyramids, or else short and squat.

Orthorhombic crystals, the third class, are based on three unequal axes. They are still perpendicular to one another, but each one is a different length. The cube would become a brick shape, and the octahedron would look lopsided. In *monoclinic* crystals, the fourth class, one of the axes is tilted. That means that two of the faces of the cube will slant. In *triclinic* crystals

figure 30.4

Three steps in drawing a crystal. Second, the basic
octahedron and its three underlying axes.

figure 30.5

Three steps in drawing a crystal. Third, one of the eight faces,
showing how the planes intersect.

(the fifth class) all the axes are tilted, and none is perpendicular to the others. Such crystals look completely distorted and they have no symmetry. In Figure 30.1, the two whitish translucent crystals just below the fluorite are calcite, which belongs to the triclinic class. They are shaped like boxes that have been slightly crushed; there are no right angles. The basic shape of a side is a parallelogram; notice the smaller parallelograms on the top face of the crystal that's in shadow. When parallelograms are put together, and there are no right angles between them, the result is an asymmetric, tilted block called a rhombohedron. (The beautiful opalescent colors in the larger crystal are caused by diffraction in the fine structure of the crystal.)

The sixth and last crystal class, the *hexagonal* class, has an extra horizontal axis. Three horizontal axes means that there can be six vertical faces around the sides of the crystal, and such crystals can look very much like pencils, which also have hexagonal symmetry. In the box, the two large crystals at the top are quartz, which is in the hexagonal class. One is on its side to demonstrate how it is essentially

columnar. The other is seen head-on to show the six-sided column. The six sides are not all the same width, but opposite sides are parallel.

When crystallographers draw crystals, they start by drawing the axes. The goal is to draw the completed crystal, called a trigonal trisoctahedron (Fig. 30.3). The drawing proceeds in three stages: first the axes, then a simple octahedron (Fig. 30.4), and then the smaller faces that decorate the trisoctahedron. These days, this kind of drawing is done by computer, but the software follows the same procedure that was used when crystals were drawn by hand. Before computers, a crystallographer would begin by tracing the standard isometric axes from a pattern. (If you want to try this exercise, you can begin by tracing the three axes labeled A, B, and C.) Each axis would be divided like a ruler, with plus and minus directions. The crystallographer would just connect all the points that were the same distance from the center, creating a perfect octahedron.

The next step would be adding the smaller faces. Figure 30.5 shows just one of the faces of the octahedron, the one labeled ABC, and it also shows the three smaller faces of the trisoctahedron, the ones labeled 1, 2, and 3. All the smaller facets that comprise the trisoctahedron intersect two of the axes at the unit length—the same as the octahedron's facets—and they intersect the third axis at double that length, labeled E, F, G. The next step is to draw the three faces numbered 1, 2, and 3 so that they intersect all three axes in the correct places. The face numbered 3, for example, intersects the axes at the points B, C, and E. The face numbered 2 intersects the axes at A, C, and F. Then it is necessary to figure out where the three axes meet—that is, to find the tentlike structure given by dotted lines. If you consider Figure 30.5 for a minute, you'll see how it is done: the two faces labeled 1 and 2 cross each other, and the drawing shows two of the places they meet, point A and point H. Connect those two points with a dotted line. Do the same for faces 2 and 3, and for faces 1 and 3. The result is three dotted lines, and they will form the pattern that is visible in the actual trisoctahedron.

The last step is to repeat the diagram in Figure 30.5, but for the faces I have labeled 5, 6, and 7. Since those faces are partly visible, they each have to be dissected into three smaller faces like 1, 2, and 3. I have not illustrated that part of the exercise, but you can see if you get it right by comparing your result to the final drawing.

I know from experience of teaching this material that it seems very dry, and my students have had a tendency to want to skip over it. But if you take the trouble to actually get out a pencil and ruler and try it yourself, you'll see immediately how crystals work in three dimensions. You will be able to imagine crystals as the intersections of many transparent planes, with each plane intersecting the invisible axes

at specific points. It is the best key to understanding crystals. (On the other hand, if you're the kind of reader who tries to understand things without actually working at them, you probably will not be able to draw or explain crystals. Some things just take practice!)

The large quartz crystals at the top of the box (Fig. 30.1) end in an irregular-looking collection of facets—or so it seems. If you look closely at the one at the upper right, you'll see that the top is comprised of exactly six facets: five large ones and a very small triangular one at the lower center. Each of these facets tilts upward from one of the six vertical sides, and each one tilts at exactly the same angle. If the crystal had a perfectly symmetrical hexagonal base, the six facets would all converge on a single sharp point.

The apparent chaos is not chaos at all—it is rigorous and simple geometry.

how to look at
the inside of
your eye

Using an expensive slit-lamp microscope, your ophthalmologist gets a spectacular view of the inside of your eyes (Fig. 31.1). But you can also see the inside of your eyes, and it doesn't require any intimidating equipment.

The easiest way to become aware of what's inside your eye is to look at a broad expanse of unclouded sky or a bright smooth wall. Don't move your eyes. If you stare intently, after a minute you'll probably become aware of cloudy or wormy forms drifting slowly around. The blurry shapes are called "floaters"; they used to be called "flying gnats." (*Mouches volantes,* or, in Latin, *muscæ volitantes.*) They are actually red blood cells deep inside your eye, suspended between the retina, in the back of the eye, and the transparent ball of jelly—the "vitreous body"—that fills the eyeball. There is a very thin layer of watery fluid around the vitreous body, which lubricates it so that it doesn't stick to the inside walls of the eye; floaters are blood cells that have hemorrhaged from the retina and escaped into the watery layer. (Think of a round fishbowl with a large ball inside. The floaters are the fish, trapped between the ball and the sides of the bowl.) Since blood cells are sticky, they tend to link together into clumps and chains; if you look closely, you'll notice that the chains are really made up of little balls.

The center of the retina is a slight depression called the fovea, and the watery layer is a little deeper there. If you lie on your back and look up at the ceiling for a while, you may notice the floaters become sharper. That is because they are slowly sinking to the bottom of the depression, like leaves in a swimming pool. The closer

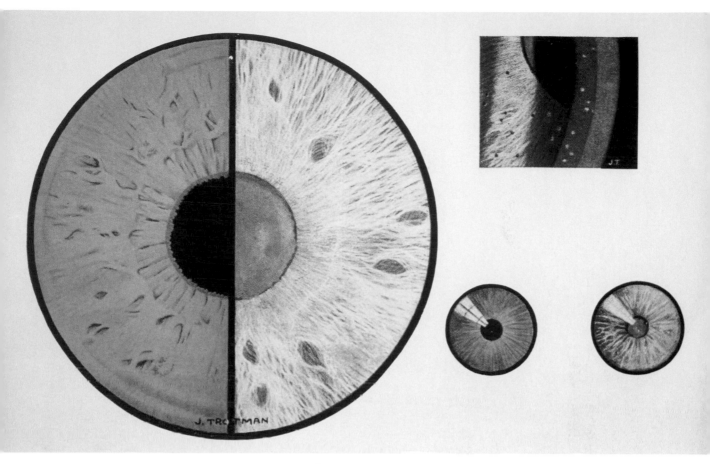

figure 31.1

The iris in heterochromic cyclitis, contrasted with the normal structure.

they get to the retina, the clearer and smaller they look. Floaters are shadows cast on the retina, and in that respect they are just the same as the shadows you cast on a screen if you hold your hand up in front of a projector. The closer your hand is to the screen, the smaller the shadow and the sharper the silhouette.

Some people have only a few floaters, and other people have large dense ones that they find continuously distracting. For some people they look faintly creased, like rumpled cotton sheets. Others experience them as bulbous things like masses of half-melted tapioca, with concentric rings all around them. Andreas Doncan, a nineteenth-century physician, classified them into four species: large circles, "strings of pearls," granular clusters of circles, and bright streaks or membranes that look like little scraps of wet tissue paper. Floaters can seem quite large, but of course they aren't; the "large circles" are less than a twentieth of a millimeter wide, and the "strings of pearls" are seldom more than 4 millimeters long. They are actually by far the smallest things you can see with your unaided eye. You may notice that your

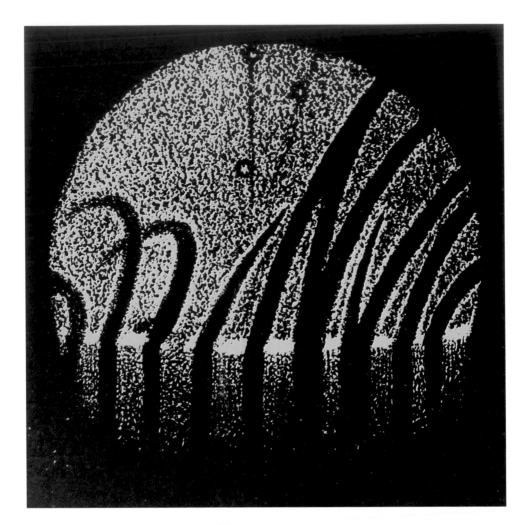

f i g u r e 3 1 . 2

The eyelashes seen against a bright light.

floaters have three or four little rings around them—those are the diffraction pattern caused by light bending around them on its way to the retina. Physicists have measured them and found that the smallest, outermost rings are only 4 or 5 microns across—that's four thousandths of a millimeter, a thousand times smaller than the smallest speck that you could see in everyday life. Four microns is only ten times the wavelength of the light that makes the floaters visible.

It is notoriously hard to focus on floaters: every time you try, they slide away. That is because they are behind the lens of the eye, so it is not possible to bring them into focus or even to turn the eye to face them. They just slosh back and forth as the eye moves. I remember one occasion when I was annoyed by floaters, and I tried to get them to move out of my field of view by turning my eyes violently from side to side. Apparently that is a common strategy among people who suffer from

floaters, but it doesn't work. A quick turn dislodges them a little, but in a minute they waver and return to the places they had been. That's because the inside of the eye has the consistency of hard-set gelatin. The floaters are like the bits of fruit suspended in the gelatin; if you spin the bowl around, everything vibrates, but eventually it settles back the way it was. (Each of the pictures in this section misrepresents what is seen, because nothing in these images can be seen directly. They aren't like ordinary pictures, where you can look around at will. Everything inside the eye is seen in peripheral vision—it is glimpsed but not fully seen.)

If you keep very still, you will see that most of the floaters are drifting slowly downward. Because the image on our retinas is upside down, it follows that the floaters are really drifting slowly *upward.* In the nineteenth century, it was thought that floaters must be lighter than the fluids in the eye, because otherwise they wouldn't rise. But now it seems the explanation is that when the eye moves, the jellylike sphere of vitreous humor turns in its socket of watery fluid, and when the eye stops moving, the sphere settles to the bottom of the eye, pushing the watery fluid up all around it like a big ice cube in a glass.

Floaters are easy enough to see, and with a little ingenuity you can see even deeper into your eye. You need a very intense light source such as a strong projector lamp or a high-wattage bulb. Small bulbs are best; if you have only a large one, put it as far away from you as possible. In a dark room, use a magnifying glass or a strong lens to focus the light from the bulb onto a sheet of aluminum foil. Put a tiny pinprick into the aluminum foil, as small and as perfectly round as you can make it. The idea is to have the light focused so exactly that it converges just on the pinhole and not on the rest of the sheet. Then go around to the other side of the sheet, look through the pinhole, and you'll see a burst of light. Almost everything you see around the light itself is actually on the inside of your eye: you're looking at shadows of things in your eye, cast on your own retina.

In the mid-nineteenth century, several German scientists drew pictures of the things they saw (Figs. 31.2–31.5). (These drawings omit the very bright light that

figure 3 1 . 3

Water droplets and grains of dust on the cornea, seen against a bright light.

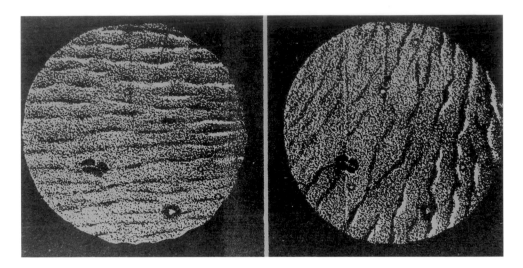

figure 31.4

The appearance of corrugations on the cornea, seen against a bright light.

shines right in the middle of your field of view.) The first thing you're apt to notice, especially if you're squinting, is your own eyelashes, which remind me of tree trunks in some prehistoric swamp (Fig. 31.2). If you open your eye a little more, you will see a large disk of light, as in these engravings, because your pupil is throwing a round spot of light on your retina. If your iris has an irregular margin, as some people's do, the circle will not be completely round. Figure 31.3 shows dark, circular blobs with brights spots at their centers. They are caused by drops of moisture that are secreted by the tear glands and spread out over the outside of the cornea. Like water drops on an irregular surface, they cling to bits of dust and tiny impurities; the bright spots are images of the impurities. Hermann von Helmholtz, one of the scientists who drew these pictures, says these droplets drift slowly downward until you blink and your upper eyelid drags them back up again. (They are like the smears on a windshield that sink down until the wiper comes across and pulls them up.)

Figure 31.4 shows what happens if you close your eye and rub it for a while with your fingers. That actually distorts the surface of the cornea, rumpling it like a rug that has been pushed up into folds. Figure 31.5 shows features that are part of the lens itself, which is made of concentric circles of transparent cells. (These are all normal or common conditions, and if you see them you probably don't need to call a doctor.)

There is even a way to have a look at the very back of the eye, at the blood vessels that spread out over your retina. Even though the vessels lie on top of the retina, we aren't normally aware of them because the photoreceptors underneath them have gotten used to living in the shade. But if you can shine a very bright light on the

retina from an unusual angle, the shadows will shift and the blood vessels will suddenly become visible. I have done this using the same apparatus, but without the aluminum foil sheet. Just take away the foil and focus the light source right into your eye. Don't look at the bulb itself, but look away, toward a dark corner of the room. At first you might not see anything, but if you move your eye slightly to one side, and then back, you'll see a sudden flash of thick, undulating veins. (If the experiment doesn't work, you can wait until your next eye exam, but constantly looking aside to see your retinal veins will probably irritate your doctor.)

It's an uncanny sensation suddenly seeing your own retinal blood vessels "projected" onto the walls of the room. It happens because you have shifted the normal angle of incoming light and cast skewed shadows of the vessels onto the retina. But how odd to think that every day, wherever you look, you're looking *through* a net of curving blood vessels. It is as if we are all seeing the world from behind a dense spiderweb.

The retinal vessels form a pattern that is different in each person, so they can be used like fingerprints to distinguish you from everyone else. The same is true, more subtly, of each of the pictures in this section—your right eye and your left eye will have their own patterns of recurring floaters, their own distinctive corneas, their own structures in the lens. If you try these experiments, you'll get a sense of the texture and feel of your eyes—their minuscule imperfections, the mass of the jelly inside them, the slightly notched and soiled surface of your cornea, the spidery tendrils that cling to your retinas.

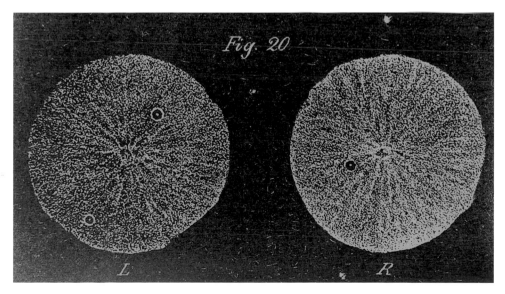

f i g u r e 3 1 . 5

Shadows of the crystalline lens, seen against a bright light.

32

how to look at
nothing

I s it possible to see absolutely nothing? Or do you always see something, even if it is nothing more than a blur or the insides of your own eyelids?

This question has been well investigated. In the 1930s, a psychologist named Wolfgang Metzer designed an experiment to show that if you have nothing to look at, your eyes will stop functioning. Metzer put volunteers in rooms that were lit very carefully so there was no shadow and no gradients from light to dark. The walls were polished, so it was impossible to tell how far away they were. After a few minutes in an environment like that, the volunteers reported "gray clouds" and darkness descending over their visual field. Some experienced an intense fear and felt as though they were going blind. Others were sure that dim shapes were drifting by, and they tried to reach out and grab them. Later it was found that if the room is illuminated with a bright color, within a few minutes it will seem to turn dull gray. Even a bright red or green will seem to turn gray.

Apparently the eye cannot stand to see nothing, and when it is faced with nothing, it slowly and automatically shuts down. You can simulate these experiments at

figure 3 2 . 1

Picture of nothing.

home by cutting ping-pong balls in half and cupping them lightly over your eyes. Since you can't focus that close, your eye has no detail to latch on to, and if you're sitting in a place with fairly even illumination, you won't have any shadows or highlights to watch. After a few minutes, you will begin to feel what the people in those experiments experienced. For me, it is a slow creeping claustrophobia and an anxiety about what I'm seeing—or even *if* I am seeing. If I use a red lightbulb instead of a white one, the color slowly drains out until it looks for all the world as if the light were an ordinary white bulb.

(This experiment won't work, by the way, if you close your eyes. The slight pressure of your eyelids on your corneas and the tiny flicker of your eye muscles will produce hallucinations, called entoptic lights, which will give you something to look at. The only drawback to using ping-pong balls is that your eyelashes get in the way. The experimenters recommend using "a light coating of nonirritating, easily removed, latex-based surgical adhesive" to fasten the eyelashes to the upper lid— but it's probably better to get along without it.)

These experiments are interesting but they are also artificial. It takes something as contrived as a polished white wall or halves of a ping-pong ball, to create a wholly uniform visual field. There is another way to see nothing that I like much better, and that is trying to see something in pitch darkness. In recent decades scientists have figured out that it takes only between five to fifteen photons entering the eye before we register a tiny flash of light. That is an unimaginably tiny quantity, millions of times fainter than a faint green flash from a lightning bug. Unless you have been in a cave or a sealed basement room, you have never experienced anything that dark. And yet the eye is prepared for it.

It takes at least five photons to produce the sensation of light, instead of just one, because there is a chemical in the eye that is continuously breaking down, and each time a molecule breaks, it emits a photon. If we registered every photon, our eyes would register light continuously, even if there were no light in the world outside our own eyes. The chemical that emits the light is rhodopsin, which is the same chemical that enables us to see in dim light to begin with. So as far as our visual system is concerned, there is no way to distinguish beteween a molecule of rhodopsin that has broken down spontaneously and one that broke down because it was hit by a photon. If we saw a flash every time a rhodopsin molecule decomposed, we would be seeing fireworks forever, so our retinas are designed to *start* seeing only when there is a little more light.

Five to fifteen photons is an estimate and there is no way to make it exact, but the reason why it can't be exact is itself exact. It has to do with quantum mechanics,

the branch of physics that deals with particles like photons. According to quantum physics, the action of photons can be known only statistically and not with utter precision. The precise theory shows that the answer is imprecise. There is also a second reason why we can never know exactly how little light we can see. The human visual system is "noisy"—it is not efficient and it fails a certain percentage of the time. Only cave explorers and volunteers in vision experiments have ever experienced perfect darkness, and even then they see spots of light. Those are "false positives," reports that there is light when there isn't. We see light when we shouldn't and we fail to see light when, by the laws of physics, we should. Also, the two eyes take in different photons and so they never work in perfect harmony. In extremely low light, a report of light from one eye might be overruled by a report of darkness from the other. Many things can happen along the complicated pathway from the rhodopsin in the retina to the centers of visual processing.

These phenomena of false positives are called by the wonderful name "dark noise" and the not-so-wonderful technical term "equivalent Poisson noise." Then there's the light generated inside the eye itself, called the "dark light of the eye." It may have a photochemical origin, such as the light from rhodopsin; wherever it comes from, it contributes to the sensation of light.

Entoptic light, the dark noise, the dark light of the eye—this is the end of seeing. But they are wonderful phenomena. To see them, you have to find a perfectly dark spot—a windowless basement room or a hallway that can be entirely closed off—and then you have to spend at least a half hour acclimitizing to the dark. Where I live, in the city, it is impossible to find real darkness. There is a bathroom in our apartment that opens onto an interior hallway, but even if I close all the curtains, close off the hallway, and shut the bathroom door behind me, light still comes in under the doorway. I don't see it at first, but after ten minutes my eyes pick out a faint glow. Real darkness is elusive.

In the end, when there is nothing left to see, the eye and the brain invent lights. The dark room begins to shimmer and with entoptic auroras. They seem to mirror my state of mind—if I am tired I see more of them, and if I rub my eyes they flower into bright colors. In total darkness, entoptic displays can seem as bright as daylight, and it takes several minutes for them to subside. Looking at them, it is easy to be sympathetic with anthropologists who think that all picture-making began with hallucinations. Some entoptic displays are as lovely and evanescent as auroras, and others as silky and seductive as a ghost. Pure dark, in the absence of entoptic colors, is still alive with dark noise. If I try to fix my gaze on some invisible object—say my hand held up in front of me—then my visual field starts to sparkle with small

flashes of dark noise, the sign that my neurons are trying to process signals that aren't really there. They can also become quite strong, like the sparks that come off bedsheets on a cold winter night. I can also try to erase all sense of illumination by letting my eyes rest or wander wherever they want. When I do that, I am still aware of the sensation of light—really it is too dim to be called light; it is more the memory of light. Perhaps that is the "dark light of the eye," the chemicals splitting and reforming in the eye in the normal processes of molecular life.

So I am left with this strange thought: even though we overlook so many things and see so little of what passes in front of us, our eyes will not stop seeing, even when they have to invent the world from nothing. Perhaps the only moments when we truly see nothing are the blank, mindless stretches of time that pass unnoticed between our dreams. But maybe death is the only name for real blindness. At every other moment our eyes are taking in light or inventing lights of their own: it is only a matter of learning how to see what our eyes are bringing us.

how do we look to
a scallop?

Is there a rhyme or reason to all the things that I have described in this book? If I were a psychologist or a scientist, I might say there is. It looks as though there are different kinds of seeing—some depend on quick glances, and others on hard, focused staring. A psychologist might say the book is really a collection of species of seeing.

Some chapters, for instance, show how we naturally try to find orderly patterns in nature. The cracks in oil paintings are a case in point, and so are the cracks in pavements, and the patterns in the bark of trees that I alluded to in passing. Other chapters seem to be about counting and measuring. Fingerprint analysis requires it, and so does the inspection of culverts. Still other chapters have to do with the kind of concerted attention that gradually draws out invisible details. I said as much about staring at the smooth skin of the shoulder joint to find its hidden articulations, and about staring at the subtle colors in a sunset to see their invisible outlines. There are also chapters that are principally concerned with very close looking at very tiny shapes—sand and postage stamps would be examples. Yet other chapters are about an observer's ability to look at something in two dimensions and visualize it in three. That is an essential skill in looking at crystals, engineering drawings, and X rays.

Eight or ten categories could encompass this book fairly well, and when I was writing the book I thought about organizing it that way. The table of contents would have had headings like Pattern Recognition, Counting and Measuring, Focused Attention, Close Looking, Three-Dimensional Visualization. But in the end, what a

dull book that would have been. Psychologists and cognitive scientists work with categories like those, and they are certainly helpful in understanding how our brains process visual signals. But such categories are too abstract; they utterly fail to capture what is fascinating about the objects themselves. I do not look at sunsets in order to test my ability to discern similar colors or at crystals to practice my skills at three-dimensional visualization. On the contrary, as I look at a sunset or a crystal, it might occur to me that I am seeing in a special way, and afterward I might want to classify different kinds of seeing. Seeing is what is in question, not theorizing or classifying.

The pleasure of looking at unusual things is particular to those things and it is lost when it is transported into a theory. The invisible boundaries between the colors in a sunset are not like the invisible boundaries between the colors in a rainbow or in a painting. The facets of a crystal are aligned according to very particular rules, and those rules do not apply to any other objects. The way I see each kind of thing is peculiar to that thing, and the same is true outside of vision. People who say that mathematics teaches you how to think are simply wrong. Mathematics teaches you mathematics. Geometry teaches you to think like a geometer, and algebra teaches you to reason like an algebraist. It's the lines and the equations that count, that hold all the interest, just as here it is the objects that hold my attention.

So I decided not to organize this book according to some Theory of Vision, or Classification of Looking. I would rather this book were a demonstration of new things to see and new ways of seeing. In that spirit, I will end with an example of a kind of looking that is entirely beyond human possibility.

A chiton is an animal, a small one, that is common on seaside rocks. Literally, a chiton is a Greek tunic, but the animal does not really look like a tunic. In England it is called the "coat-of-mail shell," and in America, the "sea cradle," and both of those names are closer to the mark. A chiton has a gentle curl to it, like a rocking cradle, and it is segmented as if it were armored. Chitons look very much like the little, segmented shelled animals called "pill bugs" or "sow bugs" that can be found under stones. (If you pick up a pill bug, it curls, armadillo-fashion, into a little pill.) Pill bugs are nearly blind—they have only two eyes, which I imagine they do not often need to use. But chitons are an entirely different matter. Biologists have discovered that the shells—the part that faces the world, while the animal huddles underneath— are nearly covered in eyes. One species has exactly 1,472 eyes; another has "apparently no fewer than 11,500."

What do these eyes see? In the biological jargon, chitons give "shadow responses"— that is, they can shift themselves on the rocks depending on how light or dark it is. But why would a chiton need 11,500 eyes to do that? The eyes are rudimentary, but that is a

deceptive word; each eye has a tulip-shaped retina with a hundred photoreceptors—enough to form a fuzzy image. So what looks at me when I walk on the beach? And is the look a steady, monotonous, focused gaze, or a bleary unfocused seeing? How many of the 11,500 eyes does it take to glimpse my appearance on the beach and to follow my shadow as it passes over the rocks?

There is also the possibility—so far unproven—that chitons have even larger numbers of smaller photoreceptors. They have been given the wonderful name "aesthetes." No one knows what they could possibly do or even, definitively, whether they exist. It is almost as if the chiton's shell is really a dense bank of eyes camouflaged as a protective skin.

Of course it is impossible to know what the world looks like to a chiton. Things are no less strange for other mollusks: some have compound eyes; others have "eye spots" or "mirror eyes." Scallops are a famous instance—they have up to two hundred eyes, far more "advanced" than other mollusks and well able to form clear images. The eyes have a mirror at the back and two retinas: one catches light coming in, and the other catches the light focused by the mirror on its way back out. Other mollusks also have "cephalic eyes" or "true eyes"—"true," that is, by human standards, since the bio-logists count any eye on the head of any creature as "true," and others as merely "non-cephalic." Yet even in the restricted realm of "true" eyes, there is a bewildering variety: some mollusks have "simple eyes," others pinhole eyes, scanning eyes, and even humanlike eyes with lenses. The deep-sea nautilus, a favorite of shell collectors, has pinhole eyes; that is, just a hole in the front, with no lens. Some researchers have said that the nautilus must see very poorly: but it is an ancient creature—and why would a bad system of vision persist for over four hundred million years? Octopi have very large, humanlike eyes, but they also have tiny "photosensitive vesicles" that are said to be just barely visible to our own eyes as little orange spots. No one knows what the vesicles do or how they assist the enormous octopus eyes that have up to twenty million photoreceptors—more than many mammals.

Animal vision is full of incomprehensible situations—worlds we cannot hope to share, and ways of seeing that must lie entirely beyond our cognition. When I am on the beach, I like to think of the millions of eyes staring at me—the huge clear eyes of fish and birds, the watery eyes of octopi, the several hundred bright red mirror eyes of a scallop, the tens of thousands of eyes and aesthetes on every chiton. It's a reminder of how many ways of seeing there are in the world, and how many things there are to see. This book has 32 of them, and there are millions more waiting to be discovered.

1. How to Look at a Postage Stamp

Hastings Wright and A. B. Creeke Jr., *A History of the Adhesive Stamps of the British Isles* (London: The Philatelic Society, 1899), p. 18; *Catalogue of Mongolian Stamps*, edited by the Mongolian Post Office and Philatelia Hungarica (Budapest: 1978), p. 15; A. C. Waterfall, *The Postal History of Tibet* (London: 1981 [1965]); and the periodical *Postal Himal*.

2. How to Look at a Culvert

Anon., *Concrete Culverts and Conduits* (Chicago, IL: Portland Cement Company, 1941); Anon., "Flow through Culverts," *Public Works* 57 No. 8 (September 1926).

3. How to Look at an Oil Painting

Bucklow's work is detailed and careful, and it pays to read the original report: Spike Bucklow, "The Description of Craquelure Patterns," *Studies in Conservation* 42 (1997): 129–40. He refers to several interesting examinations of cracklike patterns, for example Milan Randi, Zlatko Mihali et al., "Graphical Bond Orders: Novel Structural Descriptors," *Journal of Chemical Information and Computer Sciences* 34 (1994): 403–9; and for an example further afield, *Fractography: Microscopic Cracking Processes,* edited by C. D. Beacham and W. R. Warke (Philadelphia, PA: American Society for Testing and Materials, 1976). Cracks are also mentioned, in passing, in my *What Painting Is* (New York: Routledge, 1999).

4. How to Look at Pavement

The standard work on asphalt in English is Freddy Roberts, Prithvi S. Kandhal et al., *Hot Mix Asphalt Materials, Mixture Design, and Construction,* 2nd ed. (Lanham, MD: NAPA Education Foundation, 1996), chap. 8. For concrete, see Anon., *Effect of High Tire Pressures on Concrete Pavement Performance* (Skokie, IL: Portland Cement Corporation, n.d.), 15 pp., and other publications listed in the catalogue *Concrete Solutions '99* (Portland Cement Corporation).

5. How to Look at an X ray

Lucy Squire, *Fundamentals of Roentgenology* (Cambridge, MA: Harvard University Press, 1964) and many subsequent editions. This is an immensely entertaining book, filled with exercises for the reader. For xeroradiographs, see Lothar Schertel et al., *Atlas of Xeroradiography* (Philadelphia, PA: W. B. Saunders, 1976). Many thanks to Dr. David Teplica for sharing his collection of X rays, and to Dr. Nicholas Skezas for a tutorial in reading chest films.

6. How to Look at Linear B

John Chadwick, *Linear B and Related Scripts* (London: British Museum, 1987), pl. 18, p. 37; Chadwick, *The Decipherment of Linear B* (Cambridge: Cambridge University Press, 1967); and Michael Ventris and John Chadwick, *Documents in Mycenaean Greek* (Cambridge: Cambridge University Press, 1973), pp. 155–58; J. T. Hooker, *Linear B: An Introduction* (Bristol: Bristol Classical Press, 1980), p. 102. For Linear A, C, and D, see, for example, Herbert Zebisch, *Linear A: The Decipherment of an Ancient European Language* (Schärding: H. Zebisch, 1987); *Inscriptions in the Minoan Linear Script of Class A,* edited by W. C. Brice, after Sir Arthur Evans and Sir John Myres (London, 1960); Brice, "Some Observations on the Linear A Inscriptions," *Kadmos* 1 (1962): 42–48.

7. How to Look at Chinese and Japanese Script

The six categories are from a Chinese text called the *Shuo wen jiezi;* see, for example, Florian Coulmas, *The Writing Systems of the World* (London: Basil Blackwell, 1989), pp. 98–99; Bernhard Karlgren, *Analytic Dictionary of Chinese and Sino-Japanese* (Paris: Geuthner, 1923); and William Boltz, "Early Chinese Writing," in *The World's Writing Systems,* edited by Peter Daniels and William Bright (New York: Oxford University Press, 1996), pp. 191–99, quotation on p. 197. For the comment on the dog: L. Wieger, *Chinese Characters: Their Origin, Etymology, History, Classification, and Signification* (New York: Dover, 1965 [1915]), lesson 134, p. 304. On Chinese dictionaries: John De Francis, "How Efficient Is the Chinese Writing System?" *Visible Language* 30 No. 1 (1996): 6–45. Many thanks to Etsuko Yamada for help with the Japanese grass script.

8. How to Look at Egyptian Hieroglyphs

Alan H. Gardiner, *Egyptian Grammar: Being an Introduction to the Study of Hieroglyphics,* 2nd ed. (London: Oxford University Press, 1950), especially p. 34. For the hypothesis that the blue in "foreign country" represents the Nile: Nina Davies, *Picture Writing in Ancient Egypt* (London: Oxford University Press, 1958), p. 32. Color in hieroglyphs: Champollion, *Grammaire Égyptienne, ou principes généraux de l'écriture sacrée Égyptienne appliquée à la représentation de la langue parlée* (Paris: Didot Frères, 1836), 9 ff. For more on the pictorial nature of hieroglyphs: Henry Fischer, *The Orientation of Egyptian Hieroglyphs, Part I, Reversals* (New York: Metropolitan Museum of Art, 1977), p. 5 ("the hieroglyphic system . . . virtually *is* painting"); L. Borchardt, *Das Grabdenkmal des Königs Sahun-reʻ* (Leipzig, 1913), vol. 1, p. 5. Hieroglyphs are also discussed in my *Domain of Images* (Ithaca, NY: Cornell University Press, 1999).

9. How to Look at Egyptian Scarabs

Percy Newberry, *Scarabs: An Introduction to the Study of Egyptian Seals and Signet Rings* (London: A. Constable, 1906); and see *The Scarab: A Reflection of Ancient Egypt* (Jerusalem: The Israel Museum, 1989). Etienne Drioton, *Scarabées a Maximes,* Annual of the Faculty of Arts, Ibrahim Pasha University, No. 1 (1951): 55–71, and Drioton and H. W. Fairman, *Cryptographie, ou Pages sur le développement de l'alphabet en Égypte ancienne,* edited by Dia' Abou-Ghazi (Cairo: Organisme Général des Imprimeries Gouvernementales, 1992). For criticism of Drioton's position, see William Ward, *Studies on Scarab Seals,* vol. 1, *Pre–12th Dynasty Scarab Amulets* (Warminster, Wiltshire: Aris and Phillips Ltd., 1978), p. 59.

10. How to Look at an Engineering Drawing

Henry Brown, *507 Mechanical Movements* (New York: Brown, Coombs, and Company, c. 1865 et seq.); *Ingenious Mechanisms for Designers and Inventors,* edited by Franklin Jones, 2 vols. (New York: Industrial Press, 1951), vol. 2, pp. 295–99.

11. How to Look at a Rebus

This is a book well worth seeing, even if you can't read it; you can find it in many large libraries: Francesco Colonna, *Hypnerotomachia poliphili* (Venice, 1499). There is an English translation, *Hypnerotomachia Poliphili: The Strife of Love in a Dream,* trans. Jocelyn Godwin (London: Thames and Hudson, 1999), but the original book is far more beautiful. The interpretation comes from Ludwig Volkmann, *Bilderschriften der Renaissance: Hieroglyphik und Emblematik in ihren Beziehungen und Fortwirkungen* (Leipzig: K. W. Hiersemann,

1923), reprinted (Nieuwkoop: B. De Graaf, 1969), p. 16; Jean Céard and Jean-Claude Margolin, *Rebus de la Renaissance, Des images qui parlent* (Paris: Maisonneuve et Larose, 1986), p. 90, n. 78, 79; G. Pozzi, "Les Hiéroglyphes de l'*Hypnerotomachia Poliphili*," in *L'Emblème à la Renaissance,* edited by Yves Giraud (Paris: Société d'Édition d'Enseignement Supérieur, 1982), pp. 15–27; Erik Iversen, *The Myth of Ancient Egpyt and Its Hieroglyphs* (Copenhagen, 1961), pp. 66–70. There is much more to the *Hypnerotomachia poliphili;* see, for instance, *Garden and Architectural Dreamscapes in the Hypnerotomachia Poliphili,* edited by Michael Leslie and John Dixon Hunt, special issue of *Word and Image* 14 No. $^1/_2$ (1998).

12. How to Look at Mandalas

Carl Jung, "Zur Empirie des Individuationsprozesses," in *Gestaltungen des Unbewussten* (Zurich: Rascher, 1950), in English as "A Study in the Process of Individuation," in *The Archetypes and the Collective Unconscious,* trans. by R. F. C. Hull, Bollingen Series, vol. 20, *The Collected Works of C. J. Jung,* vol. 9, part 1 (Princeton, NJ: Pantheon, 1959), pp. 290–354. Alchemical symbols are discussed in my *What Painting Is* (New York: Routledge, 1999). For Tibetan mandalas, see Loden Sherap Degyab, *Tibetan Religious Art,* 2 vols. (Wiesbaden, 1977); J. Jackson and D. Jackson, *Tibetan Painting Methods and Materials* (Warminster: Aris and Phillips, 1983); and Lama Gega, *Principles of Tibetan Art: Illustrations and Explanations of Buddhist Iconography and Iconometry according to the Karma Gardri School* (Darjeeling, 1983).

13. How to Look at Perspective Pictures

Figure 13.1 is analyzed further in my "Clarification, Destruction, Negation of Space in the Age of Neoclassicism," *Zeitschrift für Kunstgeschichte* 56 No. 4 (1990): 560–82; and I have written at length on the complexities of perspective in *The Poetics of Perspective* (Ithaca, NY: Cornell University Press, 1994); see, for instance, the recommendations on p. 1, n. 1.

14. How to Look at an Alchemical Emblem

For modern communications theory, see Edward Tufte, *The Visual Display of Quantitative Information* (Cheshire, CT: Graphics Press, 1983); Tufte, *Envisioning Information* (Cheshire, CT: Graphics Press, 1990). Other interpretations of this emblem and other emblems are in Adam McLean, *The Alchemical Mandala: A Survey of the Mandala in the Western Esoteric Traditions,* Hermetic Research Series No. 3 (Grand Rapids, MI: Phanes, 1989), pp. 43–44; and Balthasar Klossowski de Rola, *The Golden Game, Alchemical Engravings of the Seventeenth Century* (New York: Braziller, 1988), p. 58. For Steffan [Stefan] Michelspacher [Müschelspacher], see his *Cabala, Spiegel der Kunst und Natur: in Alchymia* (Augsburg, 1615). There is an English translation in the British Library: "Cabala: The Looking Glass of Art and Nature," British Library, MS Sloane 3676, pp. 1–36. The elements of heraldry are given in my *Domain of Images* (Ithaca, NY: Cornell University Press, 1999); and there is more on alchemy in my *What Painting Is* (New York: Routledge, 1999).

15. How to Look at Special Effects

Most companies use proprietary software. As of spring 2000, the best commercial program for microcomputers is Bryce 3D, which was used to make the images in this section. A good text (now slightly outdated) is Susan Kitchens, *Real World Bryce* 2 (Glenn Ellen, CA: Lightspeed Publishing, 1997).

16. How to Look at the Periodic Table

For affinity tables: A. M. Duncan, "The Functions of Affinity Tables and Lavoisier's List of Elements," *Ambix* 17–18 (1970–71): 28–42; Duncan, "Some Theoretical Aspects of Eighteenth-Century Tables of Affinity," *Annals of Science* 18 (1962): 177–94, 217–32. Subshells are explained in, for example, Robert Eisberg and Robert Resnick, *Quantum Physics*, 2nd ed. (New York: John Wiley and Sons, 1985), chap. 9. For the periodic table: J. W. von Spronsen, *The Periodic System of Chemical Elements* (Amsterdam: Elsevier, 1969); Lothar Meyer and Dmitri Mendelejeff, *Das Natürliche System der chemischen Elemente*, in the series Ostwalds Klassiker der exakten Wissenschaften, No. 68 (Leipzig: Wilhelm Engelmann, 1895); and Mary Elvira Weeks, *Discovery of the Elements* (Easton, PA: Journal of Chemical Education, 1945). I thank Sandra Wolf for the reference to von Spronsen. There are a myriad of other forms of the table; for instance: Myron Coler, "An Invitation to Explore Applications," advertisement in *Scientific American* (September 1991): 46–47 (the "scrimshaw" graph); A. E. Garrett, *The Periodic Law* (London: Kegan Paul, Trench, Trübner and Co., 1909); Eugen Rabinowitsch and Erich Thilo, *Periodisches System, Geschichte und Theorie* (Stuttgart: Ferdinand Enke, 1930); and G. Johnstone Stoney, "On the Law of Atomic Weights," *Philosophical Magazine* 6, Vol. 4 (1902): 411–16 and plate 4; Andreas von Antropoff, "Eine neue Form des periodischen systems der Elemente," *Zeitschrift für angewandte Chemie* 39 (1926): 722–25, and see 725–28; and Nicholas Opolonick, "Chemical Elements and Their Atomic Numbers as Points on a Spiral," *Journal of Chemical Education* 12 (1935): 265.

17. How to Look at a Map

Introductory material on premodern maps: C. Singer, D. J. Price, and E. G. R. Taylor, "Cartography, Survey, and Navigation to 1400," in *A History of Technology*, edited by Singer et al. (New York and London, 1957), vol. 3, pp. 501–37. The map of Burma: Joseph Schwartzberg, "Cosmography in Southeast Asia," in *The History of Cartography*, vol. 2, book 2, *Cartography in the Traditional East and Southeast Asian Societies*, edited by J. B. Hartley and David Woodward (Chicago: University of Chicago Press, 1994), pp. 701–40. For this map: Richard Temple, *The Thirty-Seven Nats: A Phase of Spiral-Worship Prevailing in Burma* (London: W. Griggs, 1906), facing p. 8; new edition edited by Patricia Herbert (London: P. Strachan, 1991).

18. How to Look at a Shoulder

The shoulder, especially in Michelangelo, is treated exhaustively in my *Surface of the Body, Based on the Works of Michelangelo Buonarroti* (unpublished MS, 1983). Some of the results are reported in my "Michelangelo and the Human Form: His Knowledge and Use of Anatomy," *Art History* 7 (1984): 176–86. An example of an anatomy text that makes note of individual variations is Barry Anson, *Atlas of Human Anatomy* (Philadelphia, PA: W. B. Saunders, 1950). An unusual and informative book is Henry Kendall et al., *Muscles: Testing and Function* (Baltimore: Williams and Wilkins, 1971); the book was used for testing the strength of polio patients one muscle at a time.

19. How to Look at a Face

My book *The Object Stares Back* (New York: Harcourt Brace, 1997) has a chapter on faces (pp. 160–200). I've also written about them in *Pictures of the Body: Pain and Metamorphosis* (Stanford: Stanford University Press, 1999). The philosopher Gilles Deleuze and the psycho-

analyst Félix Guattari wrote about faces in *A Thousand Plateaus: Capitalism and Schizophrenia,* trans. by Brian Massumi (Minneapolis: University of Minnesota Press, 1987), pp. 167–91. The basic anatomic information can be found in many gross anatomy texts. Two classics are Eduard Pernkopf, *Atlas of Topographical and Applied Human Anatomy,* 2 vols. (Philadelphia, PA: W. B. Saunders, 1964); and P. J. Sabotta, *Atlas der deskriptiven Anatomie des Menschen* (Munich: J. F. Lehmann, 1904 et seq.). For Paul Richer, see *Anatomie Artistique* (Paris: 1890), in English (abridged, from a German translation of the original) as *Artistic Anatomy,* trans. by Robert Beverly Hale (New York: Watson-Guptill, 1971).

20. How to Look at a Fingerprint
The Science of Fingerprints: Classification and Uses (Washington, DC: US Government Printing Office for the United States Department of Justice, 1984); Maciej Henneberg and Kosette Lambert, "Fingerprinting a Chimpanzee and a Koala: Animal Dermatoglyphics Can Resemble Human Ones," *Proceedings of the Thirteenth Australian and New Zealand International Symposium on the Forensic Sciences, Sydney,* September 8–13, 1996 (published by the Australian and New Zealand Forensic Science Society, on CD-ROM).

21. How to Look at Grass
Agnes Arber, *The Graminae: A Study of Cereal, Bamboo, and Grass* (New York: MacMillan, 1934). (The habitats of vernal-grass are listed on p. 334.) Also Richard Pohl, *How to Know the Grasses* (Dubuque, IA: William C. Broan Company, 1953); Sellers Arthur and Clarence Bunch, *The American Grass Book: A Manual of Pasture and Range Practices* (Norman: University of Oklahoma Press, 1953); and Charles Wilson, *Grass and People* (Gainesville: University of Florida Press, 1961). For the anecdote about Darwin, see Mary Francis, *The Book of Grasses* (Garden City, NY: Doubleday, Page and Company, 1912), p. 94.

22. How to Look at a Twig
Earl Core and Nelle Ammons, *Woody Plants in Winter* (Pittsburgh, PA: Boxwood Press, 1958); the list of flowers is in Rutherford Platt, *The Great American Forest* (Englewood Cliffs, NJ: Prentice Hall, 1965).

23. How to Look at Sand
Raymond Siever, *Sand* (New York: Scientific American Library, 1988), speculates on "reincarnation" on p. 55; see also F. J. Pettijohn, P. E. Potter, and R. Siever, *Sand and Sandstone,* 2nd ed. (New York: Springer-Verlag, 1987); F. C. Loughman, *Chemical Weathering of the Silicate Minerals* (New York: Elsevier, 1969). Many thanks to my sister Lindy, a geochemist, for help with this section.

24. How to Look at Moths' Wings
H. Frederick Nijhout, *The Development and Evolution of Butterfly Wing Patterns* (Washington, DC: Smithsonian Institution Press, 1991); the subject is also discussed in my *Domain of Images* (Ithaca, NY: Cornell University Press, 1999).

25. How to Look at Halos
Robert Greenler, *Rainbows, Halos, and Glories* (Cambridge: Cambridge University Press, 1989), is the principal source. See also R. A. R. Tricker, *Ice Crystal Haloes* (Washington, DC: Optical Society of America, 1979). Parry arcs are also described in E. C. W. Goldie, "A

Graphical Guide to Halos," *Weather* 26 (1971): 391 ff.; for Lowitz's report, see Tobias Lowitz, "Déscription d'un météore remarquable, observé à St. Pétersbourg le 18 Juin 1790," *Nove Acta Academæ Scientiarum Imperialis Petropolitanæl* 8 (1794): 384.

26. How to Look at Sunsets
M. Minnaert, *The Nature of Light and Color in the Open Air,* trans. by H. M. Kremer-Priest, revised by K. E. Brian Jay (New York: Dover, 1954), is not a primary source. On the subject of sunsets, Minnaert condenses material in P. Gruner and H. Kleinert, *Die Dämmerungserscheinungen* (Hamburg: Henri Grand, 1927). See also Aden Meinel and Marjorie Meinel, *Sunsets, Twilights, and Evening Skies* (Cambridge: Cambridge University Press, 1983).

27. How to Look at Color
For emotional primaries see *The Lüscher Color Test,* edited by Ian Scott (New York: Random House, 1969). A good general book is Hazel Rossotti, *Colour: Why the World Isn't Grey* (Princeton, NJ: Princeton University Press, 1983). CIE diagrams are discussed in C. A. Padgham and J. E. Saunders, *The Perception of Light and Colour* (London: G. Bell, 1975). A good art historical study of color is John Gage, *Colour and Culture: Practice and Meaning from Antiquity to Abstraction* (London: Thames and Hudson, 1993). Linguists' terms are proposed in Brent Berlin and Paul Kay, *Basic Color Terms: Their Universality and Evolution* (Berkeley: University of California Press, 1969); and in *Colour: Art and Science,* edited by Trevor Lamb and Janine Bourriau (Cambridge: Cambridge University Press, 1995).

28. How to Look at the Night
F. E. Roach and Janet L. Gordon, *The Light of the Night Sky* (Dordrecht: D. Reidel, 1973), go into detail on the chemical sources of nightglow, the strength and wavelength of the M-arcs, and the probable origins of the Gegenschein. Aden and Marjorie Meinel, *Sunsets, Twilights, and Evening Skies* (Cambridge: Cambridge University Press, 1983), p. 125, has a photograph of the zodiacal light seen from the Moon.

29. How to Look at Mirages
A. B. Fraser and W. H. Mach, "Mirages," *Scientific American* 234 (1976): 102 ff.; W. Tape, "The Topology of Mirages," *Scientific American* 252 (1985): 120 ff.; W. Lehn and L. Schroeder, "The Norse Mermen as an Optical Phenomenon," *Nature* 289 (1981): 362–66; David Lynch and William Livingston, *Color and Light in Nature* (Cambridge: Cambridge University Press, 1995), pp. 52–58.

30. How to Look at a Crystal
For many more exercises in visualization, try Edward Dana, *A Text-Book of Mineralogy,* 3rd ed. (New York: John Wiley and Sons, 1880). Crystal drawing is explained in detail there, and in A. E. H. Tufton, *Crystallography and Practical Crystal Measurement* (London: Macmillan and Co., 1911), pp. 362–417. The history of crystal drawings is outlined in my *Domain of Images* (Ithaca, NY: Cornell University Press, 1999), chap. 2.

31. How to Look at the Inside of Your Eye
For slit-lamp views of the eye as in Figure 31.1, see Alfred Vogt, *Lehrbuch und Atlas der Spaltlampenmikroskopie des lebenden Auges,* 2 vols. (Berlin: Springer, 1930–1931), with a third volume (Zürich, 1941); Vogt's plates are excerpted in James Hamilton Doggart, *Ocular Signs in*

Slit-Lamp Microscopy (St. Louis: C. V. Mosby, 1949). For "floaters," see *Helmholtz's Treatise on Physiological Optics,* translated by James Southall, 3 vols. (New York: The Optical Society of America, 1924), vol. 1, pp. 208–12; H. E. White and P. Levatin, "Floaters in the Eye," *Scientific American* 206 (June 1962): 119–27; and Andreas Doncan, *De corporis vitrei structura disquisitiones anatomicas, entopticas et pathologicas* (Trajecti ad Rhenum: s.n., 1854). A copy of Doncan's dissertation is in the Harvard University library. Forms on the cornea and in the lens are explored in Johann Benedikt Listing, *Beitrag zur physiologischen Optik* (Leipzig: Wilhelm Engelmann, 1905 [1845]).

32. How to Look at Nothing

The experiments on seeing nothing are described in Willy Engel, "Optische Untersuchungen am Ganzfeld. I. Die Ganzfeldordnung," *Psychologische Forschung* 13 (1930): 1–15; and Wolfgang Metzger, "Optische Untersuchungen am Ganzfeld. II. Zur Phänomenologie des homogenen Ganzfelds," ibid.: 6–29. Ping-pong balls are used in Julian E. Hochberg, William Triebel, and Gideon Seaman, "Color Adaptation under Conditions of Homogeneous Visual Stimulation (*Ganzfeld*)," *Journal of Experimental Psychology* 41 (1951): 153–59; and in my *The Object Stares Back: On the Nature of Seeing* (New York: Harcourt Brace, 1997). The quantum limit on vision is discussed in Walter Markous, "Absolute Sensitivity," in *Night Vision: Basic, Clinial, and Applied Aspects,* edited by R. F. Hess, Lindsay Sharpe, and Knut Nordby (Cambridge: Cambridge University Press, 1990), pp. 146–76; Selig Hecht, Simon Schlaer, and Maurice Henri Pirenne, "Energy, Quanta, and Vision," *Journal of General Physiology* 25 (1942): 819–40; D. G. Pelli, "Uncertainty Explains Many Aspects of Visual Contrast Detection and Discrimination," *Journal of the Optical Society of America* 2 (1985): 1508–32; Donald Laming, "On the Limits of Visual Detection," in *Limits of Vision,* edited by J. J. Kulikowski, V. Walsh, and Ian Murray, in the series *Vision and Visual Dysfunction,* vol. 5 (New York: Macmillan, 1991), pp. 6–14. The "dark light of the eye" is mentioned in P. E. Hallett, "Some Limitations to Human Peripheral Vision," ibid., pp. 44–80, especially p. 55; and H. B. Barlow, "Retinal Noise and Absolute Threshold," *Journal of the Optical Society of America* 46 (1956): 634–39.

Postscript: How Do We Look to a Scallop?

J. B. Messenger, "Photoreception and Vision in Molluscs," in *Evolution of the Eye and Visual System,* edited by John Cronly-Dillon and Richard Gregory, vol. 2 of *Vision and Visual Dysfunction,* general editor John Cronly-Dillon (Boca Raton, FL: CRC Press, 1991), pp. 364–97, especially p. 386, quoting H. N. Moseley, "On the Presence of Eyes in the Shells of Certian Chitonidae and On the Structure of These Organs," *Q. J. Microsc. Sci.* 25 (1885): 37–60. My theories about seeing are in *The Object Stares Back: On the Nature of Seeing* (New York: Harcourt Brace, 1997).

All photos, paintings, and diagrams are by the author unless otherwise credited.

1. How to Look at a Postage Stamp

Figure 1.1 From Hastings Wright and A. B. Creeke Jr., *A History of the Adhesive Stamps of the British Isles* (London: The Philatelic Society, 1899), following p. 34.

2. How to Look at a Culvert

Figure 2.1 Courtesy Portland Cement Association, neg. number 30568.

3. How to Look at an Oil Painting

Figure 3.1 Photo by Spike Bucklow, used by permission.
Figure 3.2 Photo by Spike Bucklow, used by permission.
Figure 3.3 Photo by Spike Bucklow, used by permission.
Figure 3.4 Photo by Spike Bucklow, used by permission.
Figure 3.5 Photo by Spike Bucklow, used by permission.
Figure 3.6 Photo by Spike Bucklow, used by permission.

5. How to Look at an X ray

Figure 5.1 From Lothar Schertel et al., *Atlas of Xeroradiography* (Philadelphia: W. B. Saunders, 1976), p. 173, fig. 155.
Figure 5.2 Courtesy David Teplica, MD, MFA.
Figure 5.3 Overlay by the author.
Figure 5.4 Overlay by the author.
Figure 5.5 Courtesy David Teplica, MD, MFA.
Figure 5.6 Overlay by the author.
Figure 5.7 Overlay by the author.

6. How to Look at Linear B

Figure 6.1 Diagram by the author, after John Chadwick, *Linear B and Related Scripts* (London: British Museum, 1987), p. 24, fig. 7.

7. How to Look at Chinese and Japanese Script

Figure 7.1 From *Jiten KANA-syutten meiki, kaiteiban,* edited by Inugai Kiyoshi and Inoue Muneo (Tokyo: Kasama Shoin, 1997), p. 22.
Figure 7.2 From *Jiten KANA-syutten meiki,* p. 72.

8. How to Look at Hieroglyphs

Figure 8.4 From Nina Davies, *Picture Writing in Ancient Egypt* (London: Oxford University Press, 1958), colorplate VI.

9. How to Look at Egyptian Scarabs

Figure 9.1 From Daphna Ben-Tor, *The Scarab: A Reflection of Ancient Egypt* (Jerusalem: The Israel Museum, 1989).

Figure 9. 2 From Alan Schulman, "Egyptian Scarabs, 17th–16th Century B.C.," in *The Mark of Ancient Man, Ancient Near Eastern Stamp Seals and Cylinder Seals: The Gorelick Collection,* edited by Madeleine Noveck (New York: The Brooklyn Museum, 1975), p. 73, no. 57.

Figure 9.3 From Schulman, "Egyptian Scarabs, 17th–16th Century B.C.," p. 73, no. 57, letters and numbers added.

10. How to Look at an Engineering Drawing

Figure 10.1 From *Ingenious Mechanisms for Designers and Inventors,* edited by Franklin Jones, 2 vols. (New York: Industrial Press, 1951), vol. 2, pp. 295–97, fig. 9.

Figure 10.2 From Ibid., fig. 10.

Figure 10.3 From Ibid., fig. 11.

11. How to Look at a Rebus

Figure 11.1 Courtesy Department of Special Collections, University of Chicago Libraries.

12. How to Look at Mandalas

Figure 12.1 From C. G. Jung, "A Study in the Process of Individuation," in *The Archetypes and the Collective Unconscious,* translated by R. F. C. Hull. Bollingen Series, vol. 20, *The Collected Works of C. J. Jung,* vol. 9, part 1 (Princeton, NJ: Pantheon, 1959), following p. 292.

Figure 12.2 From *The Archetypes and the Collective Unconscious.*

Figure 12.4 From *The Archetypes and the Collective Unconscious.*

13. How to Look at Perspective Pictures

Figure 13.1 From John Joshua Kirby, *Dr. Brook Taylor's Method of Perspective Made Easy, Both in Theory and Practice,* 2nd ed. (London, 1755), book II, plate IX, fig. 36.

14. How to Look at an Alchemical Emblem

Figure 14.1 From Steffan Michelspacher [Müschelspacher], *Cabala, Spiegel der Kunst und Natur: in Alchymia* (Augsburg, 1615), plate 1.

16. How to Look at the Periodic Table

Figure 16.1 Courtesy Science Division, Walter de Gruyter, Berlin and New York, 1997.

Figure 16.2 From K. Y. Yoshihara et al., *Periodic Table with Nuclides and Reference Data* (Berlin: Springer, 1985), p. 21.

Figure 16.3 From A. M. Duncan, "The Functions of Affinity Tables and Lavoisier's List of Elements," *Ambix* 17–18 (1970–71): 28–42.

Figure 16.4 From Charles Janet, *Essais de classification hélicoidale des éléments chimiques* (Beauvais: Imprimerie Départementale de l'Oise, 1928), plate 4.

17. How to Look at a Map

Figure 17.1 From Richard Temple, *The Thirty-Seven Nats: A Phase of Spirit-Worship Prevailing in Burma* (London: W. Griggs, 1906), figure facing p. 8.

18. How to Look at a Shoulder

Figure 18.1 Modified from Bernard Siegfried Albinus, *Tabulae Sceleti et Musculorum Humani* (Leiden: Johann & Hermann Verbeck, 1747).

Figure 18.2 Modified from Ibid.

Figure 18.3 Modified from Ibid.

Figure 18.6 Photo: German, c. 1925. Collection: author.

Figure 18.8 Photo: German, c. 1925. Collection: author.

19. How to Look at a Face

Figure 19.1 Inv. no. 15627r. Tolnay 155r.

Figure 19.3 1895–9–15–518r. Tolnay 350v.

Figure 19.5 47Fr. Tolnay 124r.

20. How to Look at a Fingerprint

Figure 20.1 From *The Science of Fingerprints: Classification and Uses* (Washington, DC: US Government Printing Office for the United States Department of Justice, 1984), figs. 1, 4, 7, 11, 12, 33, 34, 37, 40 respectively.

Figure 20.2 Ibid., figs. 72, 82, 86, 88.

Figure 20.3 Ibid., figs. 67, 124, 128, 137 respectively.

Figure 20.4 Ibid., figs. 281, 255, 269 respectively.

Figure 20.6 Print taken by Kosette Lambert and Maciej Henneberg, photo by Robert Murphy, University of Adelaide. Used with permission.

Figure 20.7 From Maciej Henneberg and Kosette Lambert, "Fingerprinting a Chimpanzee and a Koala: Animal Dermatoglyphics Can Resemble Human Ones," *Proceedings of the Thirteenth Australian and New Zealand International Symposium on the Forensic Sciences, Sydney,* 8–13 September 1996, fig. 5a. Used with permission.

21. How to Look at Grass

Figure 21.2 From A. S. Hitchcock, *Manual of Grasses of the United States* (Washington, DC: United States Government Printing Office, 1935), fig. 78.

Figure 21.3 From Mary Francis, *The Book of Grasses* (Garden City, NY: Doubleday, Page, and Company, 1912), p. 97.

Figure 21.4 From Ibid., p. 111.

Figure 21.5 From Hitchcock, *Manual of Grasses,* fig. 181.

Figure 21.6 From Ibid., fig. 366. Lettering added.

25. How to Look at Halos

Figure 25.1 Photo by William Livingston.

26. How to Look at Sunsets

Figure 26.2 Photo by William Livingston.

28. How to Look at the Night

Figure 28.1 Photograph by Art Hoag. National Optical Astronomy Observatories photograph no. 2–2227. By permission of William Livingston.

30. How to Look at a Crystal

Figure 30.3 From Edward Dana, *A Text-Book of Mineralogy,* 3rd ed. (New York: John Wiley and Sons, 1880), p. 424, figs. 814, 814, 816.

31. How to Look at the Inside of Your Eye

Figure 31.1 From James Doggart, *Ocular Signs in Slit-Lamp Microscopy* (St. Louis: C. V. Mosby, 1949), p. XIX.

Figure 31.2 From Johann Benedikt Listing, *Beitrag zur physiologischen Optik* (Leipzig: Wilhelm Engelmann, 1905 [1845]), plate 1, fig. 12.

Figure 31.3 From Ibid., fig. 13.

Figure 31.4 From Ibid., figs.14, 15.

Figure 31.5 From Ibid., fig. 20.